THE COAL MINING INDUSTRY

OF BARNSLEY, ROTHERHAM AND WORKSOP

THE COAL MINING INDUSTRY

OF BARNSLEY, ROTHERHAM AND WORKSOP

KEN WAIN

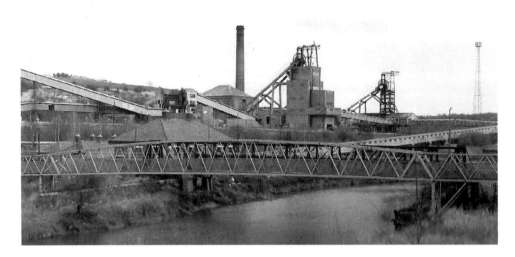

Cadeby Colliery. (Alan Hill)

First published 2014

Amberley Publishing
The Hill, Stroud
Gloucestershire, GL5 4EP

www.amberley-books.com

British Library Cataloguing in Publication Data.
A catalogue record for this book is available from the British Library.

ISBN 978 1 4456 3965 9 (print)
ISBN 978 1 4456 3977 2 (ebook)

Typeset in 10pt on 13pt Minion.
Typesetting and Origination by Amberley Publishing.
Printed in the UK.

Contents

Acknowledgements 7

Foreword 9

1 A History of Coal Mining in the Barnsley Area 10

Barnsley Area Collieries 15

2 The Mitchells of Swaithe Hall 16

3 Newton Chambers 19

4 Grange Colliery 24

5 Thorncliffe Colliery 25

6 Wentworth Silkstone Colliery 26

7 Barley Hall Colliery and Caphouse Colliery 27

The Fitzwilliams and Their Coal Mines 30

8 The Wentworth Fitzwilliams 31

9 Elsecar Colliery 44

10 Hemsworth Main Colliery 47

11 Stubbin Collieries 50

12 Cadeby Main Colliery 57

13 The Lofthouse Colliery Disaster 1973 68

14 Houghton Main Colliery 69

15 Darfield Main and Mitchell Main Collieries 78

16 Grimethorpe Colliery 82

17 Wombwell Main Colliery 86

18 Cortonwood Colliery 89

19 Wharncliffe Silkstone Colliery 92

Worksop Area Collieries 94

20 Kiveton Park Colliery 95

21 Cresswell Colliery 102

22 Shireoaks Colliery 110

23 Firbeck Main Colliery 113

24 Dinnington Main Colliery 114

25 Manton Colliery 116

26 Whitwell Colliery 119

Rotherham Area Collieries 123

27 Thurcroft Colliery 124

28 Greasborough Colliery 127

29 Aldwarke Main Colliery 129

30 Treeton Colliery 132

31 Waleswood Colliery 136

32 Maltby Main Colliery 148

33 Harworth Colliery 156

34 Rotherham Main Colliery 158

35 Silverwood Colliery 162

36 Kilnhurst Colliery 167

37 Manvers Main Colliery 169

38 Recent Coal Industry Accidents in the Twenty-First Century 172

39 The Rundown of the Coal Industry 180

Acknowledgements

Many thanks go to the following:

Mr K. G. Wain	Killamarsh	Ex-British Coal storekeeper
Mr D. R. Wain	Gleadless	Stream 7 Limited
Mr J. Gwatkin	Denaby	Local historian/Ex Colliery official
Ms Maria Sikorski	Sheffield	Photographic donation
Mr S. Fox	Beighton	Local historian/photographer
Mr M. Jones	Killamarsh	Ex-British Coal/photographer
Mr T. W. Adair	Treeton	Ex-NUM official
Mr E. Mullins	Beighton	Fire Services historian
Mr D. A. Goy	Treeton	Ex-British Coal official
Mr C. Higgins	Gleadless	Stained glass designer and historian
Mr A. Rowles	Wales Bar	Author and local historian
The Press Association	Nottingham	
Mr D. Thompson	Killamarsh	Local historian
Mr A. Walker	Handsworth	Ex-safety officer, Orgreave Colliery
Mr A. Peace	Barnsley	Photographic donation
Mr L. Widdowson	Woodhouse	Author and local historian
Mrs J. Siddons	Beighton	Author and local historian
Mr Brian Elliott	Doncaster	Author and local historian
Mr Peter Storey	Matlock	Head of Markham Vale Project
Mr A. Philpots	Swallownest	Photographic donation
Mr K. Holland	Mosborough	Photographer and local historian
Mr W. B. Clayton	Sheffield	Photographer and local historian
Mr Alan Hill	Birmingham	Author and mining historian
Sheffield Newspapers	Sheffield	Photographic donation
Mr R. Young	Wentworth	Author and local historian
Mr A. Nelson	Handsworth	Donation from L. E. Tall's Woodhouse
Mr C. Ulley	Sheffield	Photographic donation.
Mr D. Mathews	Staveley	Photographic collection (mining)
Mr M. Eggenton	Langold	Local historian; photographer
Mr Peter Davis	Barnsley	Local historian; photographic donation
Mr Benny Wilkinson	Conisbrough	Poet and ex-miner

NCB and British Coal Estates Department & scientific services	Bretby, Staffordshire	HQ technical dept, Bretby, Burton on Trent
Rotherham Libraries Archives Department	Rotherham	
Elsecar Heritage Centre	Barnsley	
National Coal Mining Museum	Caphouse Colliery	

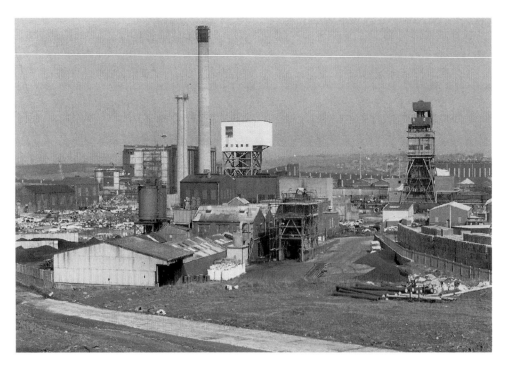

Above: Grimethorpe Colliery. (Alan Hill)

Opposite page: Trepanner coal cutter. (NCB)

Foreword

The Barnsley, Rotherham and Worksop areas have very similar beginnings to the Sheffield and North East Derbyshire coal mining area, dealt with in volume one, and as such need very little in the form of an introduction in volume two.

Suffice to say that all these areas relied heavily on the production of coal for employment and prosperity. Over hundreds of years they have all played their part in contributing to the wealth of the nation, providing the coal without which the industrial revolution would not have happened.

This was achieved by the miners placing themselves in situations which would not have happened in any other profession, risking life and limb to harvest the nation's 'Jewel in the Crown', the black diamond.

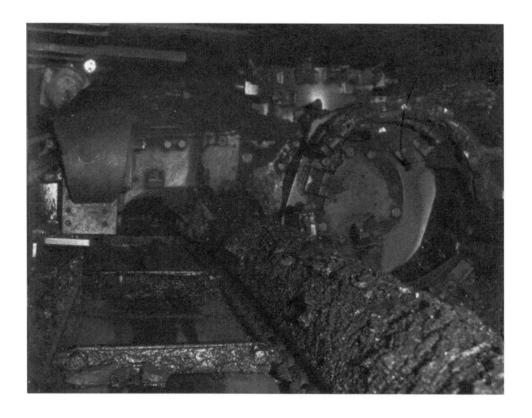

1
A History of Coal Mining in the Barnsley Area

The coal deposits of the late carboniferous period formed the coal swamps over 300 million years ago. About 100 million years before the dinosaurs, great forests of the *Lepidodendron* tree (the Giant Club Moss), which had a girth of 1 metre and a height of up to 40 metres, were laid down in layers over several thousands of years to produce several different coal seams.

The seams run in a line roughly between Huddersfield and Wakefield in the northern reaches of Yorkshire and down through the western side of Leeds to Barnsley, and sweep in an arc through Doncaster and Rotherham to Sheffield and Chesterfield in the south-east, terminating in Nottingham.

The coal seams to the northern end of South Yorkshire were relatively near to the surface and outcropping was evident throughout the area; this is where the poor quality top band of the Barnsley Bed seam surfaced and was relatively easy to exploit by means of adits (drifts) driven into hillsides or small bell pits. The archaeologists tell us that there is evidence of coal mining in the Barnsley area from the time of the Roman occupation and in the later medieval period. This was at a time (1348–1350) when the country was ravaged by the Black Death, which wiped out one third of the whole population of Europe. Later in this period, Sir John Fitzwilliam of Wentworth, who owned great swathes of land in the area, gave licence in 1367 for the mining of coal on his estate, which was first carried out near Elsecar. These pits were springing up all around the area, the coal being used for heating and in some small measure for the manufacture of iron.

When we talk about these small mines, we are talking of very small undertakings that would in most cases have a workforce of no more than six men, the fact being well illustrated by the 4th Earl Fitzwilliam, who only had nineteen men working in his own colliery at Law Wood. This type of mining continued in the Barnsley area until the late eighteenth century and the only method of transporting coal and Barnsley's other products of linen and glass to the wider communities was by the humble horse and cart.

At the beginning of the nineteenth century, in 1806, the township of Barnsley had only twenty-four colliers, just 2.4 per cent of the population, and, apart from farming, the remaining working populace comprised of linen weavers and glass makers. Because of Barnsley's geographical position away from the canals and rivers, it was very difficult to transport goods and particularly coal to the big industrial users in such places as Sheffield, so Barnsley was a slow starter in the mining industry at the time. An Act of Parliament was passed in 1815 to construct a canal from the Tinsley Collieries in Sheffield to the River

Don and on to the Dearne & Dove Canal which had two branches, one to Elsecar and one to Worsborough so as to pick up the trade from these Barnsley area collieries.

Things were now beginning to pick up, but in 1837 there were still only two recognised coal owners and in 1841 there were nine pits visited in the Barnsley area by the employment commissioner, who was looking at general working conditions and the employment of women and children in the mines. The colliery names and brief particulars are as follows:

Earl Fitzwilliam's Jump Pit, the shaft being 80 yards deep and described as being a very extensive colliery with a 6-foot-thick seam of coal, few children employed, all males, horses used, some firedamp present.

Messrs Hopwood and Jackson's Barnsley Colliery, with an upcast shaft, 118 yards deep with a furnace in an open chamber at the bottom of the shaft to draw the foul air from the workings for good ventilation, girls moving tubs naked to the waist. No horses used, a great deal of gas.

Messrs Day and Twibell's Colliery at Barnsley, shaft 198 yards deep (the deepest in Yorkshire). A new pit with no females. Coal 10 feet thick with a great deal of firedamp gas.

Messrs Field, Cooper and Co.'s Stainborough Collieries (2) near Barnsley, shaft about 100 yards. Seam from 5 to 6 feet. Horses employed, roof shattered with gas, some females.

Mr Thomas Wilson's Kexborough Colliery at Darton. Shaft 130 yards.Tackle similar to Messrs Day and Twibbel's, seam from 5 to 6 feet, a few females employed, no horses. Gateways a good height.

The executors of R. Thorpe's Gawber Colliery near Barnsley. Shaft about 80 yards, an upcast shaft. This pit had the largest gateways and most regular workings in Yorkshire, the corves (TUBS) weigh 12 cwt when full. Girls together with boys pulled the tubs.

Messr Charlesworth's Silkstone Colliery. Shaft about 90 yards, coal 5 to 6 feet thick, girls together with boys pulled the tubs.

Mr Thomas Wilson's Gin Pit at Maplewell near Barnsley, shaft 40 yards, worked with a horse and gin with one rope and one chain. Gateways about a yard high. No females employed.

Districts to the north of Sheffield, towards the Barnsley area pits, were notorious for explosions in the Barnsley Bed seams of coal and great tragedies ensued, taking many lives. In August of 1805, a firedamp explosion caused by a candle took the lives of seven men at the Barnby Furnace Colliery at Cawthorne, and, in May of 1821, a winding accident at nearby Norcroft Colliery killed six children, three of whom were only eight years of age, along with four men, when the winding gear chain broke and the winding rope was severed, allowing the cage in which they were travelling to the surface of the mine to plummet back to the bottom of the shaft, which was 60 feet deep. They were killed instantly. In the absence of any contrary evidence, one can only assume that negligence in the form of lack of, or no, maintenance was to blame for this needless loss of life. Due to public outcry and the involvement of local and national miners' representatives, a government select committee was set up in 1835, to look at ways

of resolving these horrendous tragedies that were happening on an almost daily basis. But as was usual at this time, the committee had very little bite and the investigations became little more than a laborious task that produced nothing of any significance.

The most horrendous accident involving the loss of life to innocent children happened on 4 July 1838 at Silkstone Common, Barnsley, when the Huskar Drift/ Moorend Collieries were hit by a great deluge of water, which flooded the workings and killed twenty-six children. A storm was raging on that afternoon, and a flash flood sent torrents of water along a nearby dyke onto the pit bank and down into the pit shaft. Some of the children made their way to the bottom of the shaft, which was now filling with water, to be hauled to safety, but the winding engine house was filled with water and the engine would not respond. The force of the water soon flooded the drift between the two collieries and some of the children miraculously escaped by finding their way along the pitch-black roadways to a safer place, but the sheer force of the water carried the remaining twenty-six children along the road, trapping them against a ventilation door where they were drowned. Four others were brought to safety later when the engine finally responded after the water had subsided. Word of the tragedy soon spread and it touched the heart strings of the whole nation, and in particular the local mining communities, who grieved as though the children were their own. The youngest of these children was eight years of age and the eldest was only seventeen.

Her Majesty Queen Victoria was deeply shocked and it was thought by many that her intervention, along with local parish councils and politicians who had witnessed the danger and deprivation of the mining communities, would force the government to take heed of the miners' predicament and persuade parliament to pass laws that would force the owners into better and safer working practices, which would not only improve the miners' lot, but also lead to better production and increase the owners' profits. A royal commission was set up in 1840 and a report was published in 1840 regarding the employment of children in Yorkshire, highlighting the case of a young boy, John Ludlam, who was ten and had already been working down the pit for four years. At 3 a.m. he would join the other miners and enter the pit cage, where they would then plunge into the dark world below. He would carry with him a pit lamp, a bottle of cold tea and a snap box containing one slice of bread. Upon reaching the pit bottom he would struggle through 12-inch-deep stagnant acidic water to his work. He would uncouple the coal tubs from the rope, and then couple them to the pit ponies, which would then haul them to the coal face. John's shift would finish at 3 p.m. and he would earn one shilling a day. John had never been to school and he was unable to read or write. James Gladwin was thirteen years of age and had already worked down the pit for five years. He was a putter, manhandling tubs from the wagon train; he worked twelve hours for one shilling and three pence a day. He said he had been to school about six times and could write his name, and that he went to chapel on Sundays. He said that his wage went towards supporting his family of fifteen. A further ten-year-old child, George Brammit, said that he worked dragging trucks along the pit from about 5 a.m. to 5 p.m., which he didn't feel was hard work, but that he would rather be at school.

The nation's most horrific mining disaster occurred in the Barnsley area on 12–13 December 1866 when an explosion, described by some as being like a volcano erupting, engulfed the Oaks Colliery at Hoyle Mill. A series of explosions over the

two days killed 361 people, including twenty-seven rescue workers. Investigations into the cause of the explosions were inconclusive, although it was known previously that there were large pockets of gas in the workings and it was said that the Davy lamps had not detected gas on the day in question. Normal working can release gas at any time, so this is probably what happened, but it is impossible to say exactly how it was

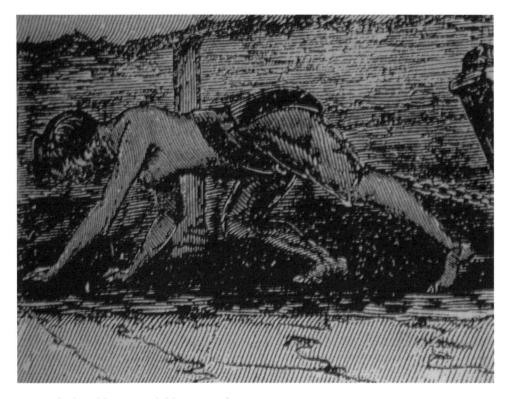

Semi-naked coal hurrier. (Children's Employment Commission 1942)

ignited. The colliery had a history of explosions in its lifetime, many of which could be put down to the use of naked flames as lights and careless use of safety lamps.

Oaks Colliery produced an output of 180,000 tons in 1862, indicating the colliery's size and capacity. One cannot begin to comprehend the grief and hopelessness the wives, mothers, girlfriends and families of those tragically lost must have felt in this catastrophic situation in what had been a very close-knit community. The pit-top scene was sheer bedlam, people turning up from all around the area in a bid to try and identify their loved ones, and helping in any way they could to try and relieve the situation. Three local doctors were soon at the pithead giving medical assistance, and Earl Fitzwilliam arrived bringing with him a cart laden with blankets. Coffins were hastily made in the colliery's joiners shop and those who were identified were taken home. The queen enquired as to the severity of the accident and started what was to become a national disaster fund by making a donation of £200 for the dependants.

Local mine owners, including the 6th Earl Fitzwilliam and Lord Wharncliffe, also worked very hard in establishing the fund, Earl Fitzwilliam being the guardian of 'The Oaks Colliery Relief Fund', which reached in the region of £50,000 – almost £1 million in today's money. Nearly 750 men, women and children benefitted from the fund until it was wound up as late as 1999.

Barnsley Area Collieries

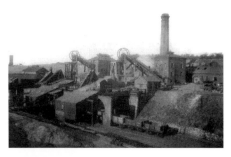
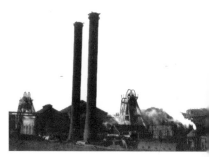

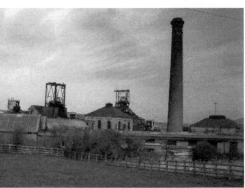
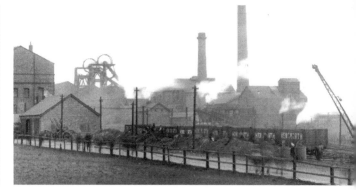

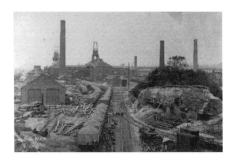
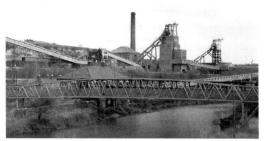

Top left: Caphouse. (Ken Wain)

Top centre: Tankersley Colliery. (Chris at Old Barnsley)

Top right: New Stubbin Colliery. (Chris at Old Barnsley)

Middle left: Elsecar Colliery after closure. (Alan Hill)

Middle right: Hemsworth Collery. (Chris at Old Barnsley)

Bottom left: Houghton Main Colliery. (Brian Elliott)

Bottom right: Cadeby Colliery after closure. (Alan Hill)

2

The Mitchells of Swaithe Hall

Young Joseph Mitchell was born around 1807 at Swaithe Hall in the parish of Darfield, 2 miles from Barnsley. He always had a passion for anything mechanical and after leaving school he served an apprenticeship at the Milton Iron Works at Elsecar, on land leased from Earl Fitzwilliam and under the ownership of Messrs W. H. & G. Dawes. After spending several years as a journeyman he went on to open a foundry of his own at Worsborough Dale. The foundry grew into a thriving business and manufactured items for the agricultural industry, expanding at a fair rate into the manufacture of mining implements. The foundry was eventually sold and Joseph turned his attention to the coal mining industry and opened several collieries in the district of Worsborough Bridge and Worsborough Dale. He opened two small collieries very close to Worsborough Bridge; Bell Ing Colliery had a tramway built in 1840 to take the coal from the pit.

The second pit was called California and was within a few hundred yards of the other. All the collieries in this district mined the 9-foot-thick seam of Barnsley Bed, coal, which was very gassy and presented continual problems with explosions of firedamp, usually as a result of bad working practice, such as using candles and irresponsible use of gunpowder. Candles and gunpowder, which the miners had to pay for themselves, cost four to five shillings per week. Darley Main Colliery was sunk by G. J. Jarret and partners of Doncaster in 1834 at Worsborough Dale and one man was killed and one was badly injured in a gas explosion in April of 1843. A second fatal explosion occurred on 29 January 1847 after firing down coal with gunpowder, which caused the death of six miners, asphyxiated by escaping gas. In the space of only two years a third horrendous explosion occurred, which took the lives of some seventy-five men and boys, and eight horses. Experts investigating the cause of the disaster came to the conclusion that a roof fall had forced gas into the workings and it had exploded on coming into contact with the naked flame of a candle. After pronouncing a verdict of 'Accidental Death' there was a strong recommendation that an upgraded system of ventilation should be put in place before the colliery recommenced work.

In partnership with John Tyas of Barnsley and Charles Bartholomew of Doncaster, Joseph Mitchell sunk the Edmunds Main Colliery at Worsborough Dale in 1855. The colliery was equipped with the latest equipment available and was considered to be one of the safest in the area, the colliery being used as a marketing tool for coal merchants touring the area from London. Sadly, candles were still allowed to be used

with the inevitable deadly consequences. On Monday 8 January 1862, four men, who were driving a new heading road that was to connect the colliery to the new Swaithe Main Colliery, were using gunpowder to bring down the rock which, immediately after the blasting, set the adjoining band of coal on fire and ignited the firedamp gas. Flames spread along the roadways, exploding further accumulations of gas, causing a further three explosions. This again was a horrendous occurrence, taking the lives of fifty-nine men and boys, one twelve-year-old and two fourteen-year-olds, which should never have happened. The management were criticised for allowing the use of gunpowder in the headings and the usual verdict of 'accidental death' was recorded.

Not content with the Edmunds Main Colliery, Mitchell and his two partners, Bartholomew and Tyas, went on to sink the Swaithe Main Colliery, which was only 1 mile away in Worsborough Dale. The shaft sinking commenced around 1857 and the downcast shaft reached a depth of approximately 320 feet into the Barnsley 9-foot seam and was used for coal winding and man riding. The colliery had two shafts: the upcast shaft was of a smaller diameter and was only sunk to a depth of 230 yards; it had a furnace at the bottom of the shaft to draw the foul air from the colliery workings, which was discharged up the shaft along with the smoke from the furnace and discharged through a large cast iron chimney. The colliery produced over 7,500 tons per week, which was wound from the pit by two giant steam winding engines, both of 60 hp capacity.

The morning of Monday 6 December 1875 found 240 men and boys in the pit, probably thinking of the short Christmas holiday when they could spend a little time with their families. About three-quarters of them were working near to the link road leading to their sister pit, Edmunds Main Colliery, when there was a horrific explosion that was heard on the surface of the colliery and in surrounding areas, such was its ferocity. A volcanic-like stream of sulphurous black smoke and dust was thrust up the 230-yard-deep pit shaft and into the headgear covering the pit bank like a storm of black sand. Apart from those who heard the blast of the explosion, word soon spread around the local area and beyond and crowds gathered around the pit bank, waiting for news of their loved ones who worked in the pit. People were milling around the pit yard trying to be helpful when the colliery owners arrived on the scene. The first to arrive were the Mitchell brothers, John Mitchell and Joseph Mitchell Junior, who was the pit manager. John Mitchell wasted no time in setting up a rescue operation and was assisted by Mr F. N. Wardell. The government's district inspector of mines and local colliery managers and engineers all helped the rescue mission. The rescue team descended the shaft, only to find that a man was trapped in the sump, but they used ladders and were eventually able to release him and send him to the surface. On looking around the pit bottom, they found badly injured men walking around as though in a drunken stupor due to the effects of the gas. Word came from Edmunds Main that some of the men had escaped up their shaft, probably between seventy and eighty in total. As the day went on it was becoming clear that at least 120 men had been lost, but it was soon realised that there were more than 140. A search party was sent into the workings to locate the men, and they soon came across the bodies of men who had been overcome while trying to escape the rapidly encroaching afterdamp gas after the ventilation system had been knocked out by the explosion. A team of men

were sent into the southern district towards Edmunds Main and had to extinguish a fire that was blocking their way; progress was slow due to the gas accumulations until the ventilation system was restored. Dead men had to be left in the quest to find survivors but it was an impossible task and after many hours of searching it was decided that the only way forward was to bring out the badly burned and mutilated bodies that they had found. By the end of the day, sixteen men and boys had been brought out of the pit alive. On the following day another thirty-four bodies were retrieved and by Wednesday afternoon 110 were confirmed dead. The colliery's saw mill and joiners shop were hastily converted into reception areas to house the dead and those who were badly injured, but they were soon full and other buildings had to be adapted, the bodies laid in rows and identified with a number.

The injured were treated by local doctors and surgeons, who were quickly on the scene, before being transported to the Barnsley Beckett hospital. The dead were so badly injured that it was almost impossible for their wives and families to identify them – their clothing was burned and in some cases completely shredded from them, so identification by that means was not possible.One young man had his head completely blown off and another had half his skull blown away, and others had every bone in their bodies broken – the rescuers themselves were severely traumatised by the terrible sights they were exposed to. Forty-five horses were used at the colliery, but only six survived and were badly injured, having every hair on their bodies burned off. Some of the horses had to be dismembered to get them into the cages because their bodies were badly swollen.

An inquest was held on Thursday 16 December at the Barnsley Court House and the coroner was Mr T. Taylor. John Mitchell, the colliery manager, was represented by Mr John Miller QC; the colliery company was represented by Mr Shaw; the under managers' and deputies' solicitor was Mr Parker Rhodes of Rotherham; and the miners were represented by Mr Hopwood, QC, MP. Various witnesses on all sides spoke about aspects of the disaster and, after a lengthy summing up by the coroner, the jury found that the men met their deaths as a result of an explosion or explosions of firedamp, but how such explosion or explosions originated could not be determined. They were also of the opinion that, according to the evidence, the Swaithe Main Colliery was 'a fiery mine and that the general and special rules had not been rigidly carried out and that gunpowder has been recklessly used'. They stipulated that 'in all mines where safety lamps are used the use of gunpowder should not be allowed except in the stone drifts, and there only when the miners are drawn out'. The jury asked the coroner to forward this opinion to the Secretary of State. The lack of conclusive evidence, however, left a lot to be desired. A mixture of ignited gas and significant accumulations of coal dust could cause such devastation as at the Nunnery Colliery in Sheffield.

The disaster claimed the lives of 143 men and boys, ten of whom were in the twelve to fourteen age group. Big families were the order of the day, some families having four, five or six children, and the disaster left seventy-two widows who between them had 168 children. Thirty-eight-year-old George Banks from Swaithe left a widow with nine children, for example, and thirty-year-old William Smith left a widow with eight children.

3
Newton Chambers

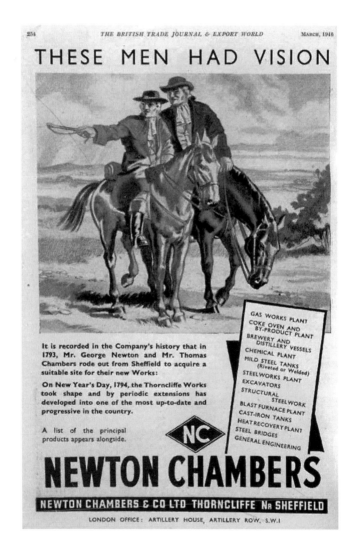

Old Newton Chambers advert.

In the late 1700s, Henry Longden, George Newton, and Thomas Chambers, of the Phoenix Foundry in Sheffield, decided to expand their business due to increased demand for their products. Thomas Chambers and George Newton set off on

horseback to identify a suitable site for their new premises, which they found at Thorncliffe. They duly leased land from Earl Fitzwilliam for the mining of coals and ironstone to be used in an ironworks that was to be built by them on the said land at Thorncliffe.

The ironworks started production in 1794; extensions were carried out over the years and the Thorncliffe works developed into one of the most up to date and progressive in the country. These were to be the forerunners of the Newton Chambers company. Newton Chambers owned seven collieries between Sheffield and Barnsley and they started operations by sinking Tankersley No. 1 in 1858.

The company went on by starting a rapid expansion programme in 1859 with Tankersley No. 2, and by 1866 coal was being brought up at the Thorncliffe Drift, Staindrop, New Biggin, and at the Norfolk Colliery, which was also a drift mine. Rockingham Colliery, which was Newton Chambers' largest coal-turning establishment, was sunk in 1875. Between them, the collieries were producing a massive 1 million tons of coal and 200,000 tons of coke per year by 1890. All this was achieved during a period of what can only be described as very stormy relationships with their employees.

In 1866 all the company's pits were laid off for nine months due to disputes, all of which were eventually resolved by peaceful means. However, only three years later, in 1869, the colliers were aggrieved by the poor working conditions and a 7 per cent reduction in pay, which had been forced upon them by the management, and a strike was called on 24 March that affected the company's seven collieries and lasted until 17 August 1870. The Chambers brothers, John and Thomas, who were in charge of the company's mining operations, never took kindly to being told how to run their business activities and would never recognise the trade unions. The miners were further embittered by the fact that by this time the company had drafted in non-union 'blackleg labour' from other outlying areas while they were trying to work and struggling to feed their families. The blacklegs that the company had drafted in, including their families, were given special privileges and moved into two newly completed rows of miners' cottages at Tankersley called Westwood Row and Thorncliffe Row, which were supposed to be for the existing workforce, which further inflamed an already critical situation. When they heard of this the local miners, numbering some 200 men, formed into groups and systematically attacked and ransacked the Thorncliffe Row of cottages, looting, and burning the possessions of the infiltrators.

In January 1870 a warlike assault by several hundred rioters took place at the Westwood Row cottages. They smashed everything in sight, even injuring the occupants. It seems that many of the rioters were complete strangers and it was strongly rumoured that the union had mustered them from all corners of the coalfield. The police officers who were in attendance were greatly outnumbered and fled to escape harm. The pit hooter was sounded at Tankersley, which alerted the Barnsley police, who were already proceeding over nearby Tankersley Park to the scene. On their arrival all hell broke loose and several arrests ensued, which saw six of the men being jailed for a month by the Sheffield magistrates and a further fifteen or so were committed to the quarter sessions to be tried for rioting and intimidation. Several

other outbursts were recorded over the next few months and rumours of an attack at Tankersley pit in October 1869 meant that police officers and the military were drafted in yet again to defend the pit property and the people who were still working.

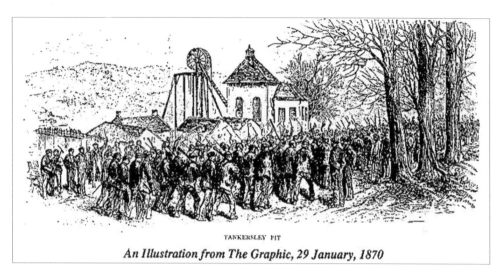

TANKERSLEY PIT

An Illustration from The Graphic, 29 January, 1870

Tankersley Colliery, January 1870. (*The Graphic* Newspaper)

Although most of the workforce were non-union blacklegs, there was a percentage of the original manpower still at work and in danger of their lives. (About one in seven remained in work throughout the disputes, which were eventually resolved towards the end of 1870.) Neither side were any better off and the colliers were made to concede. The colliers at Tankersley started back at work at a price of 1s 8d per ton and were paid every two weeks. The South Yorkshire coal owners fixed the price of coal in December 1870 at 5s 6d per ton to transport to London Kings Cross, plus 9d extra for the hire of each wagon. The strike cost the miners' union £30,000 and the Newton Chambers company paid the police £1,500 for their services during the dispute.

Ironically, both the Chambers brothers died during the disputes and were never to see the outcome. John Chambers died on 21 June 1869, aged sixty-four, and his brother Thomas died on 29 October 1869, aged seventy-one. The Norfolk drift mine was reported to be all but worked out in 1890, but managed to struggle on for another three years. Three men were killed in an underground explosion in 1893, and the colliery closure was hastened by the Yorkshire miners' dispute of that year. Newton Chambers' last colliery sinking was that of Smithywood Colliery in 1890, which was a producer of great quantity and quality well into the twentieth century. Their last acquisition was Grange Colliery in 1890, at which time the company's pits were mining over 1 million tons of coal and 200,000 tons of coke between them.

The company developed many by-products from coal, including Izal disinfectant and toilet rolls. They became familiar household names that still live on today. They went on to form the Trianco engineering company as one of its partners; the company

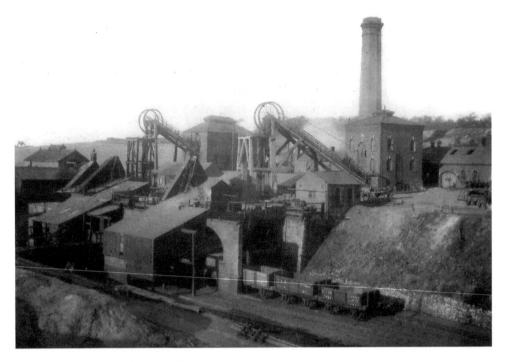

Tankersley Colliery. (Chris at Old Barnsley)

produced the nationally renowned Trianco and Redfyre coal burning back boilers for central heating systems.

Newton Chambers' four main collieries of Smithywood, Grange, Thomcliffe and Rockingham produced in their lifetime 1,083,900 tons of coal for the company. The company carried on with its operations within the industry until nationalisation in 1947.

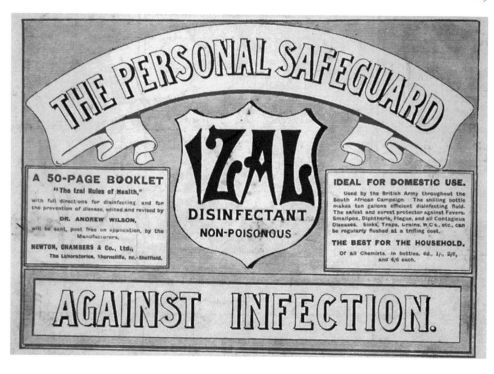

Newton Chambers old adverts.

4

Grange Colliery

Newton Chambers' Thorncliffe Collieries Ltd purchased Grange Colliery from Mr G. W. Chambers & Sons in late 1890, by which time the pit was producing about 130 tons per day. The seam was very shallow at only 53 yards and was originally sunk in 1845. Thirty years after its purchase by the Newton Chambers company, the colliery was closed for six years between 1921 and 1927 to allow for a complete refurbishment. The small diameter of the shafts restricted the output to 400 tons per day, so the refurbishment resulted in much improved output, which was catered for by a drift direct to the surface. Further improvements meant that the colliery was now able to introduce coal-cutting machinery and the tonnage was now expected to reach in excess of 1,000 tons per day. The target was surpassed and the colliery was now employing 880 men. Two further drifts were put down into the Silkstone seam from the Bradgate Quarry near Rotherham: Bradgate No. 1, and Bradgate No. 2; Bradgate No. 1 established a land sale outlet on the site for local coal sales to Rotherham and district.

Grange Colliery was served by the Great Central Railway, which transported thousands of tons of coke from the pit's coke ovens to the iron and steel industries in Sheffield and district. The colliery was nationalised in 1947 and became part of the NCB's north-eastern division No. 5 area, South Barnsley. At this time it was under the management of Mr H. Caine, employing 694 men and now only producing household coal from the thin coal seam.

The colliery remained in work for the next fourteen years, until the decision was made to close it in 1961; the manpower at this time had dropped to 140 men and the colliery was finally closed towards the end of 1962 due to exhaustion of reserves.

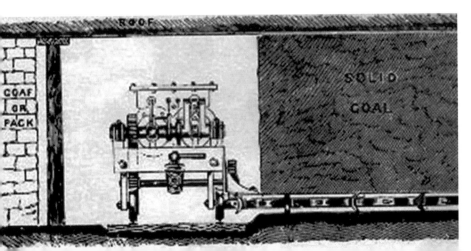

Early coal cutting machine by John Gillott & Son, Barnsley.

5
Thorncliffe Colliery

It was realised by the Newton Chambers company that their Thorncliffe Ironworks at Chapeltown was virtually on top of its own coal supply! In 1859 a drift of 1 in 10 gradient was driven into the Parkgate seam and further into workings that were left from much older pits in the immediate vicinity. The colliery eventually produced large amounts of coke in its bank of over 150 beehive-style coke ovens. Most of the output was used on site in the company's own ironworks, the remainder being shipped via the nearby LNER railway into the ironworks in Sheffield.

The coal was hauled up the drift by means of an endless rope haulage system that was powered by a steam engine placed at the top of the drift. Cart horses were used for general transport duties in favour of the smaller pit ponies due to the 1 in 10 gradient of the drift. The coke ovens produced various by-products including heavy and light oils, pitch, naphtha, paraffin wax and ammonia water and gas. The Thorncliffe plant was also the birthplace of Izal disinfectant, discovered by a research chemist called J. H. Worrall who was originally employed to carry out analytical work in 1885. Work started in the Fenton seam in 1924, when the new Silkstone drift was driven into the seam, and some ten years later the Parkgate, Silkstone and Fenton seams were all being worked to full capacity and were by now fully mechanised with the latest coal-cutting equipment.

Both Barley Hall Colliery and Skiers Spring Colliery were connected underground with the Thorncliffe Drift. Both were used for pumping operations and Barley Hall was used as an upcast ventilation shaft. In 1938 Newton Chambers introduced an innovative system to ensure that inexperienced young boys were given an insight into pit work prior to employment, by giving them tuition for two days a week comprising an hour's lecture on the surface and three hours underground with a mining expert. Between 9 November and 16 August 1943, seventeen men working in the Fenton seam set a record in raising 47,000 tons in nine months! The colliery was employing 979 men in 1949, the last coal being raised on 2 April 1955.

6
Wentworth Silkstone Colliery

The Wentworth Silkstone Collieries Ltd found a good supply of Silkstone coal in the Levitt Hagg district of Wentworth, at Stainborough, about 3 miles south-west of Barnsley. It was agreed that two drifts should be driven into the seam, and drivage work began in 1911 at the site of the original colliery, which dated back to 1856; the work commenced and went on for twelve months and the first coal was produced around June–July 1912.

The colliery went on to produce good-quality, clean coal throughout the First World War; in 1918 the Wentworth Silkstone Collieries were among the best paid in the area with coal getting rates of 2s 91/92d per ton (29 pence). The colliery survived the 1926 strike and by 1927 the employees numbered some 519 underground workers with eighty-two on the surface, producing coal from the Parkgate, Thorncliffe, Flockton and Fenton seams, for gas, steam and household use. This continued through to nationalisation, by which time the pit was turning 500 tons per day. New pithead baths were built in 1949, at a time when the manpower was now 585, under the management of Mr E. Crankshaw.

By August of the same year the output had risen to 1,000 tons per day. Prior to this time the coal was taken out of the pit via three different rope haulage systems hauling pit tubs. The NCB invested £500,000 in constructing new screens, a new coal preparation plant and a new trunk conveyor system of just over 1¼ miles in length, to convey all the production from the coal face direct to the screens. This made the pit super efficient and, as a consequence, the production more than doubled from 160,000 tons to 345,000 tons per year.

Between 1955 and 1959 the two drifts were taken further down and the Whinmoor seam was exploited; this proved to be a winner and by 1965 the seam was producing more than 8,000 tons per week. The colliery was employing 650 men at this time, and the Central Electricity Generating Board was taking all the production from the Whinmoor seam for its power stations. After a further two decades of highly mechanised mining, the pit was eventually closed in June 1978 due to progressive thinning of the seams and depletion of reserves.

Barley Hall Colliery and Caphouse Colliery

Newton Chambers leased land from the 6th Earl Fitzwilliam and the Barley Hall Colliery at Thorpe Hesley was sunk in 1886 to a depth of 165 yards into the top Silkstone seam. Although coal was reached, the pit, along with its sister pit Thorpe Hesley, sunk in 1900, were often referred to as the pits that never were – that never turned a cobble of coal and had the cleanest pit yards in the country! The pit was actually connected underground to serve as an air shaft for the Norfolk drift mine and Smithywood Colliery belonging to Newton Chambers, the coal being brought to the surface via the Thorncliffe and Smithywood collieries. Materials were transported to the workings via the Barley Hall shaft, while water was pumped to the surface from the same shaft, to relieve water problems in the Norfolk pit workings. The pit was closed at the end of May 1975, due to being worked out, after producing approximately 250,000 tons per year during its lifetime.

Thorpe Hesley was used as a pumping station for draining Norfolk and Smithywood pits, and took up a small number of tubs of coal for the boilers that provided steam for its own winding engine. South Yorkshire County Council failed to take up the gauntlet and take the colliery in its entirety to be used as a mining museum. As a consequence, Caphouse Colliery near Wakefield was later to take the crown and become the National Mining Museum!

HSE Document HSE/12/49 June 2012 states that there are still around forty British mines used for tourism, training, and adventure activities.

Entrance to the Caphouse Colliery National Coal Mining Museum (near Wakefield). (Ken Wain)

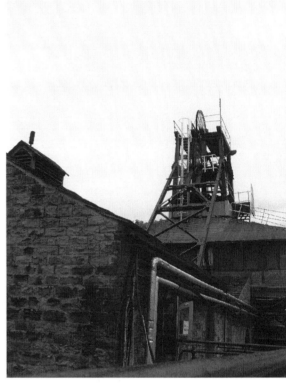

Clockwise: Steam-powered winding engine. (Ken Wain)

Caphouse Colliery headgear and winding house. (Ken Wain)

Clothing lockers. (Ken Wain)

Showers. (Ken Wain)

The Fitzwilliams and Their Coal Mines

Old Elsecar Colliery.

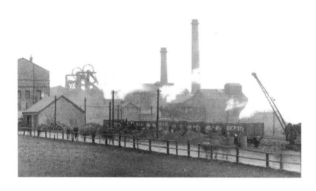

Hemsworth Colliery. (Chris at Old Barnsley)

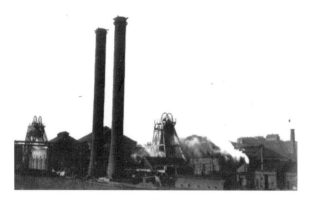

New Stubbin Colliery. (Chris at Old Barnsley)

8
The Wentworth Fitzwilliams

Wentworth Woodhouse. (Ken Wain)

WENTWORTH WOODHOUSE

Extensive coverage of the Fitzwilliam family is given because of the family connections with the mining industry, and its contribution to local employment and the nation's economy. Although Wentworth Woodhouse comes under the jurisdiction of Rotherham, the majority of their coal mines were in the Barnsley area and are therefore included in the Barnsley section of the book.

The first Earl of Strafford, Viscount Wentworth, Baron Wentworth, was born on Good Friday, 13 April 1593; he had a good education and was knighted when he was only eighteen years of age. He entered parliament to represent Yorkshire in

1611 at the ripe old age of twenty-one. He married three times and fathered at least five children, having only one son, William, to carry on the family name. He was a very strong and thorough politician and statesman who rebelled against the Puritan parliamentarians. He did not agree with their general politics and made many enemies within parliament. He was a sympathiser of Charles I and was sent to Ireland, where he ruled with an iron fist. Charles thought that he was perhaps a little over zealous and he eventually recalled him back to England, where he became Charles's friend and advisor. The Puritan parliamentarians, including his brother-in-law Denzil Holles, saw him as the main hurdle to jump to breach the king's authority and set up a conspiracy against him with false charges. He was impeached on thirty-seven different charges and held in the Tower of London in October 1640. The charges came to the House of Commons in January 1641 and Strafford defended himself magnificently at his trial on 22 March. After several failed attempts to bring him down, he could not be declared guilty of any charges that were lodged against him. They eventually used an act of parliament (a Bill of Attainder), which allowed them to automatically find someone guilty of any charges brought against them providing that it was endorsed by the king. The Bill was already set up and included the charge of High Treason. It was debated in the commons and it looked set to fail again, but underhanded methods were used to eventually lay it before the king. Among total confusion, and infighting between the parliamentarians and Strafford's rioting supporters, the Bill was passed on 21 April by a majority of 204 to fifty-nine. A petition to save his life was presented to parliament, but to no avail. The Bill was read in the House of Lords under the same kind of situation on 27 April, less than a third having the guts to stand up and be counted. The Bill was passed by a majority of thirty-seven to eleven, but the king refused to sign it. After repeated attempts, and only when threats against the royal family were made, the king reluctantly gave the royal assent and the Bill was made an Act of Attainder. Strafford was beheaded with great ceremony on 12 May 1641 on Tower Hill, by the Tower of London. Nearly a quarter of a million people thronged the streets to see the execution and several people were killed and many others were injured when make-shift seating that had been erected for the occasion collapsed from under them. The king's position was now greatly weakened and the earl's son William fled to France, where he stayed for many years for fear of retribution. He eventually returned to England and parliament allowed him to take over the earldom. He died on 16 October 1695, childless, and his estates passed to his nephew Lewis Watson, the first Earl of Rockingham, created Marquis of Rockingham in 1746.

The Rockingham estates at Wentworth were sat upon a veritable treasure chest in the form of coal and Richard Bigley made a contract with the marquis to mine it at Hoyland; the contract stated that he could only employ two men for coal getting and that he must make a drain for taking the mine water to a nearby dyke. The contract stipulated that if the drain did not work, he would have to install a pump; at this time, pumps were very primitive, typically made from a hollow tree stood on its end with a close-fitting plunger on the inside operated by a pivoted lever which forced out the water. On 28 September 1752, records show the accounts for the cost of the miners at the time:

To the colliers for getting 24 pit loads of coal	£2.0s
For filling and borrowing 5 loads each	£1.0s
To 2 men drawing 5 loads each	£1.0s
To the horse at trailing to the stack at 2d per load	4s 0d
To Joseph Hague, 10 days setting up and keeping accounts	
Total	£4.15s
	8d

Because the pit only catered for local trade, there were times when no coal was brought out because the pithead was over-stocked with coal, due to trade falling off. When this happened, the miners helped out on the local farms. Records of 1753 show that the pit was stood off for eight weeks for this reason. On 24 February of that year, Thomas Smith wrote a letter to the marquis making a request that he should consider allowing the colliers free fire coal, as was custom and practice at other pits. The colliers were to pay 16d for delivery. This seems to have been the forerunner to the present miners' free home coal. Men used wheelbarrows to take coal from the workings to the tubs in the pit bottom waiting to be wound out of the pit.

1780 saw the introduction of tubs or corves for moving the coal, which were often pulled by children with leather straps around their waists and chains between their legs, chaffing them sore. Later on, horses were used for the same task, and a horse-operated Jenny wheel was installed on the surface to wind the tubs of coal from the pit bottom.

Jenny Wheel. (Vincent Hopkinson)

The roof at Elsecar pit was held up by wooden props called punches that were supplied by the local farmers, who felled the trees from the nearby woods.

George III was on the throne when Sir William Wentworth-Fitzwilliam (aged eight), the 4th earl, was given the earldom in 1756 on the death of his father, who owned the mines of ironstone and coal on the northern reaches of Sheffield. By 1780 the collieries made a profit of £1,480. On the death of his uncle, Lord Rockingham, in July 1792, William inherited Wentworth house. Eventually, a Newcomen-type Beam engine was installed and was up and running by 1795. It boasted a steam-operated 48 inch diameter single cylinder with a 5-foot stroke and the piston rod connected approximately 3 feet off-centre to the centrally pivoted beam. The beam was 24 foot long and made from cast iron and it was probably cast at Elsecar to replace the original wooden beam. At full output, it was capable of making up to eight strokes per minute and with a lift of 40 metres it could pump out around 50 gallons each stroke. The pump served the Elsecar collieries for 125 years until 1923. It was designated an ancient monument in 1972 and National Lottery funding has since been secured for its restoration.

Profits had risen to £3,240 in 1796 and by 1801 had soared to over £6,000, with an output of coal in the region of 13,000 tons. In 1825 the colliery profits had climbed to £23,000, with the output of coal reaching 123,000 tons.

The earl was now one of the country's leading coal owners. He was also a man of great benevolence and made sure that all his workers and the poor in general during this time of political upheaval and financial uncertainty would not go without. While revelling in the extravagant lifestyle of a country gentleman, he would regularly supply cheap food to those in need and give free coal and blankets to the elderly. He was known to reduce rents on his properties and write off debt of the needy. A gentleman indeed. He sank a further three shafts in 1830 near Elsecar, into the Tankersley Ironstone seam, which was worked to supply the local ironworks until they were abandoned in 1879, when the no. 3 and no. 4 shafts were partially filled in as far as the Lidgett Coal seam. They were both shafts which drew in the air and were used for coal winding, which was done by a single-cylinder beam engine manufactured at Elsecar in 1830. No. 2 shaft was used for pumping excess water from the old ironstone workings of the 1790s to keep the coal workings free from flooding.

The marquis died in 1782 and his estates were then handed down to his nephew, the 4th Earl Fitzwilliam, Marquess of Rockingham.

Wentworth Woodhouse, the finest stately home in all of Europe, was commissioned by Thomas Watson Wentworth, 1st Earl Fitzwilliam and Marquess of Rockingham in 1724 and became the ancestral home of the Fitzwilliams for more than 250 years. The house is testament to how the aristocracy lived at the time, boasting 365 rooms with splendid works of art and paintings from around the world, a room for every day of the year, and having 1,000 windows and a network of approximately 5 miles of passageways and a façade twice that of Buckingham Palace, being some 202 yards long. A good many of the family were politicians of the Whig party and represented constituencies in England and Ireland, owning large amounts of land and property in both countries. The family had interests in coal mining for many years – the Wentworth estate was virtually sat on top of a seam – but it is to the nineteenth century and the early part of the twentieth

Elsecar Colliery in the early 1800s.

century that we turn our attention, when the family and the miners who worked in their pits lived through much upheaval and disruption and proved that teamwork and trust for each other came out tops in the face of adversity.

The Fitzwilliams were there at the onset of the Industrial Revolution and coal was their gateway to vast fortunes, accrued at this time and for decades to come. A lot of the mine owners were no more than slave drivers and forced their miners to work in fear of their lives and in dangerous conditions, due to their own greed and avariciousness.

The Fitzwilliams always provided the best for their miners, especially with the latest in mining technology, safe working conditions and fair pay. However, it has to be remembered that mechanised mining was in its infancy and men were still at this time working with open lights (candles), which were often the cause of explosions with horrendous consequences while working in areas that were poorly ventilated and prone to inrushes of gas, especially in the Barnsley seam. A flame safety lamp was bought for use at Elsecar Colliery by Joshua Birom, the earl's colliery agent, but miners still took risks by taking off the gauze over the flame to get a better light. Between the years of 1880 and 1910 there were more than 1,000 fatalities every year in British coal mines. That's an average of four miners killed every day and 517 injured. Of these fatalities, 501 were as the result of explosions, 685 from roof collapses and 286 from haulage accidents. Because of the more labour-intensive nature of the deeper mines and the continuance of bad working practices, in 1910 the fatality rate had risen by about 80 per cent to 1,818.

Left: The 4th Earl Fitzwilliam in 1828, at the time of the sinking of the second shaft at Elescar Colliery. He was the first earl to own Wentworth. (Roy Young)

Below: The Marble Saloon, Werner Gothard, 1911. (Roy Young)

The Long Gallery, pre-1911. (Roy Young)

The Whistle Jacket Room, named after the famous race horse. (Roy Young)

This small cross section of the rooms at Wentworth Woodhouse shows the reader the opulence in which the owners of this magnificent house lived. Much of this came from their coal mining activities.

In 1893 the Miners' Federation called a national strike for better wages and working conditions, and though most of the Fitzwilliams' miners were satisfied with the relationship they had with the management, there were some who were coerced into joining the federation in the belief that they would benefit greatly from it. Because the miners had withdrawn their labour from the Fitzwilliams' pits, it was thought that they were no longer employed by them. Feelings ran high among many of the miners, with fighting and rioting taking place in some of the surrounding areas. A squadron of Hussars were dispatched to guard Wentworth Woodhouse but they were not really required because there was no bad blood towards the Fitzwilliams. After a while, some of the miners from the Fitzwilliams' Lower Stubbin and Elsecar Collieries made formal representations to Mr Newbould, Earl Fitzwilliam's colliery agent, to be reinstated into their former jobs. The earl sent a letter from his home in Coollattin in Ireland to all his workmen, offering them work if they could satisfy his representative that there would be an entire absence of intimidation among his workmen, and that they would not interfere with each other whether they were or are not members of any federation.

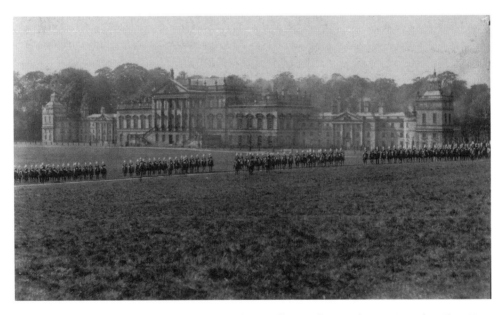

A squadron of Hussars guarding Wentworth Woodhouse during the 1893 coal strike. (Roy Young)

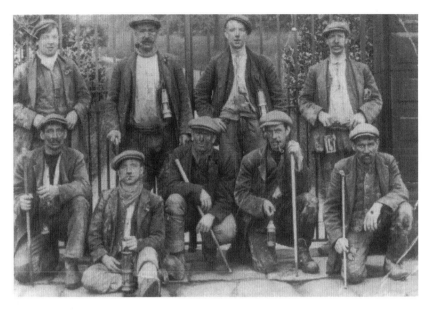

Miners from the Fitzwilliam collieries pose for the camera outside the gates of Wentworth Woodhouse *c.* 1910. (Brian Elliott)

To my Workmen at Low Stubbin and Elsecar

I am informed that you have applied to Mr Newbold to be re-engaged as my workmen, but before I can give any reply to that request I wish to lay some considerations before you.

I have always refused to belong to any association or federation which might fetter me in my dealings with my workmen; and I wish to secure for them the same absolute freedom to be or not to be members of any association or federation as they think best.

There have been no difficulties or differences between us respecting wages, I believe you had no cause for complaint, so that I am at a loss to know why you laid my pits idle.

So late as the 25th of July last I had the pleasure of seeing you all at my house and receiving a most gratifying proof of your kindly feeling and good will towards me and mine; and among my most valued possessions is a beautiful book which you gave me. In it are inscribed the names and length of service of all who were in my employment. There I see that many had worked 20, some 30, and some even 50 years and more for me and for my father before me.

Such ties as these create strong regard on both sides and are not easily broken.

I am therefore driven to believe that it was intimidation only which caused you to leave your work; and those who led you to do so are responsible for the whole of the suffering which you and your families have endured for so long, and also for the want and misery of so many others who have been thrown out of work by your action.

There will always be differences of opinion among men, but if we can bear in mind the Divine command 'to do unto others as we would they should do unto us' those differences will never assume any formidable dimensions.

There cannot be a more false or dangerous doctrine than the belief that the interests of employer and employed are opposed to each other. Their real interests must always be one and the same, and they must stand or fall together.

If my pits are re-opened it must be on the understanding that there is an entire absence of intimidation among my workmen, and that they will not interfere with each other whether they are or are not members of any federation.

I am too far off to have an interview with you myself, but if you can satisfy my representatives that there shall be absolute freedom for you all. I shall gladly welcome back to my employment as many as possible.

Yours faithfully,

Coollattin,

24th Nov., 1893.

Elsecar

(Signed)

FITZWILLIAM

This and next two pages: Elsecar Colliery, Newcomen engine house. (Ken Wain)

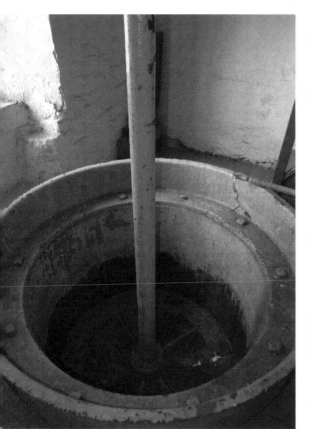

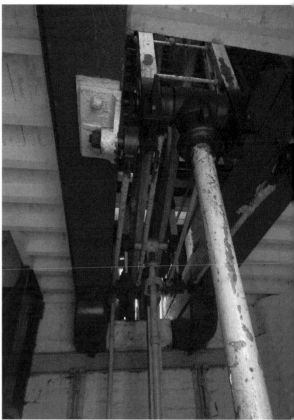

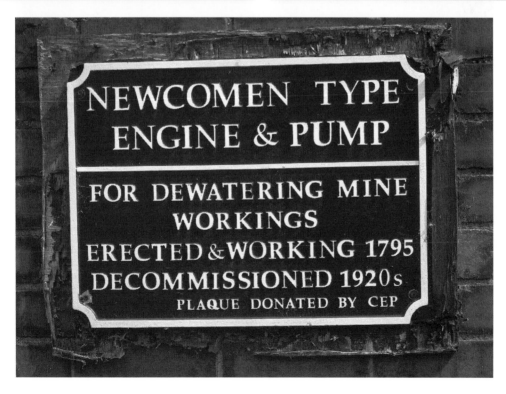

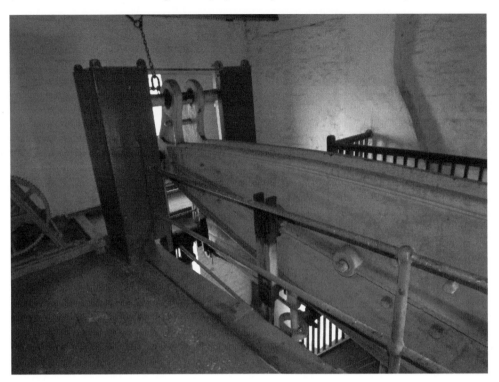

The coaling operation at the new Elsecar pit was opened out by the former manager of the old ironstone pits, John Fisher. He was soon to be overcome by financial difficulties and sold the business to Dr William Clarke, a local GP who formed a limited company with several local business men and mining experts which was to be known as the Lidgett Colliery Company Ltd. Dr Clarke became chairman of the board and consequently the pit took on the name of 'Pill Box Pit'. The pit was soon producing 800 tons of coal per week, which was transported to Elsecar via Earl Fitzwilliam's private line until the opening of the Midland Railway's Sheffield to Barnsley branch line in 1897. Ways had to be found to raise the output from the 2 foot 8 inch thick seam to compensate for the increasing costs and to ensure the future viability of the colliery. To this end, Dr Clarke invested in all types of technical equipment, including mechanical and compressed air coal cutters made by Gillott & Copley.

Later, electric coal cutters were developed at the colliery by Mr C. Foster, the colliery engine wright, and Dr Clarke took out a patent for the machines. His son started up a partnership, Clarke & Stevenson, who went on to produce the electric machines. The successful use of this machinery took the production at the colliery up to 2,000 tons per week within two years, which continued until the colliery was finally closed in 1911. Lidgett Engineering Co. took over Clarke & Stevenson and marketed the machines throughout the industry.

Machinery is now employed in almost every operation of mining coal and machines are increasingly being used for undercutting the coal seams. At the beginning of the twentieth century, we can see that this has had a marked influence on production.

	No. of Coal-cutting Machines.	Output.	Per cent of Total Output of Great Britain.
		Tons.	
1902 . . .	483	4,161,000	1·8
1914 . . .	3,093	24,274,000	9·1

John Gillott & Son advertisement.

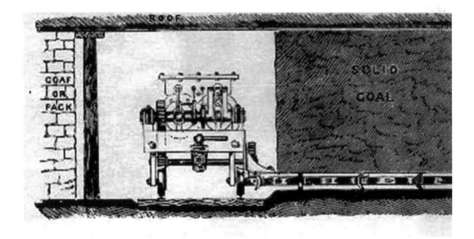

Early coal cutting machine by John Gillott & Son, Barnsley.

9

Elsecar Colliery

The 7th earl's Fitzwilliam Collieries Company started sinking the No. 1 shaft on 17 July 1905 and reached the Parkgate coal at a depth of 344 yards on 20 September 1906. On 26 September the No. 2 shaft was started and reached coal in the Parkgate seam on the 18 February 1908. The colliery was a great producer and was served by the London & North Eastern Railway Company. King George V and Queen Mary visited it on 12 June 1912 and toured the underground workings.

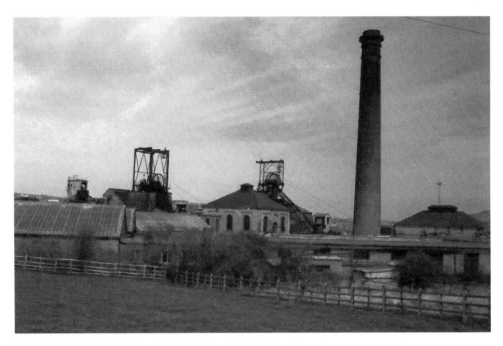

Elsecar Colliery, 1980s. (Alan Hill)

The king and the 7th Earl Fitzwilliam about to go underground to tour the pit workings. (Brian Elliott)

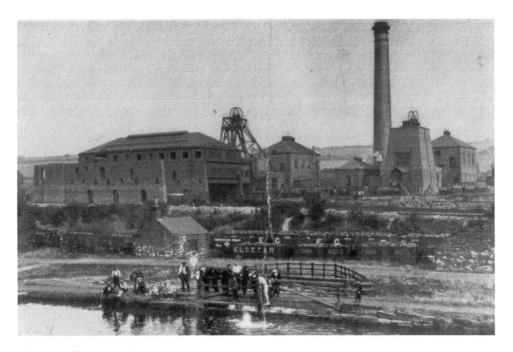

Elsecar Colliery *c.* 1900. (Roy Young)

During 1924–25 the No. 1 shaft was deepened so as to exploit the Silkstone seam, which was reached at a depth of 534 yards. The Silkstone seam was connected to the Parkgate by a drift and started to produce coal in 1927, assisted by electric coal cutters after the compressed air machines were gradually phased out underground. The pit employed 1,900 men at this time. The Thorncliffe seam was also serviced by a drift to the Parkgate level some 20 yards deeper than the Silkstone seam and was producing coal by 1938.

The Parkgate reserves were diminishing rapidly at the onset of the Second World War and during 1942–43 a surface drift of 1 in 5 was driven to the Haigh Moor seam, which was only approximately 144 yards deep and had a seam thickness of 52 inches, which proved to be a sound investment and ensured work at the pit for many years to come. Power loading was introduced and production went up accordingly. By 1949 the pit was employing 1,760 men under the management of Mr C. Round and the pit was producing coking coal, gas coal, household and steam coals. The colliery was now part of the north-eastern division No. 4 Carlton area of the NCB. At this time most of the pit's output was taken to the surface via a trunk conveyor, which proved to be a very fast, super efficient means of coal transportation.

By the early 1960s the board were making heavy investments into the colliery infrastructure and built a new coal preparation plant on the surface and improved the underground transportation system. The old steam winder at the No. 2 shaft was converted to electrical operation in 1961. 1967 saw the colliery reach its all-time record of 1.3 million tons with 1,500 men. Further developments were made into the Lidgett and Kents Thick seams in the late 1970s, but the seams became unworkable due to worsening water problems and the colliery was finally closed in October 1983 and demolished after the 1984–85 miners' strike.

Below: Elsecar Colliery just after closure in 1987. (Alan Hill)

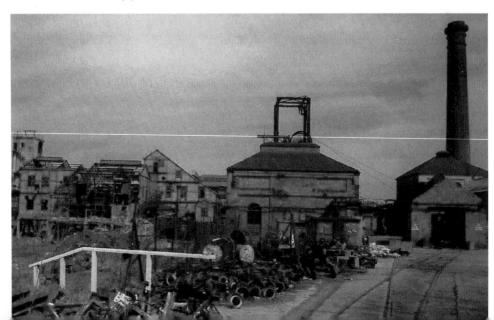

10
Hemsworth Main Colliery

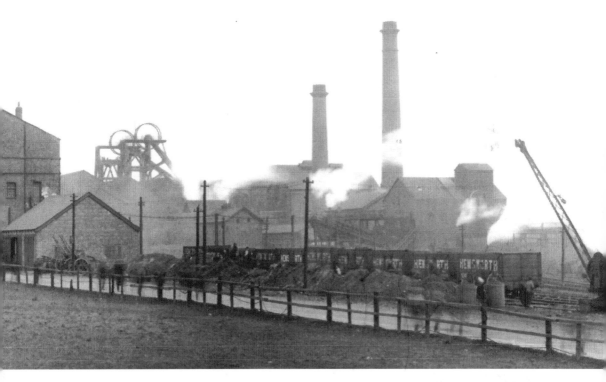

Fitzwilliam Hemsworth Main Colliery. (Chris at Old Barnsley)

The pit derived its name from the fact that it was on the estate of the 5th earl, the Right Honourable Charles William Wentworth Fitzwilliam; its owner was Mr Richard Fosdick, a London coal merchant who secured a loan from the Great Northern Railway company to finance the colliery. The sinking of the shafts commenced in 1876 and was completed one year later into the 4 foot 6 inch thick Shafton Bed seam. No expense was spared to make the pit safe and well-equipped. About 300 men and boys were employed at this time, but the pit was not fully developed and the coal trade was at a low ebb. The pit struggled from the start and the railway company was beginning to demand repayment of the loan. On 1

February 1879 the pit suffered an explosion that took the lives of five men; many others suffered horrendous injuries and burns.

Everyone regarded the pit as relatively gas free as its ventilation was well above the accepted levels at all times, plus the fact that it was working the Shafton Bed Seam which was a good 300 yards above the Barnsley seam, which was notorious for explosions and instantaneous combustion. Due to the excellent ventilation, the miners worked with open lights and the firing of explosive shots was permitted, but with restrictions. At six o'clock on the previous Saturday morning the deputy examined the whole district and recorded in his report book that everything was safe before allowing approximately 150 men and boys to be wound down the shaft. Another deputy also found the district to be safe – he fired a shot in one of the banks in the west district and everything was ok. At approximately 9 a.m., a rumbling noise was heard due to an explosion that had occurred in the same bank on the west district. The men working in the district made a hasty retreat and raised the alarm. When the bank on the west district was entered, two men were found to be dead and several others were severely injured. Some of the men came out of the pit and made their way home, and three other men were later to die from their injuries and burns caused by the blast. The mine owner, Mr Fosdick, and HM mines inspector Mr Wardell, from Wath, were accompanied by Mr Bennett, the mine manager, down the pit, where they made an immediate inspection and could see where the ignition had taken place. They decided that it was highly probable that a roof collapse had released a sufficient amount of gas to be ignited by the flames of the candles. This only goes to show the inherent danger of using open lights. If safety lamps had been used to light the area of work and to test for gas, the explosion would not have happened.

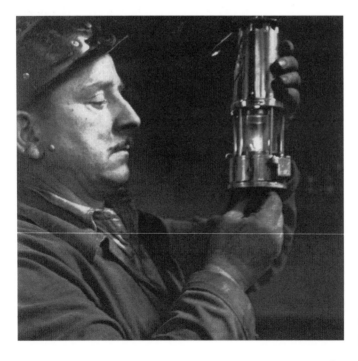

Colliery official testing for gas 1950s. (NCB)

In 1890, because of financial difficulties, Fosdick could not repay the loan and the pit was taken over by the Hemsworth Colliery Coal Company, of which Fosdick was a director.

In 1905 the miners had a dispute with the mine owners regarding poor wages at the time and not being able to give their families a decent living. The owners were stubborn and would not enter into negotiations. They had stocks of coal and tried the old method of telling the miners that they could be laid off if they persisted with their demands. The miners decided to strike, hoping that they would call their bluff, but the owners were very vindictive and retaliated by taking the outrageous decision to evict the men from their homes. Most of the men lived at Kinsley, where the colliery company had rows of houses built for their miners to rent. The men were given little or no notice about this and the owners sent a contingent of police to evict them, taking all their belongings from the houses and laying them in the street. Heavier pieces of furniture which were upstairs were lowered down ladders, some being damaged in the process. Local hauliers with horses and carts, accompanied by others from outlying areas in an act of compassion, arrived to take them to wherever they could find somewhere to live. Just a few of these people were able to find temporary accommodation with close family members, who themselves were already living with their large families in what could only be described as overcrowded, damp and smelly conditions. These people were now living in complete squalor with as many as four or five people of both sexes sharing beds or sleeping on the floor, covered in whatever clothing or rags they could find. The landlord of the Kinsley Hotel took pity on the children and kitted out the ballroom in the hotel as a dormitory for them, each being found a bed. Other families who were not so lucky were living in tents erected by the local authorities and a Methodist minister from Hemsworth. A police officer was heard to say that he was very sad and that it was the most awful job he had ever done in his whole career, to turn these people out onto the streets, causing great hardship and suffering. There were over 400 families affected, approximately 2,500 people, by this act of inhumanity. The Great Northern Railway Company were now demanding repayment of the loan to Richard Fosdick, which was not forthcoming and led to the company being put into administration. Major J. R. Shaw from Purston Hall, who was the owner of South Kirkby and Featherstone pits, bought the colliery in 1906, but it took a further year before the miners were balloted on his proposals for a settlement. This was finally accepted after a majority vote in 1907 and the men went back to work on his terms. The major, as part of his promise to the miners, built a housing estate, which was to become the 'Red City'; he also made them a bowling green and miners' institute. The work was completed towards the end of 1918, some ten years later!

11
Stubbin Collieries

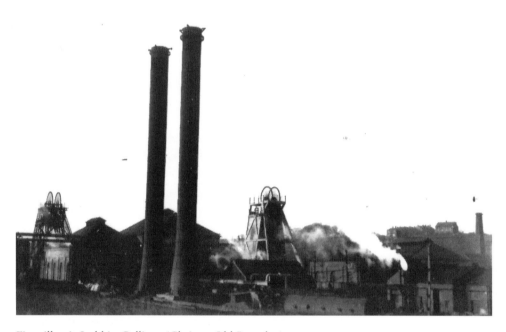

Fitzwillam's Stubbin Colliery. (Chris at Old Barnsley)

West of Rawmarsh, the 6th Earl Fitzwilliam had three pits at Stubbin on the Wentworth Estate, Stubbin, Top Stubbin and Bottom Stubbin, working the Barnsley seam He died on 20 February 1902, aged eighty-six. This man was held in the highest esteem by all of the miners working in his pits, and by all the local community of Wentworth, Elsecar, and other surrounding villages, for his generosity and fair treatment of all his employees. There were more than 5,000 miners and estate workers plus hundreds of other people who attended his funeral to show their respect.

The 7th earl's Fitzwilliam Collieries Ltd decided to sink the two shafts of New Stubbin Colliery during 1913. The shafts reached a depth of 287 yards into the Parkgate seam. The earl's two-year-old son, the Viscount Milton, removed the first grass sods from the site. The earl's local brick works at Bank pit provided the bricks for the shaft linings and the sinkings proceeded at a fair rate. Coal was reached in 1919 and full scale production commenced in 1920, to coincide with the run down of the Top Stubbin pit due to the

exhaustion of reserves. There were no redundancies and the manpower was absorbed into the New Stubbin pit. Due to up-to-the minute coal-cutting machinery and more advanced technology being introduced into the colliery in the early 1920s, they were able to keep abreast of the demands placed upon them by the South Yorkshire Chemical Company's Parkgate byproducts plant for top-quality Parkgate coke and gas coals.

Over the next six years, both shafts were deepened, the steam winding engines were converted to electrical power, a new pit bottom was developed, and the underground transportation system was revolutionised by the introduction of 2-ton mine cars and the operation of diesel powered locomotives for transportation of the coal to the shaft bottom. On the surface, a new coal preparation plant was commissioned in 1954 and was finished in time to take the new production from the Silkstone seam, which came on stream in September 1955. Over the next three years, production had shown a dramatic rise to some 532,000 tons in 1958 and the colliery had at that time an estimated life of thirty years. The reconstruction was reported to have cost in the region of £1.25 million. Against previous estimates, the Parkgate seam was still producing well, along with the Thorncliffe and Silkstone seams, which were both now seeing the advantage of highly increased mechanisation in the form of British Jeffrey Diamond and Anderson Boyes coal cutting and loading equipment. The colliery went on to work for a further twenty-one years. The Parkgate reserves were worked out in 1966, followed by the Thorncliffe in 1973; the Silkstone seam worked for a further five years until it became impossible to carry on and the colliery was eventually closed in July 1978.

The grave of the 6th earl, William Thomas Spencer Wentworth Fitzwilliam, and his wife, Lady Frances Harriet Douglas, in Wentworth Churchyard. (Ken Wain)

The 7th earl opened up a factory on Sheffield and was soon to be manufacturing the world famous Simplex motor cars, built to rival the Rolls Royce.

Fitzwilliam Collieries' management always kept to the forefront when it came to implementation of new technology, new methods of working and the improvement of conditions, with an emphasis on safety for the welfare of their employees. The 7th earl, affectionately known by his workers as 'Billy Fitzbilly', opened the pithead baths under the Miners' Welfare Scheme on 29 November 1930, to be followed by a new canteen in May 1934, and the miners' restaurant was opened by Lady Fitzwilliam in November of 1941.

The colliery's greatest achievement was a weekly production of 16,189 tons in 1935, two years after the development of the Thorncliffe seam. Just after nationalisation in 1947, the colliery became part of the NCB's north-eastern division No. 4 Carlton area; the colliery manager at the time was Mr H. G. Spooner, who had a manpower complement of 1,250 producing coking coal, gas coal, household and steam coals – the combined production of some 430,000 tons coming from the Parkgate and Thorncliffe seams. Viable reserves in the Parkgate seam were now more difficult to extract and in January of 1952 the NCB decided to embark upon a much-needed redevelopment scheme, which was required to modernise the colliery to enable it to make preparations to tap into the Silkstone seam.

 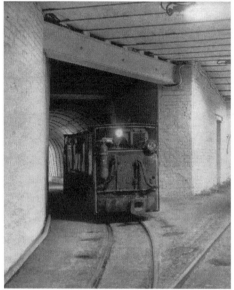

Above left: Workmen's canteen. (NCB)

Above right: Underground diesel locomotive. (NCB)

William Thomas Spencer Fitzwilliam, the 6th earl, was born in 1815 and died in the depths of winter in February 1902. His funeral was a splendid affair, with his body placed in a solid oak coffin and his last journey being made in a black and silver glass coach, drawn by a team of four jet black Friesian horses with plumes of black ostrich feathers to compliment their long flowing manes and feathery fetlocks, each attended by their own horseman dressed in sombre black attire. The funeral procession set off from Wentworth Woodhouse at one o'clock, led by 1,000 of the earl's local miners with a guard of soldiers from the Yorkshire Dragoons. All the staff from the house were in attendance along with the local villagers, carrying floral tributes more befitting of a royal wedding, bringing colour as never seen before in the soot-covered streets on the mile long journey to his final resting place in Wentworth churchyard. The earl had amassed his wealth mainly from the efforts of his miners and reportedly left in excess of £2.5 million (£3 billion today). For all his wealth, he was not miserly with his money; he gave a lot to local good causes to improve the people's lot. The 'New Church' in Wentworth was commissioned by the earl and he ordered the architect James Loughborough Pearson, later famous for his design of Truro Cathedral, to design it. The church was duly built in 1872 in commemoration of the earl's parents at a cost of £25,000, for the benefit of the family and the community. The church has a spire that is 200 feet tall and can be seen for miles around and the interior is very spacious, with seating for 500 people.

Above left: New Wentworth church exterior. (Ken Wain)

Above right: New Wentworth church interior. (Ken Wain)

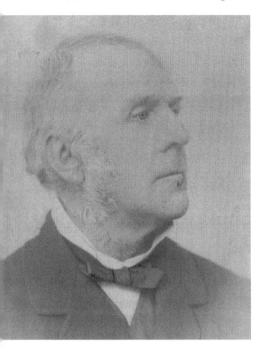

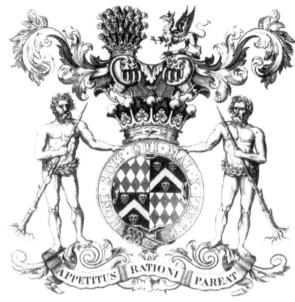

The Arms of the 6th Earl Fitzwilliam

Above left: The 6th Earl Fitzwilliam. (Roy Young)

Above right: The arms of the 6th Earl Fitzwilliam. (Roy Young)

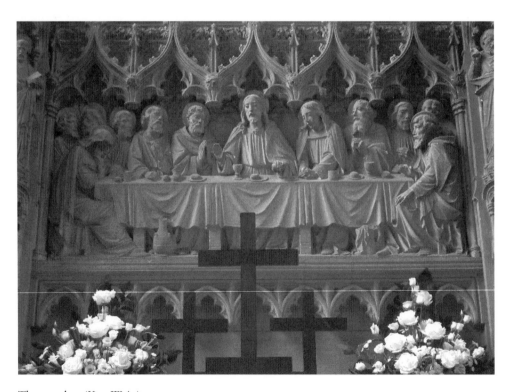

The reredos. (Ken Wain)

The stone carved reredos above the altar depicted the Last Supper and was commissioned by the 6th earl's children to commemorate the golden wedding anniversary of their parents: a wonderful gift and a lasting legacy to the Holy Trinity Church and to the country's heritage, but a typical example of the extravagance which the family were to carry on. Vast amounts of inherited wealth were squandered on gambling and philandering with their own gold-digging licentious family members and friends, with debauchery and illicit liaisons leading to illegitimacy and contestation of descent. As with the Last Supper, it was a betrayal of all that was decent. Good and bad reign in all families and sections of society, without exception, and the Wentworth Fitzwilliams were no different. They were a noble, philanthropic and worthy family, but they had their dark horses and skeletons in the cupboard.

After the death of the 6th earl, his son William Charles De Meuron Wentworth Fitzwilliam became the 7th earl and took over the running of the estate and the family's interest in the coal mining industry. In 1912, on 1 March, 1 million of the nation's miners went on strike for a minimum pay settlement of 5 shillings per day for men and 2 shillings per day for boys. The miners had for years been held in a stranglehold by the coal owners and had now decided that enough was enough; the nation ground to a standstill as it was reliant on coal for the wheels of industry to keep turning. The miners were on strike for the sake of their families and the long-term future of their jobs and no amount of persuasion would deter them from being resolute in their stance against the coal owners. The country was on its knees and Prime Minister Herbert Asquith had to persuade the government to pass a bill to give the miners a minimum wage, which he did while standing in tears at a third reading of the bill. The bill was passed by a large majority, and the miners returned to work in April with a sense of power for future struggles but with a feeling of uncertainty over the fact that the figures of 5 shillings and 2 shillings were not laid down. As the miners had now been out of work for a month with no income, many of them were destitute and their families were near to starvation. However, the Fitzwilliams were always on hand to help their miners and as with every dispute, things were soon forgotten and life went back to normal.

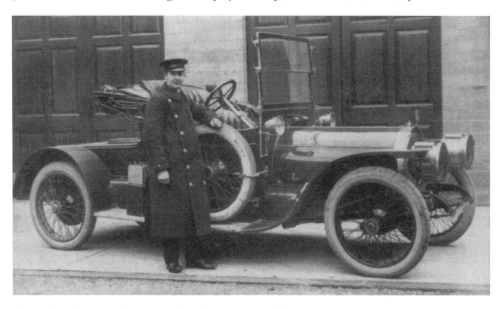

The 7th earl's personal car with chauffeur, in the stable courtyard. (Roy Young)

The last Simplex car to be made in 1925, shown here outside the Cutlers Hall, Sheffield. (Roy Young)

12
Cadeby Main Colliery

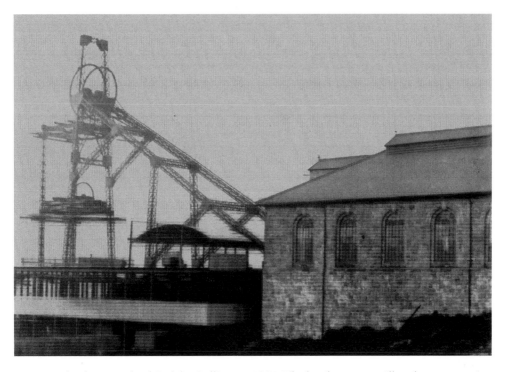

A very early photograph of Cadeby Colliery, c. 1891. The headgear was still under construction (note the absence of the winding ropes). (John Gwatkin)

The Cadeby Main Colliery Company started the sinking of what was to be the deepest pit in Yorkshire into the Barnsley seam on 25 March 1889. Coal was reached in 1893 at about the time of the formation of the new Denaby & Cadeby Main Collieries Ltd. The No. 1 and No. 2 shafts were 751 yards and 739 yards deep respectively. Ironically, both shafts suffered heavy inflow of water and it was decided to line the shafts with cast iron tubing to stem the flow. As with most collieries of this era, steam was the power medium for most operations on the surface installations, from the two giant steam winding engines manufactured in Leeds by John Fowler & Co. to the more lowly saw benches in the joiners shop. Electrical power was soon to be used throughout the colliery, yet again to be provided by two steam-driven DC generators.

The colliery was always regarded as being one of the best equipped – within a year of its inauguration, it was using electric coal washing equipment and producing large quantities of coke from approximately 200 coke ovens.

Cadeby was located by the River Don, which gave it an immediate advantage in being able to transport its coal direct to the Hull Docks for export to the overseas markets. Within fourteen years the colliery was well served by the railways, bringing direct access to the local iron and steel making industries in the Sheffield area. All collieries working the Barnsley seam were susceptible to spontaneous combustion and the use of electrically operated machinery underground was banned in many districts until more stringent regulations were introduced to ensure the safe working of these machines.

It was fortunate that when their majesties King George V and Queen Mary were in the district and visiting Conisborough Castle on Monday 8 July 1912, 300 of the miners stayed away from work to see them as Cadeby was to suffer two major explosions in the early hours of Tuesday 9 July 1912. Ninety-one men and boys lost their lives in the colliery's south district. The first explosion of methane gas and coal dust occurred at about 1.30 a.m., killing thirty-five of the thirty-seven men in the district at the time. One of the survivors, a road-layer by the name of William Humphries, summoned assistance from an adjoining district after realising something was wrong when he felt air passing over his face in the wrong direction. The men toured the south district and soon confirmed that an explosion had taken place and that there were no survivors. The surface was contacted and told of the news, after which an emergency rescue plan was set into motion. Colliery officials, rescue teams and volunteers were mustered and went into the pit to try and retrieve the dead and rescue the injured. At 11.30 a.m. another, more violent, methane gas and coal dust explosion occurred, killing fifty-three of the recue party, including HM district chief inspector of mines Mr William Pickering and his assistant Mr John Hewitt, along with the Denaby Colliery manager, Mr Charles Bury. One of the rescuers, thirty-five-year-old Frank Wood, was so mentally disturbed after working for two days bringing the badly mutilated dead out of the pit that he committed suicide by drowning. Two others died later after succumbing to their injuries. Had it not have been for the fact that their majesties were in the area, the death toll would have been considerably higher.

The king and queen arrived at Cadeby Colliery and immediately mingled with the mourners, giving them their heartfelt support and condolences. The king was visiting shaken and Her Majesty Queen Mary shed a tear with a young widow.

Church bells tolled ninety-one times across the mining communities of the Don and Dearne valleys, out of respect for the ninety-one men and boys who died in the two explosions at Cadeby Main Colliery on Tuesday 9 July 1912. In 2012, a parade of men, women and children with close connections to those who perished 100 years before set off from the old Cadeby Colliery site at 11.00 a.m. to Denaby cemetery to the centenary commemoration service and the unveiling of a new memorial installed to honour the memory of those courageous men and boys. The parade was headed by the Doncaster mayoral car, followed by a little white pony pulling a mock-up of a coal tub, reminiscent of the pit ponies that were used at the time of the disaster. Dodworth

HM King George V travelling through Mexborough from Wentworth to visit Cadeby Colliery after the 1912 disaster. (Alan Peace)

Grieving miners gather at the pit top on Tuesday 9 July 1912.

Colliery band marched ahead of the members of the local communities, who between them carried various miners' banners and the banner of the mines rescue service. The parade came to a halt outside the miners' memorial chapel to observe a one-minute silence, after which it continued to the Denaby Main Cemetery. Civic dignitaries including HM Lord Lieutenant of South Yorkshire, David Moody; the Bishop of Hallam, the Rt Revd John Rawsthorne; the Rt Hon. Caroline Flint MP; the mayor of Doncaster, Peter Davies; and the civic mayor of Doncaster, Christine Mills, along with local clergy and members of the memorial group, were gathered in front of the small memorial garden in which is situated the new memorial. 11.25 saw the opening of the service by local clergy, followed by the hymn 'O God Our Help in Ages Past'. A roll call of the ninety-one victims was read by the Reverand Reg Davies and Jeff Lovell, chairman of the memorial group. A sermon followed with prayers and the hymn 'Abide With Me'. Jeff Lovell gave a speech on behalf of the group and accompanied the oldest surviving relative, ninety-three-year-old Mrs Irene Newton, who unveiled the memorial while remembering her grandfather, Mr James Beech, who was forty-four years of age and was killed in the first explosion. Mrs Newton, who now lives in Weston-super-Mare, was born in Mexborough and remembers vividly her family and friends working in the local coal mines.

The poem 'Memorial Most Worthy' was read by its author Benny Wilkinson.

Ninety-three-year-old Mrs Irene Newton, who unveiled the memorial. (Ken Wain)

Pit pony with replica coal tub. (Ken Wain)

Family members of the deceased carrying the colliery banner. (Ken Wain)

Cadeby Main Colliery memorial. (Ken Wain)

Benny Wilkinson reads his poem 'Memorial Most Worthy'. (Ken Wain)

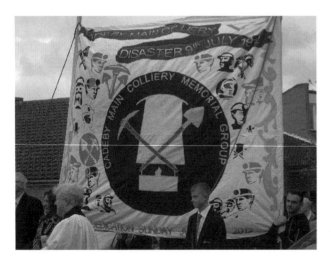

Cadeby Main Colliery banner. (Ken Wain)

Memorial Most Worthy

The tolerance of love holds sway
over tragedy passing
Still strong in hearts, since its
dawn came unpaged
Its memory unending, Ten
decades now amassing
When the anger of mining
thundered and raged

Merciless with intent its fiery
temper ignited
No mortal or other could
withstand its will
To road, stall and gate advanced
cruelly uninvited
And black dust laid its shroud in
the silence of still

In terrible seconds mining dangers
ran amok
The cold finger of tragedy
revealed the sad cost
Amid twisted steel, timber,
choking dust and rock
The terror of the aftermath gave
count to the lost

Alarm heralded the brave, human
moles of dedication
The courage of rescuers in haste
took the task
To the black depths of hell, with
no hesitation
They sought living or perished,
what more could one ask

In that muted calm, further disaster
hung pending
Then in terrible rage ignited its mur-
derous intent
The gallantry of rescuers lay perished
and ending
Their duty bound bravery now fruit-
less and spent Yet mines hold no
mercy, no sympathy or shame
To invasion of need their dangers
hold fast
Now twice the head count in that dark
domain
Eighty eight lost souls that count was
cast
A cataract of tears over spilled an
ocean of despair
The sorrow of the fatalities spoke the
guilt of rages
Kin witnessed their ascent in safe
hands of care
Such sorrowful scenes would find
history pages
Disaster manifests itself in life's rest-
ing place
As tear stained masses complete a
human epitaph
Heart felt prayers were etched on each
and every face
Surely the lost were treading Gods
heavenly path
Brotherhoods strong bond, shall neer
decay of neglect
For fallen brothers its need was truly
thus born
This day in prayer we will voice heart
felt respect
May Gods infinite light greet this
memorial dawn
We shall not tire to the count of the
years
The lost souls must know our measure
of sorrow
And if heaven be kind they will wit-
ness our tears
Not just this day but for every tomor-
row

Benny Wilkinson

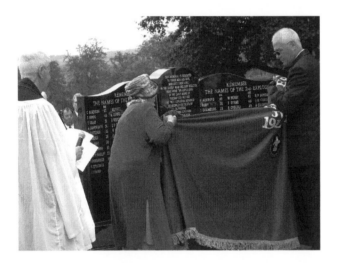

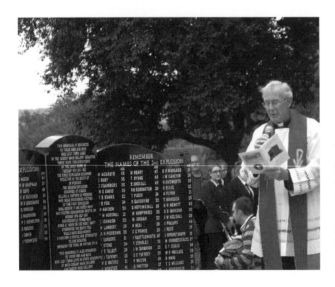

Top and middle: Jeff Lovell and ninety-five-year-old Mrs Irene Newton unveil the memorial. (Ken Wain)

Bottom: The Bishop of Hallam, the Rt Revd John Rawsthorne, gives the dedication. (Ken Wain)

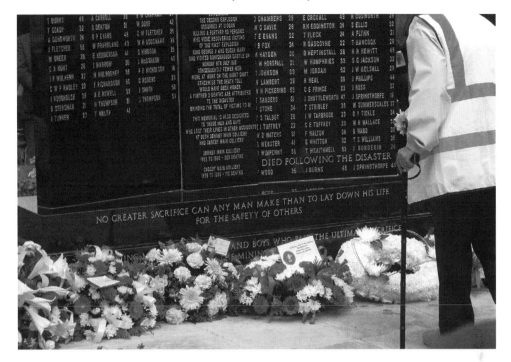

Wreaths are laid on the memorial. (Ken Wain)

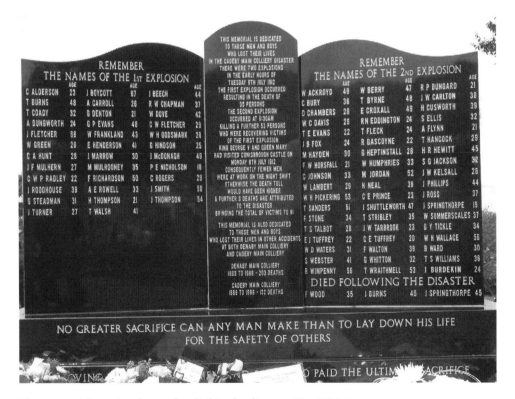

The memorial naming those who died in the disaster. (Ken Wain)

After the memorial was unveiled it was dedicated by the Bishop of Hallam, the Rt Reverend John Rawsthome, and wreaths were laid at its foot, followed by the hymn When I Survey the Wondrous Cross. The service was closed at 1.30 p.m. and photographs were taken in abundance before a buffet was held in the Denaby & Cadeby Miners Welfare.

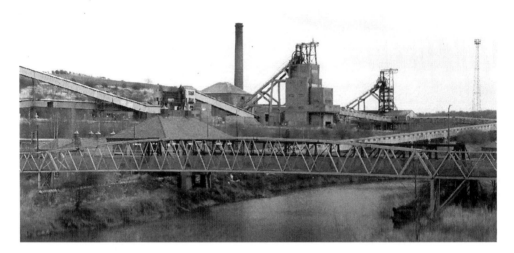

Cadeby Colliery, 1987. (Alan Hill)

Following the 1912 disaster, it was said in no uncertain terms in a Home Office report into the disaster that there had been several breaches of the recently introduced Coal Mines Act of 1911. It was apparent from statements made between the management and the president of the Yorkshire Miners' Association that there was a good case to prove that striving for high production and profits were put before the health and safety of the workforce. Cadeby Main was to become the deepest colliery in Yorkshire with the largest steam winding engines in the county, manufactured by John Fowler & Co. of Leeds. Steam generators provided the power for the colliery and the lighting both on the surface and underground. Extensive workshops were built to house equipment for the manufacture and repair of colliery machinery and a large joiners' shop was also built, along with a blacksmiths' department and stores. The Barnsley, Beamshaw, Dunsil, Newhill, Parkgate and Swallowood seams were all worked at Cadeby Main Colliery. A high percentage of the Parkgate steam coals and coke was exported and the coal was transported by barges on the River Don to Keadby and the Hull & Goole docks; this continued until the opening of the new Immingham docks in 1912. Coal was first hauled by the Great Central Railway on 14 January 1908. March 1927 saw the Denaby & Cadeby Collieries Co. Ltd join forces with the Yorkshire Amalgamated Collieries Ltd. The company had a working capital of £3.2 million and the pits within the company were Darton Main, Dinnington Main,

Maltby Main, Rossington Main and the Strafford Colliery Co. Ltd, making it one of the largest mining consortiums in the country.

Throughout the 1940s the two principal collieries being worked in this area were Barnsley and Parkgate, which were hand mined with the coal transported out in tubs. When the colliery was nationalised in 1947, the National Coal Board decided to bring all the coal production from both Denaby and Cadeby to the surface via the Cadeby No. 2 shaft.

A major reconstruction scheme was put into place in 1956 which cost in excess of £4 million; the No. 2 shaft steam winder was decommissioned and replaced by an electric winder, which allowed skip winding to be introduced to wind coal from the Barnsley, Beamshaw, Dunsil and Parkgate seams. In 1957, the No.1 shaft winder was replaced by an electric winder, and within three months it was being used for materials and man riding only, all the coal production now being wound via the No. 2 shaft. Denaby Main and Cadeby Main collieries amalgamated in May 1968 and Denaby was closed. Due to worsening geological conditions, on top of the fact that the colliery had been making heavy losses for the last twenty years, British Coal decided to close the colliery in November 1986.The remaining coal reserves would be worked by Barnburgh and Goldthorpe collieries. 370 men were working at the colliery at this time, and 190 of them decided to take voluntary redundancy, the remainder being transferred to Rossington and Markham Main collieries.

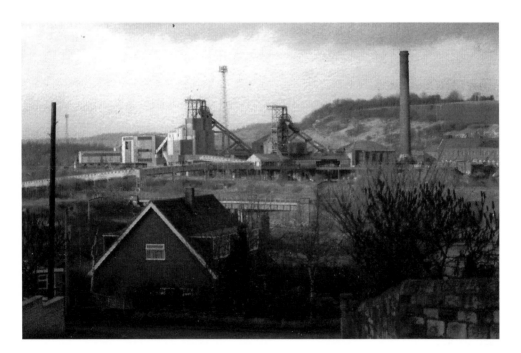

Cadeby Colliery after closure in 1987. (Alan Hill)

13
The Lofthouse Colliery Disaster 1973

From the end of February 1973, the men working on the south 9B district were complaining of a foul smell emanating from the coal face each time a cut was taken, but despite constant complaints, very little investigation took place. This went on for three weeks until on 23 March, as the men were working on the coal face, they became aware of a rumbling, rushing sound, accompanied by a sudden lack of air, as though the supply had been cut off. Water began to seep from the coal face and the men instinctively began to run for their lives towards the surface as the water broke through with a tremendous crash, bringing foul-smelling thick slurry with it, following the men at a fair pace as they tried to escape. Twenty-three men managed to escape by leaving via the return airway, but seven others were unaccounted for and feared trapped by the seething river of what was estimated to be 3.5 million gallons of water, slurry, and debris that was swept along with it from old mine workings that were apparently not taken into account when the Lofthouse coal face was extended beneath them. Two large holes appeared in a farmer's field near to the colliery, in an area believed to be above the scene of the disaster. It was thought by some that there may have been a pocket of air in which the trapped miners were sheltering. Heavy drilling equipment was brought on site and an air shaft was put down in the hope of providing extra ventilation to sustain any survivors until a rescue could be executed. The two holes were filled with thousands of tons of building rubble, with the hope that this would stem the flow of water into the affected workings. It was soon realised that the airshaft was of little or no use whatsoever and the body of one of the seven missing miners was eventually extracted from the rubble.

Arthur Scargill, the NUM president, made an impassioned plea for the search to carry on for the sake of the miners' wives and families, but the NCB's area director, Norman Siddall, called off the search, saying that under the circumstances it would be too dangerous an exercise to try and find and remove the remaining men. The district was sealed off. Arthur Scargill and his arch-rival Edward Heath, the prime minister of the day, visited the colliery together to give colliery support to the survivors and the bereaved. In the following year the miners brought about the collapse of the Heath government when they went on strike over pay.

A black granite obelisk was erected near to the site of the tragedy as a memorial to the seven miners who lost their lives. Their names are engraved on the memorial: Frederick Armitage, Colin Barnaby, Frank Billingham, Sidney Brown, Charles Cotton, Alan Haigh, and Edward Finnegan.

14

Houghton Main Colliery

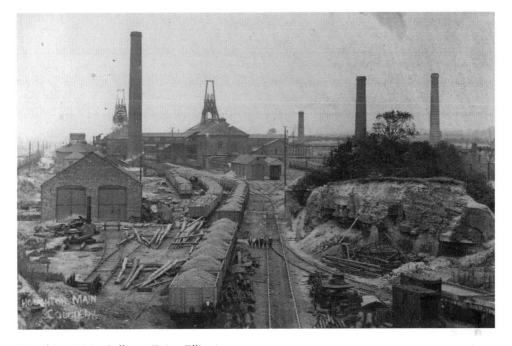

Houghton Main Colliery. (Brian Elliott)

The Houghton Main Colliery Company started sinking two shafts in 1873. The company was registered in 1875 with a working capital of £100,000. Both the No. 1 downcast shaft and the No. 2 upcast shaft were 14 feet in diameter and lined with brick. Production started to some extent in 1875 and the Barnsley bed seam was reached in 1878 at a depth of 550 yards.

Only eleven years later, in 1886, a tragic over-winding accident occurred that took the lives of ten men. It was 7.45 p.m. on the evening of Thursday 30 December 1886, when the colliery under-manager Mr C. Dunbar, who was sat at home near to the pit, heard what was described as a rumbling noise emanating from the No. 1 pit. He rushed out of the house towards the pit, calling at the lamp cabin for a lamp on the way. When he reached the pit bank, he was met by the banksman, Albert Holdsworth, who told him that he thought the pit was on fire, because he had seen flames licking

up the shaft and into the headgear pulleys. The winding engine man, Allen Beresford, came to them and said that something had happened but he didn't know what. He went on to say that when the cage was about 150 yards from the surface he heard something in the shaft above him before being struck on the head by a lump of wood, which dazed him. The manager asked him if he knew where the cage was and he said no. Mr Dunbar then ran to get Mr Elliott, the pit manager, who he met at the pit gates; he told him what he knew at that time and they both proceeded to the No. 2 pit, where they checked that the fan was working alright and ensured that the ventilation was as it should be.

The inquest into the accident was held in the Cross Keys public house at Darfield and the burial was at Darfield churchyard, where there was one grave for all of the ten men and a memorial of grey granite stood on a plinth of Yorkshire stone engraved with the names of the ten men. The memorial was erected in affectionate remembrance by the workmen and friends of the ten men who lost their lives at the Houghton Main Colliery on December 30 1886. The names of the men are as follows:

Joseph Walker	48	Collier
Samuel Walker	20	Trammer
Charles Walker	19	Trammer
James	49	Collier
Alvin Hardcastle	18	Trammer
Joseph Pearson	47	Collier
Joseph Pearson	20	Trammer
Edward Baxter	29	Collier
William Mannion	42	Trammer
William Barton	17	Pony

Poster with names of men killed in the overwind disaster. (Ken Wain)

The burial took place in Darfield Churchyard on 4 January 1887 and the service was conducted by Reverend H. P. Cooke, rector of Darfield, and Reverend F. Sleap, the vicar of Darfield. The Reverend H. J. Smith of St Helen's church at Elsecar also conducted a service for William Mannion, who was of the Roman Catholic faith. November 1887 saw the unveiling of the memorial, which was performed by local dignitaries, families and friends of the ten men.

> After finding things to be in order they went to the fan drift to see if they could smell any gas or anything else unusual. Everything seemed to be in order so I signalled the pit bottom on the shaft bell and received an answer and Mr Elliott said we should go down the pit to see what had happened. By this time another five men had arrived and they accompanied us down the pit. We went to the No. 1 pit bottom and Daniel Elliot told me that the cage had come back into the pit bottom sump with ten men in the cage. It was a sickening sight; I saw an arm, a leg and several other body parts and clothing strewn about the pit bottom; the cage which was made from iron and timber had crashed into the pit bottom sump smashing solid oak beams across the sump, such was the ferocity of the impact. It was twisted and looked like matchwood with the remains of bodies trapped inside, most being immersed in water inside the sump. I was given a list of names of the men who were on the cage and gave it to Mr Elliott, at the bottom of No. 2 shaft.
>
> Mr Dunbar

It soon became apparent that the three-deck cage had over-wound and that the headgear was severely damaged. The King's patent detaching hook was severely damaged and the rope had snapped, allowing the cage to plummet down the 535-yard deep shaft at a terrifying 200 mph in approximately twelve seconds. The detaching hook was invented and patented in 1860 by John King, of Pinkston in Nottinghamshire, who saw the need for a safety device because of the amount of overwind accidents. In overwind, the hook would shoot up through the Bell Plate and shear the copper pin, which would allow the wings of the hook to be forced inwards, suspending the cage in the headgear and releasing the rope. It was said that Beresford was seen drinking in three different pubs before the beginning of the shift. He was arrested on suspicion of manslaughter and taken into custody. At his trial it became evident that he had only had two glasses of beer on that day, and that he was perfectly sober. The judge was told that he was well thought of and held in high regard by the local community and at the colliery, where he had worked since it was opened. He was given a fair trial and exonerated, and there was cheering in the courthouse.

In 2009, because of general neglect and the ravages of time, the friends of Darfield churchyard decided that a general clean up of the area, including the refurbishment of the memorial, was overdue. Fundraising and manual work was carried out in a great endeavour over the following two years, with help and time being given freely by many friends and residents. Some of Darfield's more famous friends speaking at fund raising events included Catherine Bailey, television producer and director and author of *Black Diamonds*; Brian Elliot, author of a profusion of books about the mining industry, including the famous *Barnsley Pits and Pitmen*, and the account of the miners' strike of 1984–5 as edited from the day-by-day diary of South Yorkshire miner Arthur

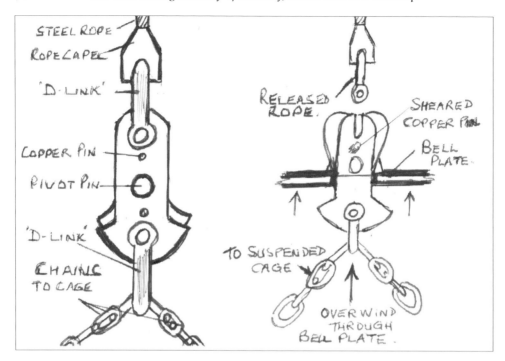

Rough sketch of King's patent detaching hook. (Ken Wain)

Wakefield; Martyn Johnson, author of two satirical accounts of his life as a Sheffield copper in Attercliffe; Stephen Smith MBE; Ian McMillan; and Frank Morley.

After the £4,200 needed to carry out the work was raised, the work was carried out by stonemason Mr Roberts, who cleaned and repainted the names on the memorial and lay new Yorkshire stone kerbing around the base of the memorial; it was thought only right and proper for a rededication service to be carried out in honour of the men who lost their lives.

The church was full on the morning of 30 June 2011 when the service was carried out by the Reverend David Hildred, and the Houghton Main Male Voice Choir sang a stirring rendition of Edwards' and Hands' 'Take Me Home'. Brian Elliott told the story in vivid detail of the over-wind disaster, and the choir led the congregation through the churchyard to the site of the memorial, where Revd Hildred said the prayer of dedication after which the Hardcastle family, relatives of two of the victims laid a wreath in their memory. Revd Hildred gave the final blessing and the congregation spent a few minutes in quiet contemplation, before meeting at the church hall for refreshments.

In the early 1920s, further underground shafts (Staple shafts) were sunk from the Meltonfield seam into the Barnsley and Parkgate seams; a little later, a third concrete-lined shaft of 20-feet diameter was sunk to overcome expected water problems and ensure better ventilation, also catering for the anticipated extra output. The markets dried up to some extent and the sinking was halted in 1928. It was recommenced nine years later in 1937, and completed in 1940, linking to the Thorncliffe seam at 818 yards. By 1923, Houghton Main was employing 1,956 men underground and 480 on the surface,

Darfield Church records for burials on 4 January 1887, showing entries for the ten men who lost their lives in the Houghton Main overwind accident on 30 December 1886. (Ken Wain)

Alvin Hardcastle and family after laying the wreath in memory of two family members who died in the disaster. (Ken Wain)

Members of Houghton Main Colliery male voice choir by the memorial. (Ken Wain)

producing approximately 750,000 tons of coking, gas, household and steam coals per year from the Barnsley, Meltonfield and Parkgate seams. The manager at the time was Mr J. H. Hesketh.

On 12 December 1930, a firedamp explosion occurred killing seven men – the youngest, John Pearson, was only twenty-two years of age. The others were: Norman Nicholson, aged twenty-four; William Richards, aged twenty-four; James Lackey, aged thirty; Albert Holden, aged thirty-two; Charles Watson, aged thirty-eight; and Jacob Newberry, aged fifty. The explosion was caused by shot firing, igniting an accumulation of gas.

The new £25,000 pithead baths were opened in 1931 and had facilities for 2,016 men; this was accepted with open arms by most men, although there were still some who preferred to walk home in their 'pit muck' and let their wives wash their backs in the tin bath in front of the coal fire – old habits die hard. In 1933, the production had remained stable, but now with a reduced manpower contingent of 1,808 underground and 415 on the surface, under the management of Mr R. J. Taylor. One assumes that this was the result of increased mechanisation at the time.

By 1940, the pit was working an additional coal seam, the Beamshaw, with better working methods and continuing mechanisation, which saw the pit turning 1,250,500 tons with eight fewer men underground, but with eighty-five extra surface workers to deal with the additional output and extra administration. At the time of nationalisation in January 1947, under the management of Mr F. C. Mackie, the pit had 2,089 men underground.

The NCB took over and the pit was now on course to be one of the nation's 'Big Hitters'. Houghton Main and Grimethorpe were amalgamated and joined underground. Beamshaw, Meltonfield and Winter seam coals were hauled underground and skip- wound to the surface at Grimethorpe No. 1 Pit. Only six years later, at the time of Her Majesty Queen Elizabeth II's coronation in 1953, the Parkgate and Meltonfield seams were worked out and the pit was only working the Barnsley seam. Plans were afoot to tap the Dunsil seam, which was about 18 yards below, and the pundits reckoned that the combined effect of working these two seams would extend the pit's life expectancy to around seventy years, taking it into the twenty-first century. The pit was selling 3,480 tons per day with 2,391 men underground, approximately half of which were working on the coal face.

In 1975 another firedamp explosion took the lives of five men and seriously injured one other on the B05s district. HM chief mines inspector said that the probable cause of the ignition of the firedamp, which had been allowed to accumulate in a heading without proper ventilation for several days, was a faulty auxiliary fan that was known to have been open sparking for the previous nine days.

The Health and Safety Executive prosecuted three officials from the mine for infringement of various sections of the 1974 Health and Safety Act. The men who died were named as: Richard Bannister, aged thirty-one; Raymond Copperwheat, aged forty-two; Leonard Baker, aged fifty-five; and Frederick Arnold Wilkinson, aged fifty-nine.

Houghton Main Colliery held an open day on 16 July 1977, in the queen's silver jubilee year, to commemorate its centenary. NCB chairman Derek Ezra had just announced a £16 million investment into the colliery for a scheme which would allow them to tap into millions of tons of coal reserves in the Dunsil seam. Each coal face would cost £500,000 to equip. All this was envisaged in 1953, but it had taken twenty-two years to prove the

reserves by underground boring techniques. The colliery general manager Mr Tony Griffin said, 'The extra coal means that there are more that 43 million tons in the Houghton Main/ Dearne Valley complex. To reach the coal will mean driving extra underground drifts into the coal seam which has a thickness of between 4–6 feet. The coal would be mined at about half a million tons per year and taken to the surface via the nearby Dearne Valley drift. The coal would be cleaned at the new coal preparation plant and transported on a new rail link in 32-ton wagons to Yorkshire CEGB power stations and BSC steel works.' Houghton Main's existing operations would continue alongside the new developments, which meant the pit would soon be producing in excess of 1 million tons per year. It was estimated that the new project would produce an extra 2,200 tons per day over the next fourteen years. The scheme was expected to be completed by 1979, when the manpower was increased from 1,300 to 1,750, taking the pit forward into the twenty-first century.

In the early 1980s a new coal prep plant was built, and coal winding ceased at Houghton Main. Throwing good money after bad, another coal prep plant was built at Grimethorpe to process coal from Houghton Main, Grimethorpe, Darfield, and Barnsley Main collieries, but the fortunes of Houghton Main were now on a knife edge. Area director Norman Sidall told *Coal News* in June 1990 that the pit was not living up to expectations and its performance was well below the expected output. He said that the colliery had the coal and the necessary equipment to produce the coal profitably, but the operating costs were well over £2.9 million in the previous year and so far this year they were already over £2 million.

In October 1992, the British Coal Corporation announced the closure of thirty-one pits and the loss of some 30,000 jobs. Ten of the pits were earmarked for immediate closure, Houghton Main being one of them. The colliery was closed with the loss of 440 jobs, leaving behind millions of tons of prime coal. The colliery was offered to the private sector but there were no bids and the site was quickly cleared.

Now, twenty-two years later, Peel Environmental is looking to build a renewable energy park on the old colliery site. As before, when the colliery supplied the coal to enable the power stations to supply the region's electrical energy requirements, the energy park would burn waste products from food preparation, biomass and raw timber and waste wood and paper products, etc. to produce a gas that can be used to make steam for operating turbines which generate electricity to be pumped into the national grid.

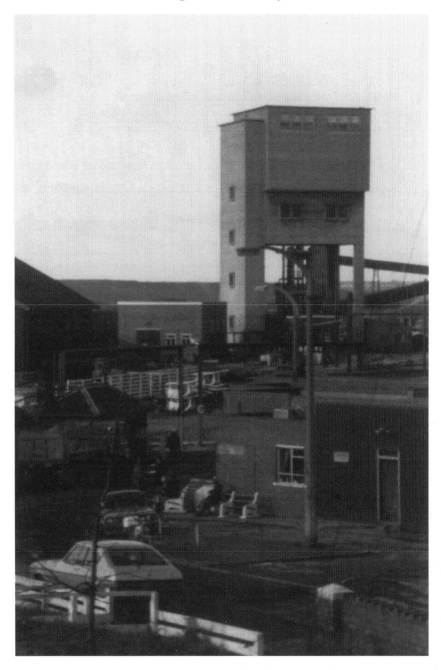

Houghton Main Colliery No. 2 winder in 1998, four years before closure. (Brian Elliott & Colin Massingham)

15
Darfield Main and Mitchell Main Collieries

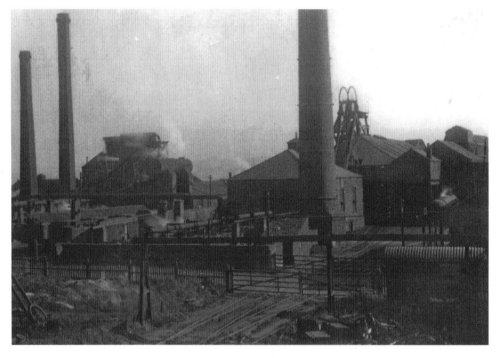

Darfield Main Colliery *c.* 1905. (Chris at Old Barnsley)

The Darfield Coal Company started sinking a colliery in the Dove Valley approximately 4 miles south-east of Barnsley, between Wombwell and Darfield, sometime in 1856. It became known as Darfield Main Colliery and had two shafts, one being the No. 1 downcast shaft, which was 11 foot 6 inches in diameter, and the other the No. 2 upcast shaft, which was 10 foot 4 inches in diameter.

Four years later, in July 1860, after experiencing considerable difficulty due to the ingress of water from the 'Meltonfield Rock', a 163 foot thick band of water bearing strata that was threatening the whole operation because expensive cast iron tubing had to be introduced to line both shafts against this deluge of water, both shafts had been taken down to a depth of 337 yards into a 7-foot-6-inch-thick seam of good-quality Barnsley Bed coal. This was a gamble that made the exercise worthwhile and

production started immediately. After only twelve years of working, the colliery was hit by another tragedy when an underground fire swept through the workings on 13 October 1872; it was soon realised that the fire was much more serious than originally thought and the mine workings were flooded. It was closed for thirteen months and there was an accumulated loss for the owners of more than £100,000.

The Shipley Colliery Company of Derby were soon to take over the colliery until the management of Mitchell Main Colliery Company Ltd, which was based less than a mile away on the western extremities of the colliery, took over in 1902 and amalgamated them. This immediately took away the rivalry that had existed between them and enabled them to pool their resources to take coal from an area of approximately 3½ miles by 1½ miles amounting to some 3,000 acres. The Mitchell Main shafts had already been deepened in 1899 to a depth of 600 yards into a 6-foot-thick seam of Parkgate coal and it was now decided to take and wind coal from seams above the Barnsley seam, from Darfield and those below from Mitchell Main. Work was started in 1913 on the sinking of a third 21-foot-diameter shaft into the Thorncliffe seam but was halted after only one year because of the First World War. Towards the end of the war, in 1917, the sinking was recommenced and was completed on reaching the Thorncliffe seam at 625 yards. The first half of the shaft was lined with a German system of tubing to hold back water ingress.

Completion of the shaft meant much better ventilation for both collieries. It was used for coal winding and the upcast shaft for the whole pit, No. 1 and No. 2 shafts now being the downcasts. The Barnsley seam was worked out in 1910, at which time development work was being carried out that brought the Meltonfield seam on stream. The Beamshaw seam started production in late 1938.

A feasibility study was carried out in February 1931 as to whether the two collieries were still viable and the inspector's conclusion was that he had grave doubts as to the desirability of maintaining Darfield Main at all, as a coal-winding proposition. The output did not warrant extensive replacements by modern machinery.

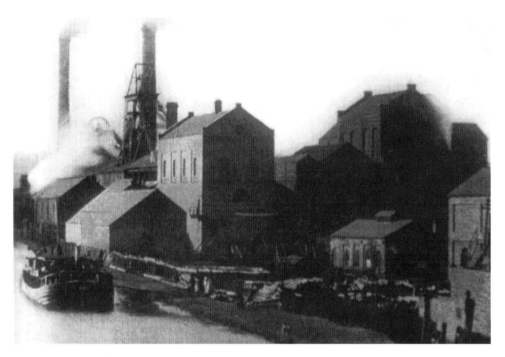

Mitchell Main Colliery *c.* 1905. (Chris at Old Barnsley)

The No. 3 shaft was now the main coal winding shaft as well as being used as the upcast ventilation shaft for part of the Mitchell Main Colliery and parts of Darfield Main. In 1949 the two pits were now an integral part of the NCB's north-eastern division under the chairmanship of Major-General Sir Noel G. Holmes, KBE, CB, MC, and in the No. 4 area, Carlton, sub-area 'B'. The area general manager at that time was Mr A. Scott. The combined manpower at both collieries at this time was 1,968, with 1,004 at Darfield under the management of Mr E. C. Johnson and 964 at Mitchell Main under the management of Mr J. Dolan.

The collieries were both producing coking coal, gas coal, household coal and steam coal. The NCB decided in 1952 that there should be a further reappraisal of the two collieries and, ironically, it was decided to close Mitchell Main. Extensive reorganisation was carried out at Darfield Main, involving work on the surface installations and underground.

A new coal preparation plant was built, along with new engine houses with the latest electric winders, new railway sidings and pithead baths for the men. Underground, new coal faces were started in the Winter seam, which, although it was only 2 foot 6 inches thick, posed no serious problems using Anderson Boyes Longwall coal cutters and hand filling, but additional roof supports had to be used due to a soft roof. When Mitchell Main closed in 1956 the men were transferred to Darfield, which raised the manpower contingent to just over 1,300 and a target of 10,000 tons per week was set for the Meltonfield, Winter and Beamshaw seams. By 22 November the colliery reached a record weekly output of 12,000 tons of top-quality

coking coal. Mechanisation was gradually introduced and, in 1961, 125 hp Anderson Boyes Trepanner coal cutters and Dowty self-advancing hydraulic roof supports were installed on the Meltonfield district, bringing about a completely new system in coal getting at the colliery. Two years later, the colliery mechanisation scheme had been completed, replacing all the traditional hand-filled faces.

The Meltonfield stopped production in 1970, leaving the Beamshaw and latterly the Kents Thick Seam to provide all the colliery's production at a time when the annual output had reached 241,000 tons with 875 men. This was not to last long and the quality of both seams rapidly deteriorated, meaning that Darfield could no longer supply its traditional markets and was only able to fulfil its contract to supply the CEGB. The No. 2 and No. 3 shafts were deepened to 695 yards into the Silkstone seam in the early 1980s, when the colliery was integrated into the south side of the Grimethorpe Colliery mining complex. Because of the poor quality of the Kents Thick Seam, the NCB decided to abandon the seam and concentrate on production from the Silkstone Seam. Darfield Main merged with nearby Houghton Main Colliery in November of 1986 and it was closed in 1989, just four years after the miners' strike, as part of the Thatcher government's pit closure plan.

16
Grimethorpe Colliery

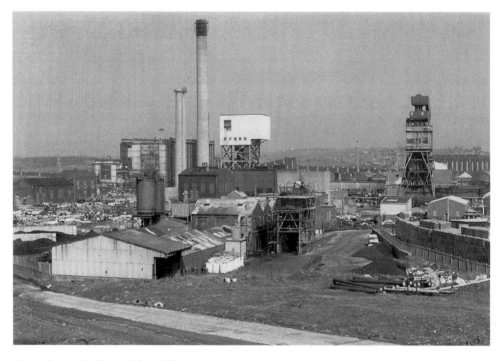

Grimethorpe Colliery. (Alan Hill)

In 1894 the Mitchell Main Colliery Company began sinking the No. 1 downcast shaft for Grimethorpe Colliery at Cudworth, 4½ miles north-east of Barnsley, and only two years later, in October 1896, the ownership of the colliery was transferred to the Carlton Main Colliery Company. The companies amalgamated under the name of the Carlton Main Colliery Company Limited in 1900. The Barnsley Bed seam was reached at a depth of 560 yards in 1897 and a second shaft was sunk approximately 80 yards away, both eventually reaching a depth of 586 yards. The No. 2 shaft was the upcast shaft and in the early days was used for ventilation and winding of materials while the No. 1 downcast shaft was used for winding coal and man winding. Due to constant ingress of water into both shafts, and after several attempts, the shafts were eventually lined with concrete to stem the water down to 130 yards.

At some time during the First World War, the colliery management decided to work the Parkgate seam, which necessitated the sinking of a staple shaft from the Barnsley seam down a further 272 yards. Deepening of the upcast shaft took both shafts to a depth of 854 yards to allow the seam to be worked, and to allow for future plans to work the Haig Moor and Fenton seams, openings were made in the staple shaft. Money was spent on a scheme to sink the No. 3 upcast shaft in 1925, but efforts were cut short due to a fall-off in trade. Work resumed on the shaft sinking at a later date, but when things picked up it was decided to work the Beamshaw seam at 485 yards. The shaft sinking had gone well below this and the country's first skip-winding system was installed in the shaft, which was used experimentally between 1936 and 1940 and wound coal purely from the Beamshaw seam. The staple shaft was used to ventilate the workings and in 1927 an electric winding engine, the largest one in the country, was installed underground to wind coal from the Parkgate seam up to the Barnsley seam, to be wound up the No. 1 shaft to the surface at a rate of some 300 tons per hour. In the late 1930s a plan was laid down for the winding of coal from all five coal seams via the No. 1 downcast shaft; the Barnsley Bed, Haigh Moor and Parkgate coal was already being wound up the No. 1 downcast shaft by the conventional cage and tubs method, but because the Haigh Moor was washed out in 1938, it was decided to work the Meltonfield seam by running two drifts from the Beamshaw seam. Because these two seams were accessed from the No. 3 shaft, which was served by skip winding, it was not a feasible proposition: the Meltonfield coal was a good clean coal but the Beamshaw was dirty and the quality would have been compromised if mixed for skip winding. By the same token it was not a workable proposition to wind either of the seams on an independent basis from either No. 1 or No. 2 shaft insets by skip, because neither of them had the necessary equipment installed for winding coal. Winding coal by the cage and tub method in the No. 1 shaft was now the order of the day and because the Barnsley Bed and Haigh Moor seams had now got a much reduced output, there was sufficient capacity to enable the five seams to be wound from the Barnsley level, which was accessed by bringing the coal together via a system that involved the use of two drifts and both the staple shaft and the No. 3 shaft.

Apart from the Meltonfield seam, which was still being developed, the others were turning to their full capacities and at the time of the commencement of the Second World War the colliery was fully mechanised. The colliery was nationalised in 1947 and taken into the NCB's Carlton No. 4 area, north-eastern division. Two years into nationalisation, in 1949, the manager was Mr J. R. Harding and the colliery was one of the largest in the area, with 2,616 men on the books, and producing good-quality coking, gas, manufacturing and house coal. Shortly after nationalisation, Grimethorpe Colliery merged with Houghton Main Colliery and a £7.5 million scheme was put into place to wind the output from both collieries from the Grimethorpe No. 1 shaft. This was to be no easy task and involved constructing two roadways for locomotives to haul coal from the Meltonfield, Beamshaw and Winter seams at Grimethorpe to the No. 1 downcast shaft and another driven to Houghton Main. The roadways came together at the No. 1 shaft for the coal to be skip wound

to the surface. The No. 3 shaft was sunk to the Parkgate seam at Grimethorpe and the No. 3 shaft at Houghton Main carried on winding the Parkgate coal until the output from both collieries was eventually taken out at Grimethorpe. The Houghton Main No. 1 and No. 2 shafts were then used purely for man riding and materials.

A new £5 million power station was built on the Grimethorpe site in 1958 to replace the ageing Frickley Power Station and provide power to the collieries in the Carlton No. 4 area. In preparation, the Kents Thick coal seam was developed at Grimethorpe to provide the coal for firing the power station and a further locomotive roadway was driven into the Kent Thick seam to transport it to the No. 1 shaft for winding to the surface. Many referred to the roadway as the 'Golden Mile'. Further drivages and modifications to the colliery's underground infrastructure took place during the early 1960s and by 1963 the complete integration of the two pits had been completed and all the output was now wound from Grimethorpe.

On 11 August 1965, 163 men were travelling on the paddy train when the driver signalled for it to stop, which would automatically apply the brakes; ironically, the haulage rope fastened to the rear of the paddy snapped at this precise time and the paddy proceeded down the haulage road, picking up speed as it went along. Realising what was happening, the miners jumped off the moving train, and fortunately there were no fatalities, but eleven of them were injured and were taken to the Barnsley Beckett Hospital. The injuries were not life threatening and the men were sent home after treatment.

The colliery built a 'Coalite' plant in 1966 and started producing smokeless fuels for the home household markets. The colliery just seemed to go from strength to strength when the new Fenton seam was tapped at a depth of 809 yards, with an average seam width of 7 feet interspersed with bands of dirt making it difficult to extract. Methane gas was found in the seam and a methane drainage system was put into place, which enabled the gas to be piped to the surface to supply a local brickworks.

In 1978, about 68 per cent of the Houghton Main/Grimethorpe production was being used to supply the new power station, with 10 per cent going to the 'Coalite' plant and the remainder used for coke production. Estimated reserves in the Fenton seam stood at approximately 7 million metric tons, so a surface drift was commenced in 1979 to exploit the seam. At this time, the NCB set up a £174 million scheme to bring together the collieries in the south side of the Barnsley area; the south side collieries were Barnsley Main, Dearne Valley, Houghton Main and Grimethorpe, which were all joined together underground with 9 miles of roadways. The coal from all the collieries was brought to the surface up a 1½-mile tunnel at Grimethorpe and taken to the new £28 million centralised coal preparation plant on the south side complex, which was the most advanced plant of its kind in the whole of Europe at the time. Barrow Colliery sent its first Fenton seam coal up the south side drift in April 1985 and it was envisaged that the drift's eventual capacity could be as much as 3 million metric tons. In 1980–81 the colliery turned a record breaking 1,225,486 metric tons.

In the early 1980s, after years of research by the NCB's scientific department, in a gigantic step forward in the worldwide race to burn coal efficiently and cleanly, the Grimethorpe Colliery site was chosen for the construction of a revolutionary test facility for a new pressurised fluidised bed coal burning boiler which would bring

greater output efficiency and the ability to burn poor quality, high sulphur coals and ash so as not to pollute the atmosphere. The United Kingdom joined forces with the United States of America and the Federal Republic of Germany under the remit of the International Energy Agency and funded the scheme equally to the tune of £20 million. The NCB's member for science, Dr Joseph Gibson, said that the Grimethorpe test facility was the biggest pressurised fluidised bed combustor in the world and that it clearly had a vital role to play in proving the technology and would lead on to establishing advanced, efficient coal burning for electric power generation and large scale industry. He believed the Grimethorpe Colliery complex could do no wrong and that its developments were moving on from strength to strength, being one of the most technological and productive units in the country.

After the 1984–5 miners' strike, the pit continued with its record breaking achievements and broke another record when, in 1986, the men of C64's face cut an amazing 10.3 miles of coal in one week from the Newhill seam. A team of eighty men working a three shift system between them completed ninety-two strips, which equates to 5.7 tonnes per man shift, 17,338 tons per week, beating the previous best by 3,411 tons. 1988 saw another record smashed when they hit 34,346 tons in one week. The pit went on to brush a European record on one side when it washed 180,000 tons of coal in one week at the south side coal preparation plant, also in 1988. The snowball continued to roll when, in 1989, the colliery produced in excess of 1 million tons for the first time since just before the strike. The pit manager said, 'We have the technology and the coal reserves, the ingredients for a successful future.' This was not good enough. October 1992 saw British Coal announce thirty-one pit closures with the loss of 30,000 jobs. Ten of the collieries were listed for immediate closure – Grimethorpe was one and worked its last shift on the 30th of that month. Over the last twelve years British Coal had spent an approximate £350 million on the complex, looking to further growth. The site had a good 75 million metric tons left in the bowels of the earth, and Grimethorpe made an operating profit of £750,000 at the end of its last financial year. In 1993 British Coal closed the fluidised bed research plant due to government backing being withdrawn, and 14 January 1994 brought the news that British Coal had announced the demolition of the fluidised bed research plant. The government showed its true colours and plunged a knife into the side of one of the country's most likely projects to bring million of pounds worth of income into the nation's economy. The Swedish company ABB Carbon, who had early involvement in the scheme, have since gone on to develop and build full-scale plants in Europe and the United States of America and boasts orders from Japan and Czechoslovakia. All this for a government hell-bent on putting the final screw into the coffin of the mining industry and denuding the nation of billions of pounds in the future economy. In typical fashion, now that the country is in an economic mess, everyone else gets the blame, but, as Aunty Margaret said, we must beat the enemy within! It must have been a big enemy for the nation to pay such a price.

Wombwell Main Colliery

Sir William Wombwell's estate agreed terms in the second half of 1853 for the lease of land whereby coal could be extracted at increasing rates for the first six years, and than increased to £1,200 per annum in the following years. The original lease was given to the Darley Main Company who, after original exploratory boreholes, decided that it could not go ahead with the sinking due to severe geological faults and water in the sub strata. However, sinking started in December 1853 and coal was reached in the Barnsley seam at a depth of 224 yards some ten months later in October 1854. The Wombwell Main Colliery Company was formed on 1 January 1855 and the first working lease was granted in November of that year. Two shafts were sunk and the Barnsley seam was found to be 7 foot 6 inches thick, eventually producing high-quality coking and household coals, known locally as 'Wombwell Hards'. Certain areas were producing from a seam thickness of 10 foot 6 inches. Contrary to the Darley Main Company's original fears, little or no water was encountered and geological faulting was virtually non-existent, allowing rapid progress.

By the 1870s, the pit was turning 1,000 tons per day and was able to sell every cobble, resulting in the best wages for miles around. As with all the collieries working the Barnsley seam, the risk of spontaneous combustion was extremely high, and as a result the colliery suffered a serious underground fire in 1882, which resulted in the pit having heavy monetary losses that lasted almost a full year. The third shaft was eventually deepened to exploit the Parkgate and Silkstone seams – the Silkstone seam being reached at 587 yards in 1884. In 1893, after the miners' strike, the colliery underwent considerable modification both on the surface and underground.

Due to the exceptional demand for coke from the local ironworks, the company installed two banks of coke ovens, which were unable to cope with the demand. By 1898, the colliery had now installed ninety coke ovens and not only did they supply the Sheffield ironworks but had expanded to such an extent as to be able to supply ironworks throughout the rest of South Yorkshire and into Nottinghamshire. The Parkgate seam was further developed and cutting machines were installed, which upped the output to 1,200 tons a day. The Thorncliffe, Fenton, and Beamshaw seams were developed at a later stage and by 1927, the colliery had 1,400 employees on the books. By 1945 this had dropped to 1,148 men, probably due to the loss in available manpower during the war years. 1949 saw the manpower rise back up again to 1,215, producing coking coal, gas coal, household and steam coals – the colliery was now the

fourth-largest in the No. 5 South Yorkshire area of the NCB. It went on coaling for another two decades without any serious problems until its final closure in May 1969, due mainly to dwindling reserves and difficulty in underground transportation.

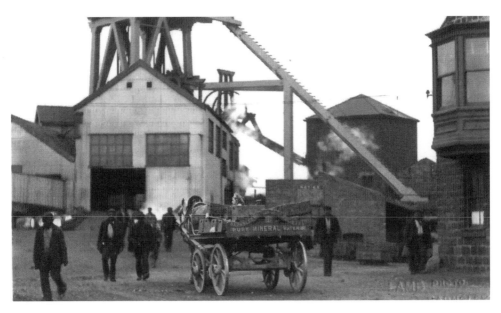

Barnsley British Co-operative making a delivery of mineral waters to Wombwell Main Colliery. (Chris at Old Barnsley)

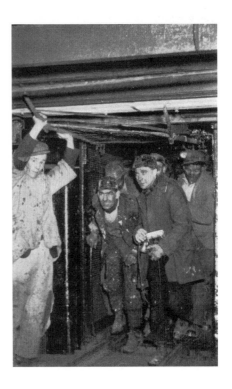

Leaving the cage at the end of shift. (NCB)

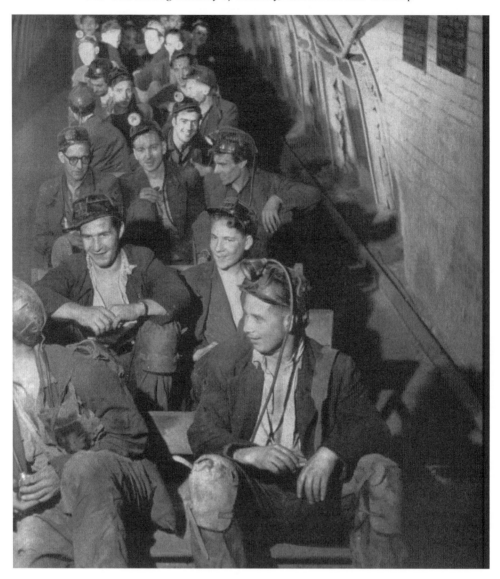

On their way to work on the paddy. (NCB)

18
Cortonwood Colliery

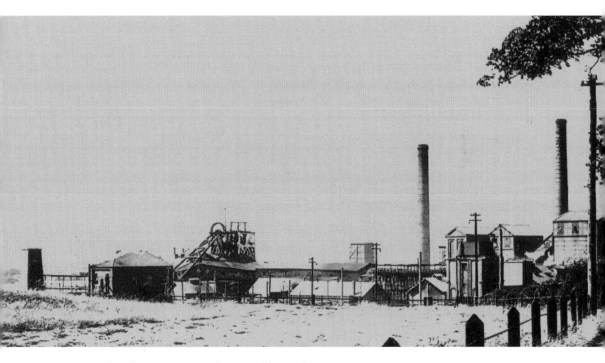

Cortonwood Colliery *c.* 1900. (Chris at Old Barnsley)

Brampton Colliery Company Ltd was formed in 1872 and in 1873 it sunk the two largest shafts in South Yorkshire. It became the Cortonwood Colliery Company Ltd and coal was reached in the Barnsley seam at 213 yards in 1875. The No. 1 downcast shaft was 20 feet in diameter and water from the old Meltonfield seam had to be stopped from flooding the shaft by means of inserting tubing to stem the flow. Both shafts were deepened sometime in 1907 to 506 yards to exploit the Parkgate seam. The company decided on a comprehensive modernisation scheme in 1908 and laid down new sidings, purchased fifty new regenerative coke ovens from Koppers of Sheffield, and built a new coal preparation plant. It was reported to have cost the company £50,000. The new plant installation was soon making money in the form of producing top-quality coke, benzole, tar, sulphate of ammonia and surplus gas,

making it one of the top performing by-products plants in South Yorkshire. Various shaft deepening projects took place over the years and in 1927 a major reconstruction was carried out at the colliery, to include the installation of electric winders, skip winding and a modified coal preparation plant.

Trunk conveyors were installed underground – the work was completed in 1935 and in the early 1940s both shafts were winding coal: Haigh Moor coal from the No. 1 shaft and Silkstone coal from the No. 2 shaft. In 1949 the pit employed 1,012 men mining coking, gas, household and steam coals. In the 1960s the colliery had yet another facelift to the tune of £1 million, which saw it through the next two decades into the 1980s, when it was now only working the Silkstone seam, producing coal for making coke. The steel industry did not purchase the coke due to a general slump in steel sales and the pit was forced to stockpile the fuel, accruing financial losses of £12 million over the last four years. On 1 March 1984 British Coal announced that Cortonwood Colliery was to close. The president of the National Union of Mineworkers, Arthur Scargill, had for some time been predicting the government's intention of closing the nation's coal mines in favour of nuclear power, their excuse being that the mines were uneconomical. The miners went out on strike on 5 March 1984 in a bid to save the pits and their livelihoods. Although the miners realised that this was no ordinary strike, they did not expect the depth of feeling that was fostered among them, or the effect that it would have on the lives of themselves or their families for the foreseeable future. The strike quickly turned into a bitter struggle between themselves, British Coal and the Thatcher government. Lives were lost and many miners were injured and arrested in some bloody confrontations with police forces, who were drafted into the coalfields from all parts of the country to disperse the picketing miners. The government was determined it was not going to have a repeat performance of the 1974 strike, when the Heath government was brought down, and used every dirty trick in the book to achieve their aims. Cortonwood Colliery was officially closed on 25 October 1985.

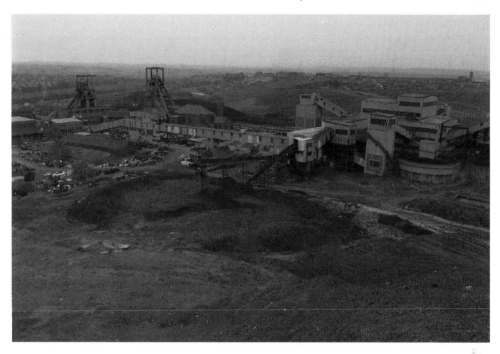

Cortonwood Colliery just after closure, February 1987. (Alan Hill)

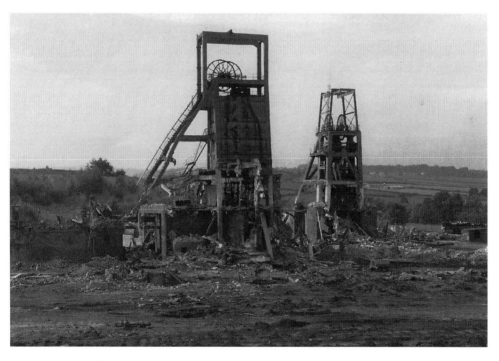

Cortonwood Colliery in ruins. The war-torn image of Thatcherism. (Alan Hill)

19
Wharncliffe Silkstone Colliery

Pilley village, midway between Wortley and Birdwell, approximately 4½ miles south-west of Barnsley, was chosen to be the site of the new Wharncliffe Silkstone Colliery. The company purchased the land from around the colliery site from the GNER company. Under the instructions of the Wharncliffe Colliery's management, the Derby-based company of mining engineers Woodhouse & Jeffcock commenced the shaft sinking operations in 1853 into the Silkstone seam and the colliery was opened and producing its first coal in 1854. The pit had only been open for four years when the mine owners decided on a 15 per cent wage cut due to a general depression and a slump in coal sales. The miners were incensed by this and a meeting was held in the White Bear Inn, in Shambles Street, Barnsley, on 10 April 1858. The men were led by Wharncliffe man Mr John Normansell, with whose assistance they formed the South Yorkshire Miners Association, who had their first branch at the Wharncliffe Silkstone Pit.

The colliery had four shafts in total: the No. 1 shaft was 151 yards deep into the Silkstone seam; No. 2 shaft was located about half a mile south and to a depth of 196 yards into the Whinmoor seam; No. 3 shaft was 90 yards deep and served the Thorncliffe seam; and the No. 4 shaft was first of all sunk into the Silkstone seam and then in 1889, was deepened to 220 yards into the Whinmoor seam. Around 1880, the pit was modernised and mechanisation was to follow some two years later in the form of compressed air operated coal-cutting machines, manufactured by Gillot & Copley, the machines first being patented in 1868.

Electrically operated machines were introduced in 1890, giving a marked improvement in production; by 1912 the colliery was generating its own electricity, making it even more efficient and cost effective. The colliery took advantage of this by bringing a further fourteen regenerative coke ovens on line and was able to further its electricity production from gas engine-powered generators, using waste gas from the coke ovens. This project was a great success, and as a result a further ten ovens were built. The colliery brick works was modernised in the late 1930s and began manufacturing roof tiles and other products allied to the building trade, which added to their further prosperity.

In 1914 the pit was employing 2,000 men and doing well; it was Whitsuntide of that year when an underground explosion, which was thought to have occurred as a result of a spark from a coal cutting machine, ignited an accumulation of gas that killed eleven men and injured four others. After nationalisation the pit became part of the north-eastern division South Barnsley No. 5 area of the NCB and was by this

time under the management of Mr F. Clayton and employing 1,097 men. A surface drift was driven into the Fenton seam and coal production was transported via this medium direct to the screens; the three remaining shafts were used for pumping and ventilation proposes. By the late 1950s, the colliery began its decline due to dwindling coal reserves, which were of poor quality. The colliery closed in January 1966 and the remaining coal was taken out at nearby Rockingham Colliery.

Next page:

Top left: Cresswell Colliery. (Peter Storey)

Top right: Kiveton Park Colliery. (Old postcard)

Second row, left: Firbeck Colliery. (Fred Brewer)

Second row, right: Manton Colliery. (Mike Eggenton)

Third row, left: Dinnington Colliery. (Ken Wain)

Third row, right: Shireoaks Colliery. (Mike Eggenton)

Bottom: Whitwell Colliery. (Old postcard)

Worksop Area Collieries

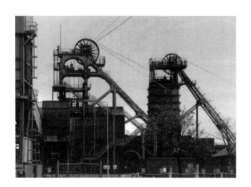

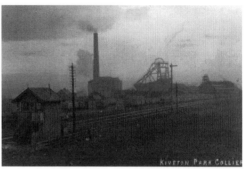

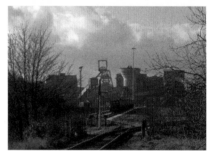

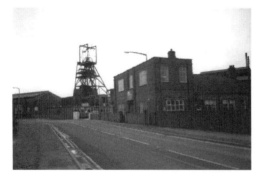

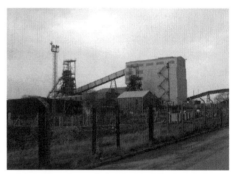

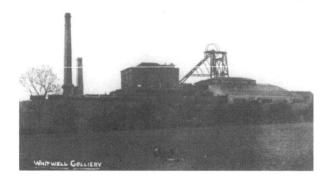

20
Kiveton Park Colliery

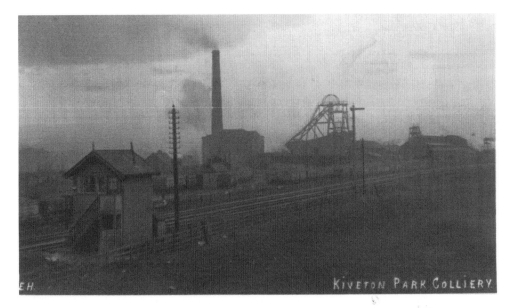

Kiveton Park Colliery. (Old Postcard)

Carrington & Company was registered in 1864. It was formed by Thomas Carrington, a mining engineer from Church Gresley, and thirteen businessmen, who between them started the company with a capital of £200,000. The company was soon to be known as the Kiveton Coal Company. The lease was granted by the landowner, the Duke of Leeds, and amounted to several thousand acres.

The company decided to sink two shafts into the Barnsley seam at Kiveton Park in 1866. 5 December 1867 saw the Barnsley seam reached at 400 yards. Coaling was started in 1868 and proved highly successful; 1870 saw the pit producing its own gas, and by 1872 over 100 houses had been built along with a hospital, a Co-op store, a Methodist chapel and a school for the miners' children. In 1873 the Kiveton Park Colliery Company was formed and took over the running of the colliery. Both shafts were extended in 1884, No. 1 into the Thorncliffe seam and No. 2 into the Silkstone seam. The Thorncliffe coal was fed to the colliery's coke ovens, which had been in operation since the early 1890s, and had a ready market with the local iron and steel producing companies. The colliery

was producing its own gas by 1870 and continued to do so until 1956, when it was obtained from the national grid. Coke ovens were built at this time.

A new shaft was sunk in 1886 into the Thorncliffe seam at a depth of 700 yards, but the venture proved to be uneconomical due to a dirt band running through it, making it inferior quality, and was abandoned ten years later. Another shaft was sunk beside the original shaft and they were coupled together to gain better ventilation by descending 700 yards into the Silkstone seam and passing through the High Hazels seam at 300 yards, which was opened up in 1900 to extract this valuable top-quality house coal. Poor-quality, dirty, Thorncliffe coal and the lack of other coking coals forced the closure of the coke ovens in 1895. My grandfather tells me he remembers the time when, in 1890, the High Hazels seam was tapped and he, along with other family members became part of the team who worked this seam. He recalls, 'The roof was bad and came away with the coal, and we had lumps as big as battleships, we had to put a shot in them to enable us to move them!' In 1906 new screens were built for the High Hazels coal due to it being good house coal and the power house was built in 1908.

The First World War started in 1914 and carried on for four years and as with every other industry at this time, manpower was at a premium because a good many of the men went as volunteers to join the war effort. Kiveton Park was proud of its men who joined up, but it left a big void in trained men and everyone had to pull together to achieve the extra production that was required to keep the steel works in Sheffield and Rotherham supplied for the production of armaments. After the war ended in 1918, a memorial was erected on the wall of the colliery offices in commemoration of the sixty-three Kiveton Park employees who were killed in action.

The pit was just getting back into the swing of things after the war and starting to put plans in place for the mechanisation of the colliery when it was halted by the 1926 strike. Gas production was stopped in 1926 during the strike, but never restarted due to a drop in demand. Kiveton Park was amalgamated with Sherwood Colliery in 1928. The colliery made a speedy recovery after the strike and was fully mechanised by 1929 and the manpower had risen to 2,244, with a saleable output of 21 cwts per man shift. A new steel headgear was erected in 1931 and things were at last beginning to look up. The welfare acts of that year and 1934 played a big part in ensuring the building of the pithead baths, a medical treatment centre and a canteen for the men between 1936 and 1938. Although Kiveton Park Colliery had its fair

The memorial in honour of the men from Kiveton Park who were killed in action during the First World War. (Ken Wain)

share of individual fatalities, it was considered lucky, due to the gaseous conditions in the lower depths of the workings, that it only suffered one serious explosion.

Five men were killed in a gas explosion while working in the High Hazels seam in 1941. It is thought that the explosion resulted from a fracture in a deputy's flame safety lamp, causing the ignition of gas. The men were listed as being Charles Bradford, Jonas Eames, William Eames, Frederick Hofton and Robert Walker. A pony that was working in the vicinity survived the explosion with burns.

The pit was taken over in 1944 by the United Steel Company, who ran the colliery until its nationalisation in 1947. The colliery became part of the NCB's Worksop No. 1 area, which had its headquarters at Todwick Grange; its manager was Mr J. Goulding who had a manpower contingent of 1,339 men, and the pit was producing household, manufacturing and steam coals at the time. 21 December 1967 saw the colliery's last two ponies, Duke and Taffy, brought out of the pit and into retirement.

Because of the pit's long life expectancy, the National Coal Board invested several millions of pounds into the colliery's infrastructure, bringing about several reorganisation schemes, both underground and on the surface. The steam winders were electrified, new screens were constructed along with new colliery sidings and more importantly the new surface drift was brought into use in 1977. The drift was christened 'The Jubilee Drift' in commemoration of the queen's silver jubilee of that year and was officially opened by Sir Derek Ezra, the NCB chairman at the time.

The colliery was now, after 101 years, a drift mine, the original shafts being used for the transportation of men and materials. Kiveton Park Colliery was often the scene of heavy picketing during the 1984 miners' strike. The police introduced a new tactic in using high-intensity searchlights, which were directed at the pickets, creating disorientation and confusion and preventing them from being able to see any activity beyond the lights when trying to talk to people approaching the colliery in the hours of darkness. Peaceful picketing turned into violent clashes between the police and the pickets, when, on the morning of 5 October 1984, 4,000 pickets were confronted by 2,000 police including riot squads and mounted police, ending in eleven men being injured and several being arrested. An episode in the colliery's history that would rather be forgotten, but which will live on forever among the local community.

During the forty-sixth week of the strike, miners had started to drift back to work in larger numbers and 150 miners staged a walk in at Kiveton Park during this week in January 1985, at the time when the NUM postponed its conference, which would have expelled the Notts area. NUM hopes of a peaceful settlement foundered the following week when the NUM refused to pledge in writing to discuss the closure of uneconomic pits. Four years after the strike, just before Christmas 1989, it was decided that Kiveton Park should join forces with High Moor Colliery, whose coal would then be brought to the surface via the Kiveton Park Jubilee surface drift. It was shortly after this time that £10 million was spent on developing further coal reserves and a new coal preparation plant to handle the large amounts of High Moor coal. Despite spending all this money and the fact that the colliery was sitting on millions of tons of reserves, the British Coal Corporation stopped production in September 1994. The colliery was mothballed and offered to the private sector, but no buyer could be found at the time and the pit

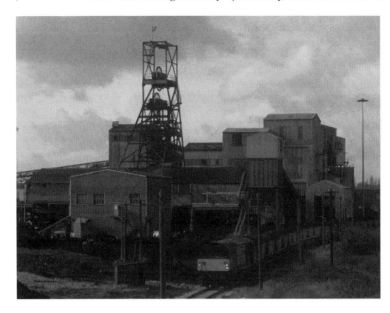

Kiveton Park Colliery. (Mike Eggenton)

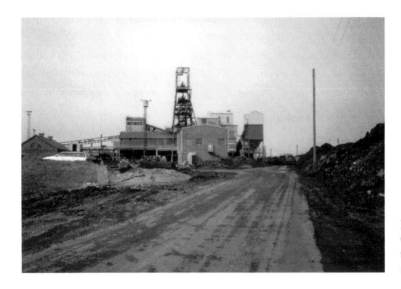

Kiveton Park Colliery just prior to demolition. (Ken Wain)

was capped and demolished in 1995 after 128 years of production. Kiveton Park was a major supplier to the Central Electricity Generating Board and worldwide export markets. However, now we are importing over 40 million tons every year.

During 2013 about 42 per cent of the nation's energy came from coal, despite all the talk about nuclear, solar and wind power. Only 5 per cent of this is from British mines – the remainder is imported from Columbia, Russia and the US. The government will not be satisfied until all the pits have gone, completing the Thatcher camp's closure plans. Then, and only then, will the country's isolation and dependency on foreign monopoly holders be felt. Our gas supplies are already being depleted at an alarming rate and we are already dependent on foreign supplies, which are demanding premium prices.

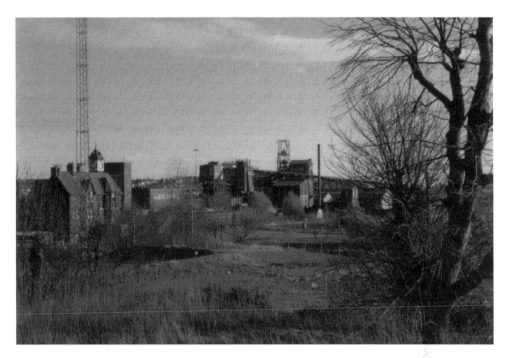

Kiveton Park Colliery just prior to closure. (Alan Rowles)

Kiveton miners' back-to-back cottages with outside toilets. Kiveton Station end. (Ken Holland)

All these terraced back-to-back cottages have now been demolished; a brand new modern estate has been built on the site for elderly people, along with a new community centre. (Ken Holland)

Kiveton Park Colliery offices in January 1995. (Alan Rowles)

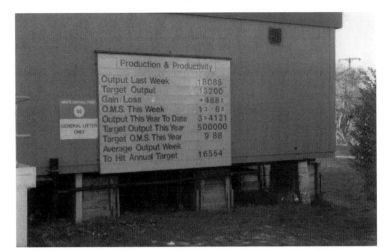

Abandoned
productivity board
just prior to closure
in 1995. (Alan
Rowles)

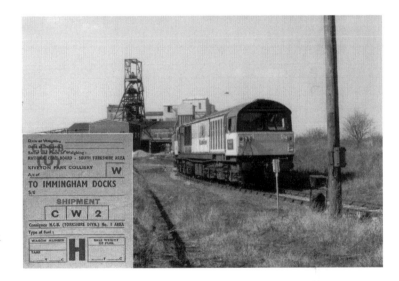

One of the last
coal trains to
leave Kiveton Park
Colliery. (Alan
Rowles)

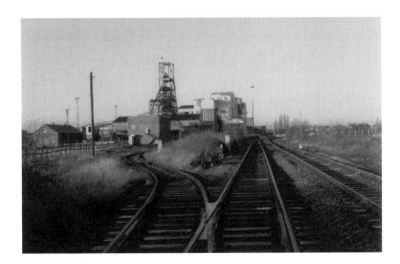

Waiting for
demolition. (Alan
Rowles)

21
Cresswell Colliery

In 1889 Mr Emmerson Bainbridge leased land from the Duke of Portland to mine coal from the Top Hard coal seam, taking in large areas of Derbyshire and Nottinghamshire. Creswell Colliery was sunk in 1894 by the Bolsover Colliery Company Limited to a depth of 445 yards and had two shafts, each 18 feet in diameter. It produced gas, household and manufacturing coals and was soon mining 3,800 tons per day, which was a world record at the time. The village at this time had a population of 3,000 people and in 1900 the colliery had a manpower contingent of 1,400 men, which by 1919 had risen to 2,000 men and boys, necessitating the building of the Creswell Model Village. 1,000 houses were built and the owners rented these to the miners for six shillings per week, free of rates, and supplied free coal and water; electric lighting was supplied as an optional extra for one shilling per week. The village boasted its own swimming baths and attracted children for swimming lessons from several different education authorities in the outlying districts.

In 1907 electric lighting was introduced into the pit, which gave a small improvement to visibility around the pit bottom area – better than the oil lamps at the time.

Ice Age cave at Creswell Craggs. (Ken Wain)

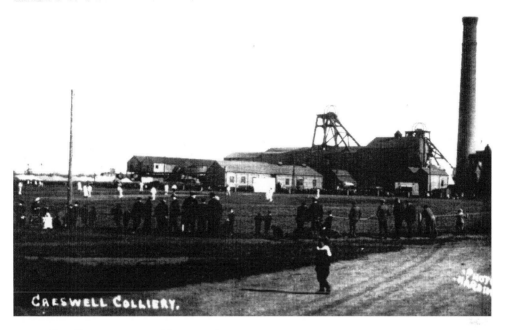

Creswell Colliery *c.* 1900. (Old Postcard)

The pit always stayed abreast with all the latest in mining technology and was known throughout the industry as a leader in things related to health and safety, being one of the first pits in the country to have its own safety department. Just two years after the nationalisation of the mines, Creswell Colliery became part of the NCB's No. 2 area East Midlands division. In 1949 the colliery was under the management of Mr G. Inverarity with 1,550 men on the books. It was Tuesday 26 September 1950 and I can well remember that I was nine years old, sitting in the kitchen having dinner with my grandfather, who had just come home from Kiveton Park Colliery after a shift down the pit, when a news bulletin came over the radio. 'Eighty miners feared trapped by underground fire at Creswell Colliery'. We got up from the table and sat in front of the coal fire with my mum and dad, huddled together, listening to this terrible news. Telephones were ringing in the background and people were shouting, but we eventually heard that a fire had started in a roadway leading to where the men were working, preventing them from escaping through the thick acrid smoke and flames. A conveyor belt had jammed at the No. 2 coal transfer point and it is thought that the friction from the rollers caused overheating of the conveyor belting, which consequently caught fire. My grandfather worked at a transfer point at Kiveton Park Colliery, cleaning up the coal that spills from the conveyor. Tears were streaming down his face as the story unfolded. Flames rapidly engulfed the roadway and travelled very quickly, due to it being a main air intake roadway, trapping the eighty men, all of whom were to perish from carbon monoxide poisoning. Mines rescue workers were drafted in from all over the coalfield and private individuals from all the local pits mounted a valiant attempt to try and rescue these unfortunate men – even one of their

colleagues who was still wearing a back brace from a previous accident went down the mine to offer his help, such was the camaraderie at the time. Sadly, eight hours late, it was stated on a poster at the pithead that it was now impossible to rescue the trapped men. The roadway was sealed off as the only means of starving the fire of oxygen. Out of respect, my grandfather did not work the following day, as was tradition at the time. The Top Hards seam was worked out in 1941 and at the time of the fire all the output was from the High Hazels seam, with 1,144 men working underground and 355 on the surface. It was agreed that the fire started at 3.45 a.m. on 26 September 1950. At the time, 232 people were underground, 133 were employed beyond the scene of the fire, and two left the district, leaving 131 in the vicinity. Fifty-one of these escaped via the return airway. The remaining eighty were certified as having died from carbon monoxide poisoning. The conveyor belt was 36 inches wide, of 7 ply construction with rubber facings. A 100 hp motor powered the conveyor, which travelled at 350 feet per minute. Twenty-four hours prior to the fire it was reported that the belt was scored – a maintenance fitter examined the belt and said that the belt was not cut, but a groove was found and it was about one third of the thickness of the depth of the belt. Nothing could be seen that would account for the grooving in the belt, and a full shift of coal conveying was carried out without any incident.

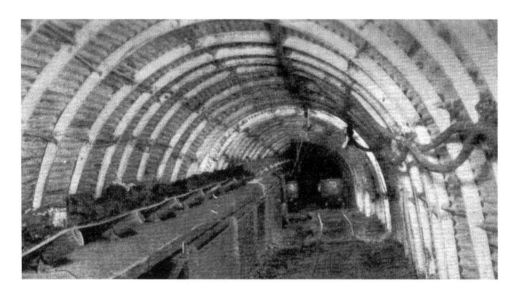

Typical coal conveyor in an underground roadway *c*. 1949. (Coal trades diary, 1949)

It was arranged for the maintenance man to stay overtime to repair the belt, but the overman instructed that it should continue to be used for the removal of some coal which had not been filled off from the previous shift. The belt was examined later and found to be grooved for about 200 yards. About 6 to 8 yards of the belt was cut through and the fitter could put his hand through the cut, but the belt was used yet again and it was reported that it was seen to have a 'trailing end'. One man

went further along the roadway to see if he could see the source of the tear which was causing the belt to trail, while a second man went towards the No. 2 transfer point ,where he encountered smoke and eventually found coils of belting which had been stripped off the conveyor, on fire in the metal chute. By this time other rescuers had arrived at the scene and attempts were made to extinguish the flames with portable fire extinguishers, but this was to no avail as some of the fire extinguishers would not work and the fire was not easily accessible. The water supply to the fire fighting pipe range was a negligible trickle due to connection problems and failed miserably. The 5-inch main was fed continuously from the Top Hard district pump during the night shift, but at other times it was fed from header tanks on the surface, via a set of operating valves through to the system. On the night in question, the Top Hard pump, for no apparent reason, failed to start at the beginning of the shift. The pump operator reported this to the overman and called for the assistance of a fitter – the pump operator and the fitter saw no reason to report this to anyone of authority on the surface, so nothing was done to adjust the surface valves to compensate for the loss in pressure, thus rendering the water main almost sterile. Conveyor systems should not be operated if fire fighting water mains are not maintained at sufficient pressure. It seems that the conveyor should not have been run after it was first thought that the belt was in need of repair, fire extinguishers were not maintained in a fit state for purpose and there was a lack of judgement in not informing surface officials to rectify the water supply situation to the main water supply for the fire fighting system. A sad state of affairs in what was a serious lack of competence, resulting in the deaths of eighty men.

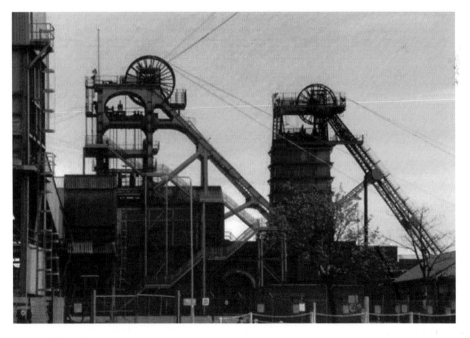

Cresswell Colliery. (Peter Storey)

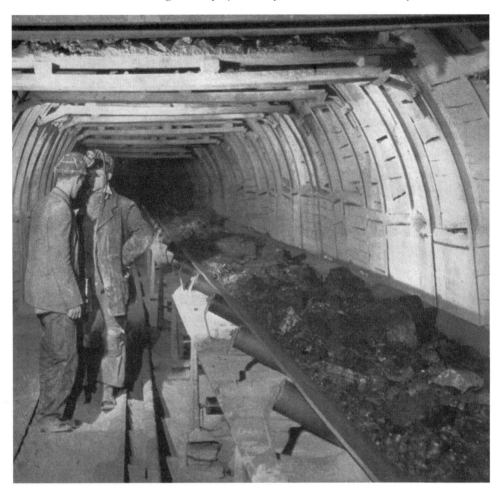

Two underground coal conveyors, the bottom photo showing dust suppression water jets in action. (NCB)

Investigations after the fire in September 1950 revealed that it was more than likely that a piece of iron stone was trapped in the No. 2 transfer point chute between the belt and the roller, causing the belt to be scored and eventually torn, this in turn leading to the belting catching fire from friction on the roller. Fire equipment was not fit for purpose, including the water supply to the fire fighting main. Three things came about as a result of the fire at Cresswell: Cresswell's telephone exchange was underground, meaning that communications were severely affected during the fire, so a ruling was made which meant that all colliery telephone exchanges would in future be located on colliery surfaces; the NCB also decided that with immediate effect, no employee under the age of sixteen would be allowed to work underground at any colliery under its jurisdiction; and a 'self rescuer' breathing mask had to be developed which could be used in an emergency fire situation to help the miners to breathe in contaminated air safely, by converting the poisonous carbon monoxide produced from the products of burning materials, into harmless carbon dioxide.

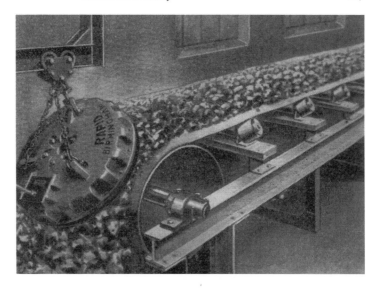

Electromagnet manufactured by RAPID of Birmingham, installed on screens above a coal conveyor to remove pieces of scrap iron and steel from the coal to prevent possible damage to the coal sorting machinery. These systems were not used on underground installations. (NCB)

Below left: Memorial stone at Creswell Cemetery. (Ken Wain)

Below right: Fully equipped underground fire station in the 1950s. (NCB)

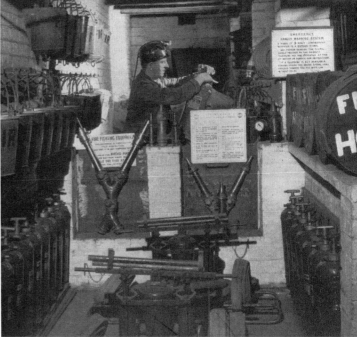

TO THE MEMORY OF		
WILLIAM ADAMS.	AGED	51
HORACE ATTENBOROUGH.	"	45
FREDERICK BARKER.	"	41
WILLIAM HENRY BIRD.	"	39
JOHN HENRY BOWDEN.	"	29
LEONARD BOWER	"	38
ERNEST BRIGGS.	"	33
JOHN WILLIAM BROCKLEHURST	"	44
ROBERT BROUGH.	"	36
ALFRED EDGAR BRYAN.	"	56
HERBERT STANLEY BUCKLE.	"	48
LEE JOHN BUXTON.	"	59
HARRY CLARKE.	"	46
SAM COCKING.	"	42
McDARA CONNOLLY.	"	28
GEORGE CHARLES COPE.	"	59
ALLEN DAVIS.	"	63
ERNEST DEAKIN.	"	60
ERNEST DODD.	"	37
JOHN DODD.	"	45
LESLIE DODD.	"	47
FRED DONCASTER.	"	27
JOHN WILLIAM DOXEY.	"	45
GEORGE ELLIS.	"	51
THOMAS HENRY EVANS.	"	50
CHARLES FOULKES.	"	49
GORDON FOX.	"	62
GEORGE WILLIAM GILLERT.	"	38
HARRY GODFREY	"	51
KENNETH AMOS GOUCHER.	"	42
PETER WILLIAM GREEN.	"	53
LESLIE HANCOCK.	"	28
JAMES ARTHUR HARRISON.	"	60
THOMAS HART.	"	39
COLIN HEMINGRAY.	"	25
CECIL HENDLEY.	"	34
REGINALD CHARLES HOLMES.	"	44
JOHN WILLIAM HUMPHREYS.	"	50
THOMAS WILLIAM HUNT.	"	51
ARNOLD HUTTON.	"	48

TO THE MEMORY OF		
JOHN THOMAS JACKSON.	AGED	58
ROBERT CHARLES JAMES.	"	52
EDWARD JOHNSON.	"	46
ERNEST JOHNSON.	"	36
REGINALD KIRK.	"	39
ALBERT LEWIS.	"	46
STEPHEN EDWARD LIMB.	"	55
JOHN HENRY LONDON.	"	48
WILLIAM JAMES LONDON.	"	51
ALBERT CECIL MALLENDER.	"	47
LESLIE MARSHALL.	"	42
WILLIAM MELLISH.	"	36
WILLIAM MELLISH.	"	55
EDWARD MILLWARD.	"	44
ERNEST LESLIE NEEDHAM.	"	44
JOHN EDWARD OLIVER.	"	53
WILLIAM HENRY ORVICE.	"	49
ERIC PARKIN.	"	36
ROBERT IDRIS PRICE.	"	34
ARNOLD LOFTIN ROBINSON.	"	29
KENNETH F. ROBINSON.	"	25
GEORGE SIDNEY ROGERS.	"	44
VICTOR ROSE.	"	52
LESLIE RUTHERFORD.	"	25
JAMES LEWIS SADLER.	"	41
THOMAS JOSEPH SENIOR.	"	42
THOMAS ARTHUR SEVERN.	"	46
JAMES SHAW.	"	56
HERBERT SHIPLEY.	"	38
THOMAS SMITH.	"	51
WILLIAM ERNEST STONACH.	"	36
JOSEPH TAYLOR.	"	42
REGINALD TEASDALE.	"	46
CAREY GERSHAM THORPE.	"	46
THOMAS TRAYLOR.	"	43
ROBERT WILLIAM T. WALKER.	"	38
COLIN CLIFFORD WARD.	"	30
GEORGE WASS.	"	37
ALBERT FREDERICK WHITLAM.	"	52
GEORGE YEARHAM.	"	57

Memorial to those killed in the disaster. (Ken Wain)

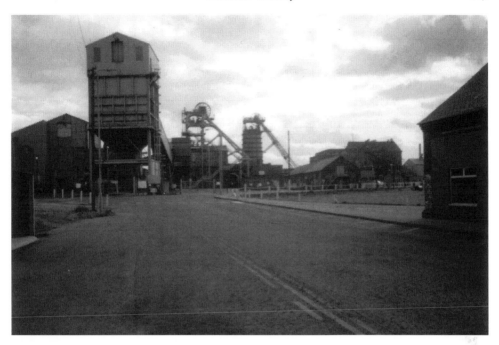

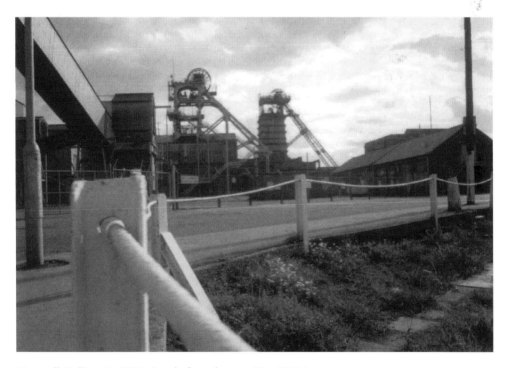

Creswell Colliery in 1991, just before closure. (Ken Wain)

22
Shireoaks Colliery

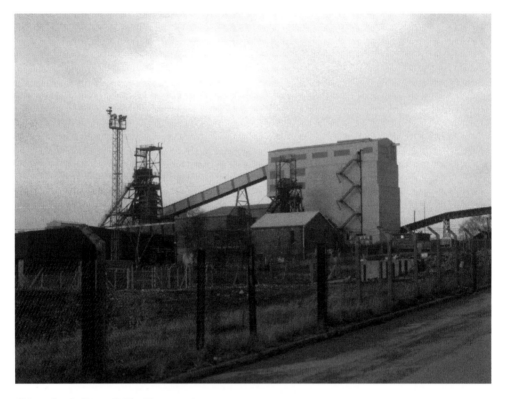

Shireoaks Colliery. (Mike Eggenton)

In the early nineteenth century, the owner and resident of Clumber House, Henry Pelham Fiennes Pelham-Clinton, the Duke of Newcastle, had an estate which enveloped a large part of North Nottinghamshire, including the town of Worksop and its surrounding areas. The duke financed and gave instructions for the sinking of two 12-foot diameter shafts into the Top Hards seam in Shireoaks, which was a small hamlet of only twenty-four cottages. This was commenced in 1854 and on 15 March 1855, twenty-one-year-old Thomas Thorne was killed when he fell down the shaft, and on 11 November Joseph Ward of Worksop was killed when a wagon fell down the shaft on top of him. There were only sixty men working at the colliery but

shaft sinking had soon progressed to a depth of 88 yards and had reached coal, but it was of poor quality so the sinking had to carry on. Problems arose when they hit water-bearing rock strata, which meant that the shaft had to be lined with cast iron tubbing to stem the flow. Up to the completion of the shaft sinking another six men's lives were needlessly lost during the operation, two when the cage over wound on 6 January 1857 and four individual accidents when men fell from poorly constructed platforms and plummeted down the shaft to their deaths. George Bennett and Henry Smithurst died in November of 1857, and Robert Whitworth in September 1858 and Thomas Peters in August of 1859.

The High Hazels seam was penetrated at a depth of 433 yards and on 1 February 1859 the shaft sinking had finished and had reached a depth of 510 yards, where a 3 foot 10 inch seam of good-quality Top Hards coal was found. Crowds gathered from Worksop and all the surrounding villages when the colliery was visited by the nineteen-year-old Prince of Wales in 1861, later to become Edward VII. He came on 18 October, St Luke's day, to lay the foundation stone of St Luke's church which the duke had commissioned from architect Thomas Chambers Hine at a cost of £4,000. The prince went on to visit the duke at Clumber House for few a days. In 1862, the duke won a gold medal at the Great Exhibition at Crystal Palace in London for his perseverance and success in such a great undertaking, for his insistence on continuing his search for the coal.

An inquest was held into the death of thirty-nine-year-old Jesse Webster in the Bull Inn, Worksop, on 17 November 1863. Apparently the deceased was working with John Stenton and George Lister on the 15th, widening a roadway, when John Tingle, the foreman, arrived on the scene and asked them if they meant to be killed, as they were working without sprags (roof supports). Webster sarcastically answered that he did not know, but if he was killed they would have spiced cake and ale and a slow walk to church. Lister told John Stenton to fetch some sprags, he got one fixed under, and was putting up another one when the roof fell in. The accident happened immediately after Tingle had warned them and all three of them were partially buried by the fall of roof, from which they were not released until nearly two hours had passed. The men had ignored rules which stated that sprags must be used at all times because they had tested the roof and believed it was sound. There were no excuses for not using them because they had an ample supply of timber and tools. In the presence of Mr T. Tylden, the colliery's manager, and the government inspector, Mr J. Hedley, Dr Williams of Worksop said that the body only had a few scratches and said that in his opinion the deceased had died from suffocation. On 17 November 1863 the jury returned a verdict of accidental death. The *Derbyshire Times* reported the accident as caused by extraordinary recklessness.

The colliery was well placed by the side of the Manchester, Sheffield & Lincolnshire Railway and found ready markets for its steam coal. The Shireoaks Colliery Company was formed in 1867 and had interests in the collieries at Steetley, Whitwell and Clowne. On 11 April 1871, thirteen-year-old Thomas Gee was run over and killed by tubs – he was the youngest person killed at Shireoaks – a shocking waste of a young life. Shireoaks employed 600 men at the time and the colliery company commenced with the building of five rows of houses for the miners.

When James Brindley's Chesterfield to Stockwith canal, which ran very close to Shireoaks Colliery, was completed in 1877, the Duke of Newcastle made an agreement with the railway company as owners of the Chesterfield Canal to put in a short link to the colliery to allow coal to be shipped to the River Trent at Stockwith. This was commenced immediately and a canal basin was formed where the coal was loaded onto barges for easy shipment. Coal was transported on the canal until 1949, when the railways expanded and gave easier access to customers. At the time of Queen Victoria's golden jubilee in 1897, John Clarkson was badly injured and was conveyed to the Sheffield hospital by horse and cart, quite a journey over rutted cart tracks and unfinished roads. This was regular practice at the time but local people had decided that enough was enough and they raised money to build a hospital in Worksop to serve the local communities. To commemorate the golden jubilee, the hospital was called the Victoria Hospital. In 1907 Shireoaks' output was approximately 150,000 tons. The Shireoaks Colliery Silver Band was formed in 1912, with twenty-two musicians at the time. It continued to work well and produced good-quality manufacturing, steam and household coal and in 1917 George Godolphin Osborne, the 10th Duke of Leeds, granted a lease to the colliery to mine coal from beneath his estate at North and South Anston and Thorpe Salvin. By 1923, under the management of Mr M. Walter, the pit was producing no less than 1 million tons per year with a manpower contingent of 933 – 717 underground and 216 on the surface. Ten years later in 1933, the manager was Mr R. J. Wilson and the manpower had dropped to 566 underground and 150 on the surface, but the colliery was still producing 1 million tons per year due to having installed compressed air equipment, which was used for coal production and underground lighting.

The colliery's production never dipped but the underground manpower dropped by another sixty-six men in 1940. The 1940 trades directory tells us that the colliery had the same manager and that electrical power had now been installed at an input of 3.3 kv (3.300 volts) – it was transformed down to a suitable voltage for machine operation, mostly 550 volts. This obviously had an impact on production but some of the men at this time enlisted for military service. In 1945 the Shireoaks Colliery Company was sold to the United Steel Company, and was taken over by the NCB after nationalisation in 1947, Shireoaks Colliery became part of the NCB's Worksop No. 1 area, north-eastern division. The manager at this time was Mr J. E. Waring, the manpower being 589 underground and 160 on the surface. The NCB saw the future possibilities for the pit and invested money into a modernisation scheme to bring it to the front in better equipment. The coal producing units were equipped with hydraulic roof supports, moving chain conveyors and the latest in coal cutting machines. 1952 saw the sinking of the Harry Crofts shaft in North Anston, which was to exploit the Dunsil seam and was to be coupled with the Shireoaks workings. In 1954 Shireoaks was used in trials for the Anderson Boyes 125 hp Trepanner coal cutting machines. The trials were very successful, leading to a new era in coal getting at the colliery. Steetley Colliery merged with Shireoaks in 1983 and Shireoaks Colliery was eventually closed in 1990.

23

Firbeck Main Colliery

Mr A. Woolaston-White had the Wallingwells Boring Company Limited put down bore holes on his Wallingwells estate, where they found coal in the Barnsley seam at a depth of 814 yards at varying thicknesses of between 4 feet and 8 feet. Firbeck colliery was registered in 1913 with a capital of £500,000. The Sheepbridge Colliery company of Chesterfield showed an interest and August 1916 saw the commencement of the shaft sinking operation for the Firbeck Main Colliery by the Doncaster Amalgamated Collieries Limited. The colliery site was at Langold village, near Worksop. The shaft sinking was completed in May 1925 to a depth of 826 yards into the Barnsley seam. Shortly after its opening and successful beginnings, the colliery was caught up in the 1926 miners' strike, after which it was soon back in production and was drawing copious amounts of coking coal, gas coal, manufacturing and steam coals, mainly for the industrial markets.

In 1923, Robert Whitehead, JP, was chairman of the board of Firbeck Collieries Ltd. By 1938 the owners were Firbeck Main Collieries Ltd, Sheepbridge Works, Chesterfield. The manager was J. Woodbridge and the under-manager was A. Vernon. They had a manpower deployment of 1,457 men working underground and 357 worked on the surface. After nationalisation the colliery became part of the National Coal Board's No. 1 Worksop area in the north-eastern division, with the divisional headquarters at Ranmoor Hall in Sheffield. The Chairman at that time was Major General Sir Noel H. Holmes KBE, CB, MC. By 1949, under the management of Mr J. T. E. Jones, the colliery was employing 1,855 men. It closed on 31 December 1968.

Nearby Firbeck Hall, which was built in the reign of Queen Elizabeth I, was modernised during the early part of the First World War when it was used to house several families of Belgian Nationals. The hall had several owners and in its heyday was an exclusive private country club and business man's retreat, said to have been frequented by Edward VII and other members of the elite society. It was eventually purchased by the Coal Industry Social Welfare Organisation (CISWO), who used it for a number of years as a convalescent home and rehabilitation centre for miners who had sustained injuries or illnesses at work. CISWO left the centre and it was closed in 1984. The hall was taken over by Rotherham Hospital, who used it as a physiotherapy and recuperation centre for a number of years. It was eventually sold to new owners and has stood empty for several years; it is now rapidly deteriorating after thieves stole lead from the roof and smashed internal fitments. It is a sad state of affairs for such a splendid building.

24
Dinnington Main Colliery

Dinnington Main Colliery had something of a chequered lifestyle, as during its lifetime it was owned by no less than three different owners prior to nationalisation in 1947. The Sheffield Coal Company originally laid plans for the sinking of the colliery, but lacked the necessary capital to complete the operation. They joined forces with the Sheepbridge Iron & Steel Company of Chesterfield and formed the Dinnington Colliery Company and sank two shafts to a depth of 667 yards into the Barnsley seam in 1903. The Colliery Club and Institute was built in 1908 by the colliery company. The coke ovens were commissioned in 1912 and continued to work for the next fifty years. The company became part of the Yorkshire Amalgamated Collieries Ltd in 1927 until its incorporation with Amalgamated Denaby Collieries Company Ltd in 1936. The pithead baths that were built in 1932 are now a grade II listed building and are earmarked for preservation. The colliery was finally taken over by the NCB on vesting day in January 1947.

As with Handsworth Colliery, Dinnington Main provided a healthy output of coke of some 4,000 tons per week, supplying the Sheffield Gas Company with about 30 million cubic feet of gas per week in the early 1940s – the gas coal fetching the highest prices. The colliery worked the Barnsley, Swallowood and Haigh Moor seams very successfully until the 1960s, when production dipped, causing the inevitable cash losses. Based on the colliery's past abilities of producing top-quality coking coal, the NCB spent more than £1 million in modernising the winding gear to electric winding and the coal preparation plant was significantly upgraded for preparing the coal for the outside coking markets in 1974. Coal was supplied to the British Steel Corporation's two local plants at Brookhouse and Orgreave, and at a later date to BCC Scunthorpe. This was proven to be a lifesaver for the pit and earned it healthy profits until the 1984 strike, when it suffered from poor maintenance causing rising costs. Costs became inhibitive and although Dinnington Main struggled on for a further six years after the strike, it was finally closed in September 1991.

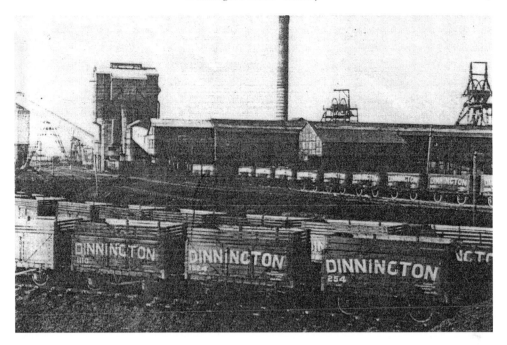

Dinnington Colliery in an old picture postcard, *c.* 1920.

Firbeck Colliery. (F. Brewer)

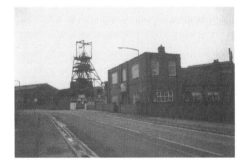

Dinnington Colliery. (Ken Wain)

25
Manton Colliery

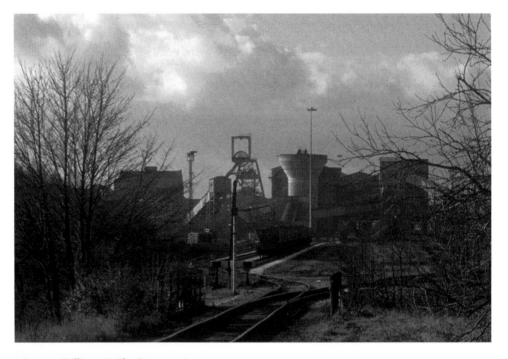

Manton Colliery. (Mike Eggenton)

Although Manton Colliery was strictly in the Nottinghamshire area, it was under the control of the NCB Worksop No. 1 area, which was later to become part of the South Yorkshire area, and as such provided employment for quite a few Sheffield area mineworkers and over the years it provided the steelworks with millions of tons of top-quality coking coal. In 1898 the Wigan Coal Corporation leased land from the Duke of Portland 2 miles to the east of Worksop and started sinking shafts into the Top Hard seam to a depth of 723 yards. The colliery went on to produce top-quality household, manufacturing and steam coals for many years. Just before nationalisation it was decided by the colliery's owners to invest more capital into the pit's infrastructure and sink its fourth shaft to exploit the millions of tons of coal reserves in the Deep Soft and Parkgate seams. After nationalisation on 1 January 1947, the NCB assessed

the colliery's future potential and went ahead with the company's plans. They sank the shaft to a depth of 911 yards into the Deep Soft seam and further extended down to 957 yards into the Parkgate seam, which made it the deepest shaft in Europe. Surface modernisation was undertaken and a new ventilation fan was installed, along with a new coal preparation plant on the surface. This made Manton the largest colliery in the Worksop area with a manpower deployment of 2,000 men, under the management of Mr F. Sharpe. An underground reservoir at Manton allowed the colliery to supply water to the local water authority, which was supplied to the local areas until the late 1970s. The Top Hard seam was closed in 1964 after sixty-six years of production.

The colliery was always producing excesses of methane gas, which was pumped to the surface and dispelled to the atmosphere; however, a scheme was devised whereby the methane excesses could be used for powering the colliery boilers. The £25,000 scheme was completed in September 1971 and resulted in a saving that at the same time released extra coal for the external markets. By the end of the 1974 miners' strike, the colliery was producing 900,000 tons with 1,380 men.

The whole of South Yorkshire's nineteen collieries, with a capital investment of £2 million, achieved an output of 11,780,000 tons with 20,000 men at the time. Further underground modernisation took place over the years, in the form of heavy mechanisation and the latest in technological advancement, to put the colliery in the top league by producing over 1 million tons of top-quality coking coal per year. At the time of the 1984 miners' strike, they were moving at a fair pace; the strike broke the momentum, but the pit was the first in the whole of South Yorkshire to return to full production after the strike and set plans to continue where they had left off, to get to the top of the league and keep ahead of the production targets. *Coal News* reported that Manton Colliery P45s Swallowood face team smashed another record in August 1987, when the extra long 274 metre face which was 2.3 metres high, produced 20,163 tons in one week, over 1,000 tons more than the area's previous best at Silverwood Colliery. Manton's next ATM face, P38s, would be producing shortly and had the same potential as P45s. The pit's second face, P41s, helped them to achieve a production of 26,000 tons and had the potential to mine a good 10,000 tons weekly.

Manton looked to be knocking the records down like skittles and with this kind of production it was set for a place in the history books. However, the British Coal Corporation in its wisdom closed the pit in 1994 as part of the Thatcher government's pit closure programme after providing years of wealth for the local communities and for the nation as a whole, while leaving millions of tons of prime coal locked away in the bowels of the earth. Now that gas and electricity prices have rocketed and during the cold snap of March 2013, it looks very bleak when the country is threatened with gas rationing. Mining methods and clean burn technologies are in place, along with the new carbon capture schemes – coal can be cheaper and cleaner. French company EDF is about to be given the go-ahead to build another nuclear power station, completely forgetting the disasters of Chernobyl and Fukushima. Nuclear waste from decommissioning these installations is to be left to future generations to dispose of.

Manton deputy Terry Ward, with machine drivers Terry Bloomer and Chris Parrot on P45s face. (*Coal News*)

26
Whitwell Colliery

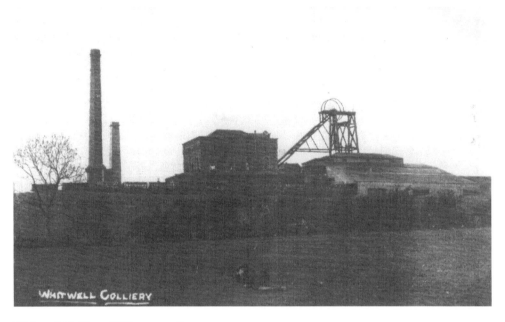

Whitwell Colliery. (Old postcard)

The Shireoaks Colliery Company Ltd arranged for the Duke of Portland to perform the ceremony of cutting the first sod to facilitate the sinking of the shafts for Whitwell Colliery, on Saturday 24 May 1890. The opening day was a big success; a marquee was put up on Whitwell Common and the duke ensured that the event was a colourful occasion by having his head gardener decorate it with flowers from his estate. Speeches were made by local dignitaries, and Canon Mason spoke of his high regard for the miners. The master sinker, Mr Aaron Barnes, had a team of twenty-two men working in the shaft for fifteen months until coal was eventually reached on 23 October 1891 in the Top Hard seam at 311 yards. Tubing was used to control the ingress of water at about 200 yards deep. The High Hazels seam was located at 431 yards. A roadway was driven from the bottom of the shaft to link up with Steetley Colliery, which provided the means of efficient ventilation of the colliery. The total

cost of the shaft sinking and the drivage of the roadway was approximately £39,000 and coal production commenced in April 1894. Double-decker cages were installed at this time to cope with the extra production. The sinking of the No. 2 shaft started in October 1896 and coal was reached fifteen months later in the Top Hard seam on 15 March 1898. The new No. 2 shaft then became the upcast shaft, to take the foul air from the colliery workings, while the No. 1 shaft was the downcast (air intake shaft), which now ventilated the workings at the collieries. Coal was mined from the Top Hards seam, which was well reputed for its steam raising qualities, at a time when the railways were just beginning to come onto the scene, ensuring the colliery a ready market. At this time the coal was hand got by pick and shovel and the miners shovelled the coal into tubs to be taken to the pit bottom by a team of pit ponies. The ponies were also used for taking the supplies back to the workings (mainly timber).

An Act to ensure the welfare of the ponies was introduced in 1911, but as with the colliers themselves, they were sometimes involved in unfortunate accidents. In 1917 a pony died when it fell from a cage at Whitwell Colliery. There was an over-wind accident at the colliery that involved a pony being suspended in the headgear when the cage was over-wound. Fortunately, the pony escaped without serious injury. The colliery went on to work coal in the High Hazels, Clowne and Two Foot seams.

Production was seriously affected during the strikes of 1921 and 1926 and police were called to keep order at the pit gates due to bad blood between the miners and the management. The miners and their families were suffering deprivation and near starvation. After the 1926 strike finished the pit got off to a good start and things were looking good for the future but, alas, in May and June of 1928, a total of twenty-nine working days were lost, leading to lay offs and the men having to sign on to the dole. A slump in the coal trade led to 400 men and boys being given their notice only one month later. During 1928–29 a power house was built for a new turbo alternator and the first electrical supply cable was laid in the No. 1 shaft. Compressed air was gradually phased out in favour of electrical power, although air was still used for some operations until the late 1930s. Better conditions and working methods meant that the Top Hard seam was exploited to great advantage, and the colliery achieved an output of almost 4 million tons between 1930 and 1942. 1934 saw the purchase of the colliery's first electrically operated coal-cutting machine, manufactured by the Sullivan Machine Company. The High Hazels seam was working in 1935 and continued to be a good producer in two areas of No. 1 pit and two areas of No. 2 pit until 1976. The pithead baths were opened by the 6th Duke of Portland on 26 June 1935, at a cost of £17,000. In 1942 a fire swept through the fan house, which caused it to be converted to electricity from steam due to fire damage.

Coal-cutting machinery was gradually introduced throughout the pit during the 1950s and mechanised steel conveyors were used on the coal face, which fed the coal onto belt conveyors to be transported to the pit bottom. In 1958, major reorganisation took place on the surface, entailing the installation of skip winding, refurbishment of the washery and screens, along with a new medical centre, rescue room, fire station and lamp room. The pit underwent reorganisation between 1956 and 1961, which meant that all the coal tub haulage systems and belt conveyors were replaced by new trunk conveyors for much speedier transport of the coal direct to the pit bottom. By 1968 the High Hazels seam

was close to being worked out and two drifts were opened out into the Clowne seam; they started production in 1976 and worked until 1985 along with the Two Foot seam. At the end of the miners' strike of 1974, the manpower at Whitwell Colliery had risen to 1,000 men and the colliery was then producing 550,000 tons per year. The NCB invested £1 million into the colliery at this time and it worked well until, as with all the other pits in the Thatcher government's pit closure programme, the miners' strike of 1984–5 and the continuing heavy losses at the colliery made its closure a forgone conclusion. A local press report put the colliery's losses at £8 million over the last year and the NCB issued a statement on 8 June 1986 that coal production would cease at the end of June.

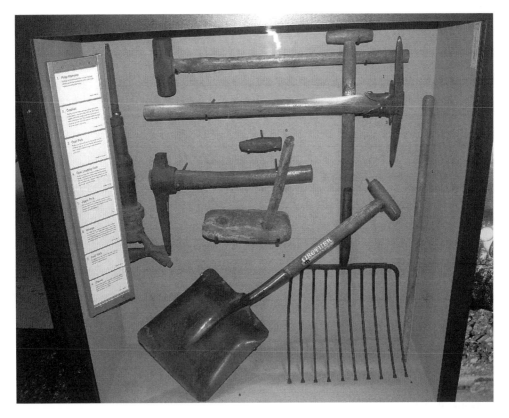

Old miners' tools on display at the National Coal Mining museum. (Ken Wain)

Fred

Av' dodged them stoo'ans, thrown bi yore
Clammed fer snap wi mates galore, Lost mi missus – poor owd lass!
Just pegged art – too much gas.
Mi eye sight's gone en am none too sharp.
Es fer pinchin snap, av just lost art.
Nah fer mi matin', av lost mi zest – May as well admit it: am just as pest!

Ah lucked around en up en darn gate, Maybe a trick from sum werkmate. No trace or sign or running tread.

Just me and lamp—en pit mouse Fred. On back legs stood, he neatly bowed, Sez Fred: 'Owd cock, Am gerrin owd, Mi legs ev gone! Am skin en boo'an

En that last fall es wrecked mi hoo'am.'

Av watched mi kids feight over bread,

Lost em all, enough sed.

Lived in man –oils coal and rock, Always flittin mi owd cock. Followed yore in search o'grub,

Lost hafe mi tail thru a runaway tub. Laft at yore when yer've tried to tees mi frum mi oil wi a lump a chee'as.

Ah saw a mouse sat on some muck On open ground he chanced his luck Hi lucked an owd 'un, whiskers white En didn't budge from ray of light.

Hi rubbed his noo'as en lucked at me En spoke es human, yes! did he 'Dun't be freetened', he just sed.

Am nowt burr a mouse, en mi name is Fred.

Du me a favour – its not a sin –

Tek mi up pit in thi snap tin.

Am redy for goo'in, mi time is near,

Dun let me dee en bi buried darn heeah,

Ar picked im up gently but ar new he were dead, So ar tuk im up pit,mi pit mouse Fred.

Ar placed him in't garden mid rose bush ser neat, En ar rote on his gravestoo'an:

'Hi never saw dayleete.'

Benny Wilkinson

Eighty-seven-year-old Benny Wilkinson lives in Conisborough and he was a pony driver at Manvers Main at fourteen years of age. He served in the Second World War, worked as a steel erector, and had twenty-two years at Yorkshire Main as a methane borer. Benny started writing poetry for his own pleasure, but was soon recognised by his family and friends as having this unique ability to transform his experiences into poetry in local dialect.

Benny became famous in his local community and the word spread, giving his poetry worldwide acclaim. I met Benny at Denaby during the commemorative ceremony and unveiling of the memorial to the ninety-one men and boys who perished in the 1912 Cadeby Colliery disaster, when he read out his poem 'The Memorial'. He gave me permission to reproduce it and the one entitled 'Fred'. Benny went on to tell me that he had written more than a thousand poems and that he had done quite a lot of work for charity, including donating some of his poetry, stand up comedy and several money-raising stunts along with his friend Peter Finnegan from Bolton on Dearne, who was chained underground for a week to raise money for the Bluebell Wood Children's Hospice at Dinnington. Some of Peter's poetry is also used in this book. Benny told me that he had written a poem for Her Majesty the Queen to celebrate her diamond jubilee, and that Her Majesty had just written to thank him for his gesture.

Rotherham Area Collieries

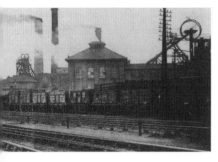
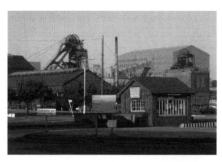

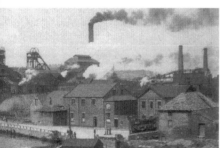

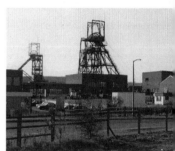

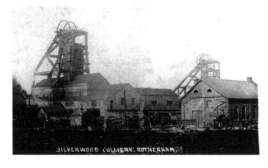
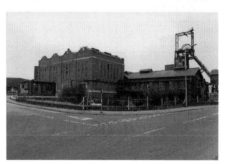

Top left: Aldwarke Colliery. (Chris at Old Barnsley)

Top centre: Thurcroft Colliery. (Mike Eggenton)

Top right: Maltby Colliery. (Ken Wain)

Middle left: Rotherham Main Colliery. (Old Postcard)

Middle centre: Treeton Colliery. (Ken Wain)

Middle right: Kilnhurst Colliery. (Alan Hill)

Bottom left: Sliverwood Colliery. (Old Postcard)

Bottom right: Manvers Main Colliery. (Alan Hill)

27
Thurcroft Colliery

Thurcroft Colliery. (Mike Eggenton)

Thurcroft Colliery was the last colliery to be sunk by the Rothervale Colliery Company, in 1909. Two shafts were sunk to 744 yards and 667 yards respectively and into the Barnsley seam; coal was eventually reached in 1913 due to an almost vertical drift having to be driven to the coal because of a severe fault encountered during the development. By 1918, production had reached a healthy 172,817 tons per annum.

Thurcroft was joined underground to Treeton until 1970, when it was sealed due to an underground fire. The United Steel Company took over operations from the Rothervale Colliery Company in 1921 and built a large coking facility near to the pit. A large proportion of the coal production and all coke was used in the company's own steel works, securing work for the colliery, which was by then employing 2,000 workers and producing in the region of 505,000 tons per annum. The pit's output

peaked at 622,232 tons in 1923. In 1942 the Parkgate drifts were opened up to gain more top-quality coal. By 1949, after nationalisation, the workforce had fallen to 1,620 men, under the management of Mr C. Smith. During the 1970s the Haigh Moor seam opened up and the Parkgate seam was abandoned in 1972, after thirty years of production.

Shortly after this, extensive reorganisation took place, which brought the colliery in line for a further £3.2 million investment programme, announced by Sir Derek Ezra in 1977. By tapping into the Swallowood seam, the colliery's coking coal output would be boosted to almost 500,000 tons and although the colliery performed to all expectations, British Coal had envisaged losses approaching some £15 million by the end of the 1990s. This, combined with what British Coal described as insurmountable geological conditions, resulted in its closure in December 1991. It was estimated that at this time, the colliery had in excess of 20 million tons of reserves and a workers' consortium, along with Rotherham Council and several mining constituency MPs tried to take over the running of the colliery. The British Coal Corporation withdrew its offer due to the consortium not being able to finance the pit's maintenance during negotiations and sealed the shaft.

Just three months prior to its closure, on Tuesday 3 September, the colliery suffered another setback when seventy-one miners were going to their places of work on a conveyor belt travelling at 5 mph and the conveyor suddenly started to pick up speed due to a faulty gear box, reaching speeds of 40 mph. Panic set in and lots of the men jumped off the conveyor, which resulted in many of them sustaining injuries from cuts and bruises to more serious injuries such as twisted and broken limbs and concussion as a result of crashing into girders and roof supports. A whole fleet of ambulances took forty-one of the casualties to the Rotherham General Hospital. An investigation was carried out by the mines inspectorate and British Coal. It was reported that a British Coal spokesman remarked that there was no danger and no one was trapped. Even though the safety standards in the mines had by now reached a much better level, there were still to be the inevitable serious accidents, which were endemic to the mining industry.

The Markham Colliery disaster of 30 July 1973 was to take the lives of eighteen miners and injure eleven others. Houghton Main Colliery near Barnsley suffered an underground explosion, killing five men, on 12 June 1975. An underground diesel train was derailed on 21 November 1978, killing seven men and injuring nineteen others at Bentley Colliery near Doncaster.

Thurcroft Colliery. (Ken Wain)

28

Greasborough Colliery

Greasborough Colliery, near Rotherham, was in operation towards the later part of the nineteenth century and provided employment for about 250 men and boys. The coal was reached at 42 yards and good-quality Parkgate steam coal was produced. The pit had a poor accident rate, including many fatalities mainly brought about by poor working practices. Four men were critically burned in a gas explosion as a result of using open candles as working lights. Two of these were to die due to the extent of their injuries. Ironically, although the colliery was doing particularly well, it was closed 'at the drop of a hat' so to speak. Earl Fitzwilliam had, in his wisdom, decided that it was no longer his desire to lease coal from under his land. The pit was closed, the pit chimney and headgear were pulled down and the equipment was sold. The manpower, by which this time was approximately 150, were left without work or compensation. Such was life at this time and it was against normal Fitzwilliam practice. It seems to contradict to logic that the earl continued with the mining of iron and coal in nearby areas for many more years to come.

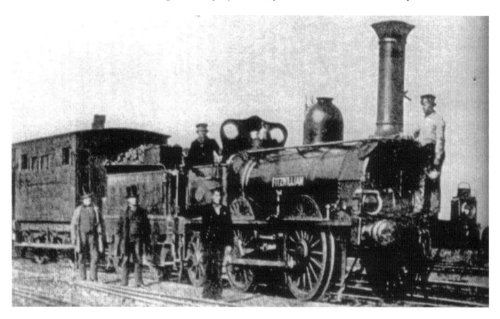

The locomotive *Fitzwilliam* was manufactured by Dodds in 1849 for South Yorkshire Railway Co., to be used on Earl Fitzwilliam's Elsecar branch line for hauling coal from his pits until in 1854 it was used for a passenger service from Barnsley to Sheffield. South Yorkshire Railway Co. was taken over by the Manchester, Sheffield & Lincolnshire Railway in 1864 and the engine was retired in 1871. (Sheffield Newspapers)

Aldwarke Main Colliery

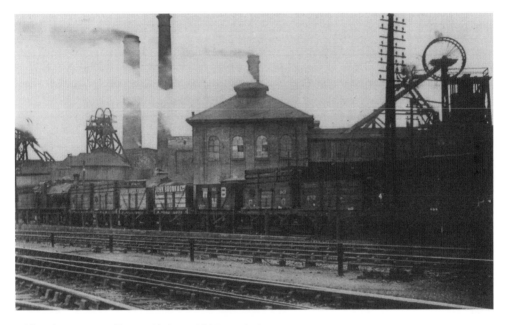

Aldwarke Main Colliery. (Chris at Old Barnsley)

Aldwarke Main Colliery, at Parkgate near Rotherham, was sunk by Waring & Company in 1862; the colliery had two shafts only 40 yards apart, sunk to a depth of 150 yards into an 8-foot-thick seam of Barnsley Bed Coal. Mainstream production commenced three years later in 1865 and after only eight years, in 1873 the pit was taken over by Sir John Brown & Company of Sheffield along with nearby Carr House Colliery.

In early January 1875, an explosion occurred at the colliery, killing seven men. The blast from the explosion had blown down material from a support buttress and buried the men. Rescuers trying to reach the men were prevented by the sheer volume of gas from reaching them. Previous tests were said to have found no gas in the area and the pit was always previously thought to be relatively gas free. The coroner recorded a verdict of 'accidental death' and recommended that more deputies should be employed and that the use of naked lights should be abandoned and that

safety lamps should be introduced, which the owners said they would carry out with due haste. Within four years of acquiring the colliery, the company had deepened the shafts to 217 yards in the Swallowood seam and sunk two further shafts to 405 yards in the Parkgate seam. This was later to be taken down further into the Silkstone seam at 494 yards. Vast amounts of coke and by-products were manufactured at the colliery from its 120 beehive type coke ovens. The colliery supplied its own Atlas Iron and Steel Works in Sheffield. The Atlas works were manufacturers and suppliers of iron and steel products to the mining industry. The iron and steel making industries in the Sheffield district expanded rapidly from the mid-eighteenth century and throughout the nineteenth century. Obviously, the demand for coke increased at the same rate, absorbing all the production from the larger local collieries like Aldwarke, Sheffield Nunnery and Barrow near Barnsley.

Advertising company products at the end of the nineteenth century left a lot to be desired, but the John Brown Company pulled off a first when on 14 June 1883 they entertained local gas institute members to a banquet which was actually served underground, in a main roadway in the Parkgate seam. They even went to the lengths of having an orchestra in attendance, the likes of which has never been seen since, but although it was not an orchestra, the Cresswell Colliery band did play underground sometime in the early 1970s. Larger collieries were sunk into the deeper seams of steam and coking coals during the 1860s and for the next two decades or so, to cater for the greater demand as a result of the evolution of the steelmaking plants which were springing up throughout Sheffield and district, two further shafts were sunk due to the distance to travel into the new coal reserves. The shafts were put down some 2½ miles from Aldwarke Main at Warren House: the first was in 1893 to the Parkgate seam and by 1899 the company were employing 4,500 men in their collieries; the second shaft was sunk in 1908 to the Swallowood seam; both these shafts were being used for man riding and ventilation purposes.

Electricity was introduced into the colliery in 1907, at about the same time the Royal Navy began to phase out steam powered vessels in favour of diesel engines. This was the thin end of the wedge for coal on the high seas. The *Sheffield Daily Independent* trade review of 31 December 1924 stated that the coal market was favourable and with an increasing output and higher prices, colliery owners could look forward with confidence. However, there was a fly in the ointment in that the railway loco men went on strike and in January this caused considerable dislocation to colliery working and distribution, but fortunately it was short lived and the coal industry entered into a period of prosperity. The demand for home supplies was steady, and with a good export trade, the output from the pits was readily absorbed at profitable prices. Yorkshire Best Hards sold on the home market at 22s 6d-23s 6d per ton. Export prices were 28s to 28s 6d per ton. Best house coal was 30s 6d to 32s 6d per ton. Output slowly increased and by June the prices had risen on the home market to 23/- to 24/-, but to keep the export market happy the prices were dropped by 6s per ton and house coal dropped by 2s per ton. The wagon makers were full of orders and as a result prices advanced to a figure that was prohibitive. 12 tonners were being quoted at as much as £180 each. The coal trade did not have a very happy

time during the last half of the year, from July onwards, and the record was one of constantly falling prices. With home users working short time and the export demand very slow, it was a daily struggle to keep the pits working and the sidings clear of stocks. December was no better and Christmas was very bleak.

Aldwarke Main went on to turn coal from the Parkgate, Silkstone and Swallowood seams and it was estimated that by 1932 the colliery had put in excess of 35 million tons of coal into the nation's economy. Aldwarke Main was taken into the NCB's north-eastern division Carlton No. 4 area after nationalisation. In 1949 it employed 1,338 men under the management of Mr N. Irving. At this time the colliery was producing coking coal, gas coal, household and steam coals; however, by the late 1950s it was realised that the coal mining operation had started to lose money as the coal seams became exhausted and the colliery closed at the end of June 1961.

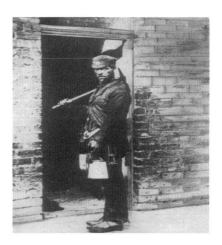

Miner posing for the camera outside his home, *c.* 1900. (Author's Collection)

30
Treeton Colliery

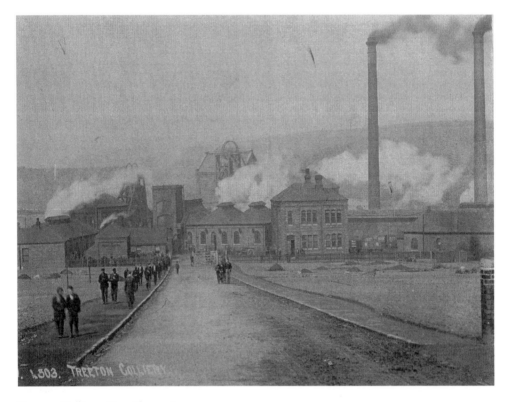

Treeton Colliery. (Ben Clayton)

The first sod was cut at Treeton Colliery on 13 October 1875 by Mrs Jaffray, wife of the director of the company. The colliery commenced operations in 1877 under the management of a canny Scot by the name of Ormiston. It had two shafts, one of which had two levels: one into the High Hazels seam at 711 feet and one into the Barnsley seam at 999 feet. 830 men were employed underground and 208 on the surface.

The colliery, under the new management of Mr W. Baxter, did well in its first year of production and then came upon bad times, with temporary closure in September 1878 and lay-offs as a result of a general decline of trade within the industry, but by 1880 the coal trade had picked up and the pit bounced back into full production

and by 1882 played a major part in the local employment scene at that time by its on-going development. This was at a time when electricity was used for the first time underground at Trafalgar Colliery in the Forest of Dean to operate a pump, and fifteen years later, electric street lighting was installed in Treeton village, the power being supplied from the colliery dynamo – the installation cost £200 and Treeton was the first village in the country to have electric street lighting.

The recession of 1883 meant that the colliery had to be closed yet again until a national economic recovery breathed new life into it. In 1891 the population of Treeton had risen to 1,000 and at this time there were 240 coal mining companies that between them owned 374 collieries in South Yorkshire alone. In 1898 a Washery Plant was installed at the pit. The new managing directors, the Jones family of Treeton Grange, were more benevolent than most of the coal masters and by 1905 had erected 400 houses for the use of their employees. In 1910 compressed air coal cutters were introduced into the colliery and revolutionised the way in which coal was mined for the foreseeable future and, through the efforts of all concerned, production had reached almost 250,000 tons by 1918, when the pit became part of the United Steel Companies Ltd. By 1913 two steam-driven turbo generators were installed to supply the colliery's power requirements and the original dynamo was donated to Sheffield University sometime in 1924.

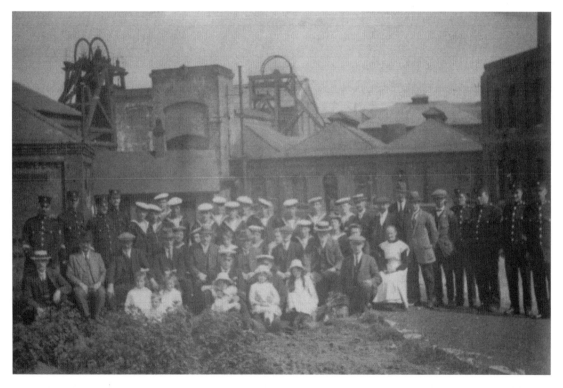

Celebratory photograph in Treeton pit yard, believed to be for the homecoming of the servicemen from the First World War. (Ben Clayton)

PLOWRIGHT BROS. LTD.
ENGINEERS

Telegrams :
"Plowright" **CHESTERFIELD** Telephone :
3266 (4 lines)

Production and usage figures worthy of note at this time are as follows: total known coal production for the world, excluding Brown coal or Lignite was 1,100 million tons in 1912 and 1,250 million tons in 1913, as compared with ten years previously in 1903 at 800 million tons. The Royal Commission on Coal Supplies' final report in 1905 gave an approximate figure for British consumption in 1903 as follows:

Factories	53,000,000 tons	32%
Mines	18,000,000 tons	11%
Domestic	32,000,000 tons	19%
Iron and steel industries	28,000,000 tons	17%
Other metals and minerals	15,000,000 tons	9%
Gas works	13,000,000 tons	8%
Railways	5,000,555 tons	3%
Brick works, potteries, glass works, chemical works	2,000,000 tons	1%
Total	166,000,555 tons	100%

The UK's production in 1912 was 260 million tons, which was 23.6 per cent of the world's production – the manpower was 1,069,000, equating to 660 tons per man. The UK exported 67 million tons in the same year, approximately 25.8 per cent of the world's production. Ironically, the British mines at this time were estimated to be consuming some 20,500,000 tons per year for the production of motive power to keep the wheels turning. UK production in 1913 was 287,430,476 tons, of which Yorkshire and North Midlands jointly produced 72,951.841 tons from 635 collieries.

The 1921 and 1926 strikes caused major setbacks for Treeton Colliery but because of the company's other interests in its iron and steel works in Sheffield, Stocksbridge, Frodingham, Wellingborough and Workington, there was a ready market for all the coal it could produce. Treeton's output at the time of nationalisation in 1947 was 338,000 tons with 1,118 men, as compared to 1971 when it produced 650,000 tons with 850 men, which amply illustrates the greater reliance on advanced mechanisation during this time of on-going industrial revolution. Although millions of pounds were to be invested into the colliery by the NCB in building a surface drift for quicker transportation of the coal to the colliery surface, it became evident that due to the miners' strikes and the influence of the ugly head of politics, the pit was not to be part of the now limited life of the industry, even though it was argued that a further capital

investment to develop another coal seam would have proved to be a real earner for local employees and the country as a whole. After the 1984 strike, as at many other collieries, relationships were strained between men and management; the management wielded the iron fist and although there were general all-round improvements in this direction over the following years, British Coal said that coal reserves were dwindling and further investment was not forthcoming.

In 1987 Bob Horton, the area Director, had already put in the thin end of the wedge and announced that single face working and a reduction in manpower by 180 to 450 was the only way forward. By the time of the pit's closure in 1990, the output had now dropped to 291,599 tons. The colliery site was soon to be cleared and returned to its original owner the Duke Of Norfolk. The only things that remain are a couple of coal tubs and a half of the colliery winding wheel, which serve as a sad memorial to a once proud and happy local community. They can look back with pride. They will not be forgotten.

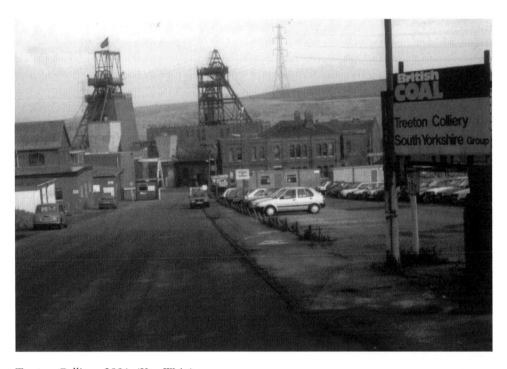

Treeton Colliery, 2001. (Ken Wain)

31
Waleswood Colliery

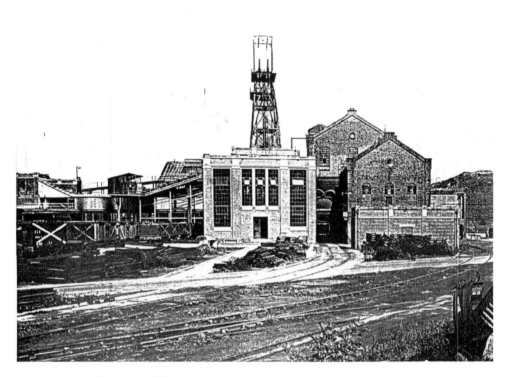

Waleswood Colliery. (David Thomson)

Waleswood Colliery was sunk in 1856 by Skinner and Holford. Two shafts were sunk into the High Hazels seam at a depth of 97 yards, between Swallownest and Wales village in South Yorkshire. The winding engine was manufactured by Worsley Menses of Wigan and the winding system was protected by the latest safety equipment available at the time, comprising twin calliper brakes on the winding drum, which were automatically applied by a set of weights if the steam pressure fell dangerously low and the Melling patent over-wind and over-drive prevention equipment. Shaft signalling equipment was supplied by GEC.

In 1864, two more shafts were sunk into the deeper, thicker Barnsley seam at 197 yards. By 1897 compressed air was introduced into the pit and used to power the coal-cutting machinery and haulage systems; this increased production considerably and the coal began to flow more quickly, making the pit ponies redundant and giving them a well-earned early retirement. The pit had a good few years until 1912, when the miners went on strike, after which, at the beginning of the First World War, the pit installed a bank of twenty-four Babcock & Wilcox coke ovens, which was the pit's saving grace due to being able to turn almost its entire production to coke making for the local steel trade.

All this was set asunder when, in August 1915, a horrendous accident took place which saw two cages collide when they were half way down the shaft. One cage was coming up empty and the other was going down with ten men on board. The collision was so bad that the winding ropes were severed and all the men in the ascending cage were seriously injured. By some miracle the cages were found to be locked together and into the shaft sides, preventing them from falling down the shaft. As soon as it was realised what had happened, in an amazing act of heroism, three men named as Albert Tomlinson, John Walker and Percy Havercroft descended the shaft in an inspection bucket to see if they could rescue the injured men from the damaged cage. On reaching the scene it was immediately realised that Edward Wingfield, one of the men in the cage, was badly injured with a gash to the head and both his legs broken, and was, despite being in great pain, holding on to a colleague who was hanging through the bottom of the cage. He maintained his grip until the man was rescued and then in an act of selflessness insisted that all the others were saved before himself. All

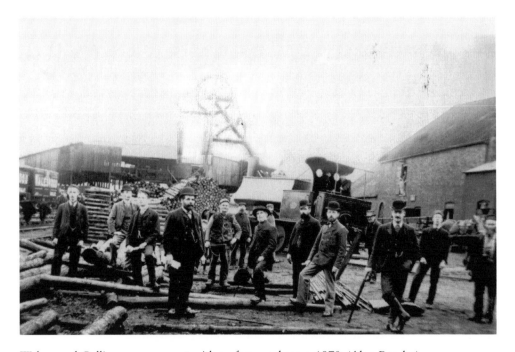

Waleswood Colliery management with surface workers *c.* 1870. (Alan Rowles)

the men were rescued 'by being carried across a girder' into the bucket, which made five journeys to the surface and back, taking a good two hours. These men were in danger of their own lives and could have been hit by the ropes swinging in the shaft. The king awarded the Edward Medal 2nd class to Havercroft, Tomlinson, Walker and Wingfield for their courage.

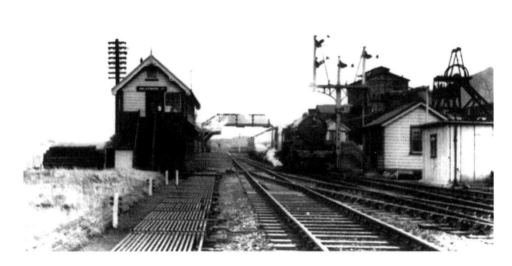

Express train passing through Waleswood station *c.* 1940. (Alan Rowles)

By the 1940s it was hoped that a weekly average of at least 6,000 tons could be achieved by taking advantage of the newly opened Parkgate seam, but it was not to be due to a soft dirt band above the coal, which came down when the coal was cut and became mixed with the coal – this amount of contamination was very difficult to remove by the colliery's screening plant, thus rendering it of poor quality due to the high ash content on burning. Waleswood coal had to be mixed with that of other collieries to be used by the power stations. After several reviews it was decided that it would be more viable to let the profitable pits of Kiveton Park and Brookhouse, which lay to either side of Waleswood and had many years of reserves left in them, work the remaining coal. To reorganise Waleswood would cost in excess of £250,000, after which its efficiency could still not be guaranteed because the life expectancy of the pit was only approximately seven years if it operated without any production problems, which seemed highly unlikely. Within a year of nationalisation, the NCB, after repeated talks with the National Union of Mineworkers, which ended with no amicable resolution, ordered that the closure should take place at the beginning of September 1948. Even though most of the 800-strong work force were offered

employment in the local area pits, nearly 100 men stayed underground in protest against the closure and were joined in the conflict by some of the workforce at Brookhouse Colliery, who came out in sympathy with them. Consequently, because of the strike, the NCB gave the strikers one week's notice and closed the pit on Saturday 28 May 1948. The pithead baths were then converted and used as a workshop and stores for the local NCB estates department and were used well into the 1970s.

It was in the early 1950s when coke oven electrician Mr Malcolm Jones was just going off shift one Sunday afternoon at about 2 p.m. when he noticed thick smoke coming from one of the buildings on Waleswood Railway Station; which was right beside the colliery and quite near to the colliery headgear of No. 1 shaft. He ran back to the coke ovens and told the staff, who in turn alerted the fire brigade and the railway company, who were able to stop the trains from running until the fire was extinguished. Mr Jones was awarded £20 by the railway company for his quick actions, which could quite well have averted what could have been a potential rail disaster and spread to the colliery.

This was the main Sheffield to Grimsby line for passenger and freight traffic. A short branch line joined the main line a few hundred yards away from the colliery. The branch line formed a curve that eventually traversed the Killamarsh Meadows and joined with the London & North Eastern Railway, allowing coal to be transported all over the country.

The banksman's shaft signalling equipment. (Alan Rowles)

The winding engineman's signals and shaft depth indicator. (Alan Rowles)

Alan Rowles was amazed to learn that the winding house, which had been bricked up for many years, one half of which was separated off and used as a store, still housed all the winding equipment, which had lain undisturbed since the closure of the colliery in 1948. He learned that the building was to be demolished at the time that he was on holiday; on his return he was able to take this valuable set of photographs for future generations, but sadly the winding engine had already met its demise while he was away. I am greatly indebted to Alan for allowing me to reproduce them in this publication for all to see, the equipment being almost 150 years old at the time of demolition in 1995.

Above: Steam-operated solenoid valve with counter balance weights which dropped and automatically applied the calliper brakes in the absence of steam pressure, set below the winding drum. (Alan Rowles)

Right: Steam pressure gauge. (Alan Rowles)

Winding drum and calliper brake frame with over-wind and over-drive governor mechanism, shown bottom left. (Alan Rowles)

The Melling patent over-wind and over-drive equipment. (Alan Rowles)

In 1903, Waleswood Colliery introduced compressed air to operate the underground haulage system winches, because for some unknown reason young lads were not volunteering to be trained as pony drivers. The ponies were brought out of the pit and some were used for work on the surface, taking supplies for underground use to the pit bank, until they were eventually retired to nearby farms.

Hudswell Clarke's advert for locomotives and tank engines featuring the tank engine manufactured for Waleswood Colliery with the Waleswood nameplate on the tank, *c.* 1916. (Coal trades diary 1949, Ken Wain)

The pit's coke ovens supported a thriving by products plant which was producing tar, naphthalene, ammonia, and gas among others.

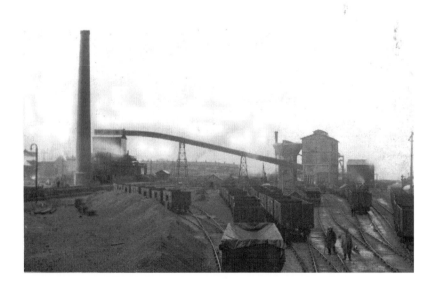

Waleswood coke ovens and marshalling yard *c.* 1930. (Alan Rowles)

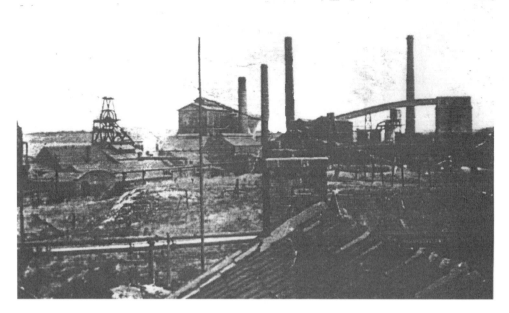

Waleswood pit and coke oven *c.* 1930. (Alan Rowles)

Waleswood coke ovens *c.* 1930. (Alan Rowles)

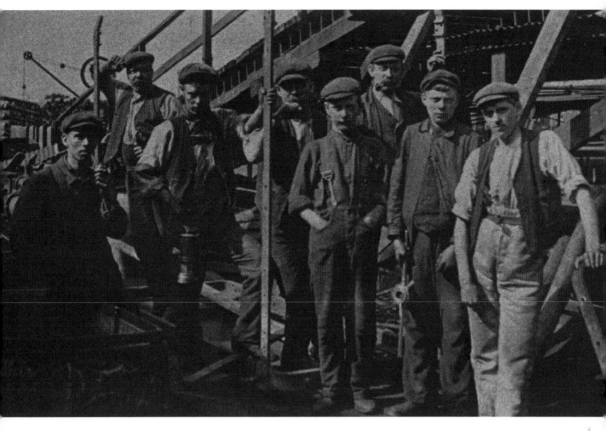

Waleswood surface workers *c.* 1930. (Alan Rowles)

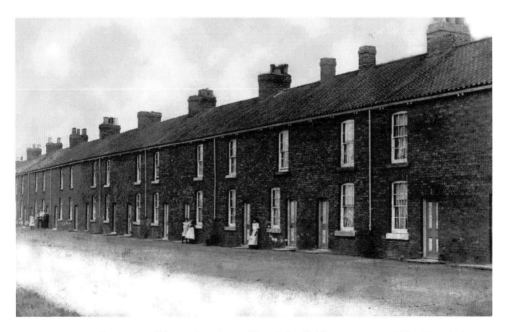

Miners cottages, known as 'Pigeon Row', topside of the Colliery entrance. (Alan Rowles)

Miners' children at the Waleswood sports ground celebrating Princess Margaret's engagement in the 1960s. (Ken Wain)

Waleswood winding house shortly before demolition in 1985. (Alan Rowles)

Modernised miners' cottages on the east terrace at Wales Bar. (Ken Wain)

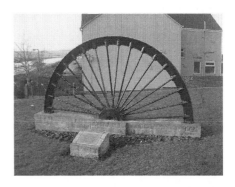

Wales Parish Council have erected a monument
in the form of half the winding wheel and a
plaque to commemorate the three collieries in the
vicinity. (Ken Wain)

32
Maltby Main Colliery

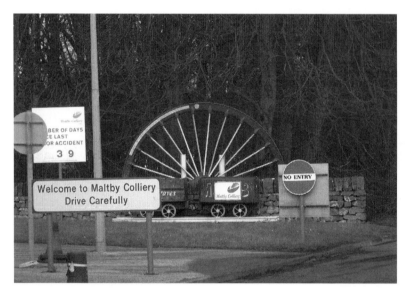

Maltby Colliery entrance. (Ken Wain)

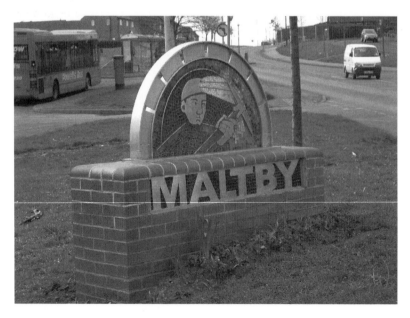

Maltby village sign. (Ken Wain)

Coal lorry leaving Maltby Colliery. (Ken Wain)

In 1907, the Sheepbridge Coal & Iron Company of Chesterfield set up a subsidiary company, the Maltby Main Colliery Company, to sink two shafts into the Barnsley seam. The first shaft sinking commenced on 8 March 1908 and reached the Barnsley seam at a depth of 820 yards two years later on 17 June 1910. This was to be known as the No. 2 shaft and would be used for winding men and materials. The No. 1 shaft was held up after hitting an inrush of water from underground springs, which had to be removed at a rate of some 20,000 GPM by two powerful pumps housed in two separate pumping houses which were set into the shaft side. Coal was finally reached in January 1911 and the No. 1 shaft was used for winding coal. The colliery company was to build 1,000 houses for the use of its employees. Only seven months later, on 21 August, three men were killed in an explosion, again in the Barnsley seam, being notorious for spontaneous combustion.

On 26 July 1923 a firedamp explosion occurred and caused a fire in the underground workings. The men were withdrawn from the pit. The colliery manager, Mr A. Butler, instructed twenty-six men to descend the mine to carry out work to seal off the fire and one man, Original (Reg) Renshaw, a platelayer who was working away from the fire area. On the morning of 28 July, a further ninety-five men were working underground making a total of 122 men, when another firedamp explosion, which was believed to have been caused by the original fire, occurred. Firedamp accumulations had got worse in the days preceding the explosion. At the time of the explosion, two miners, who were

further away from the site, saw the flash and felt the hot air from the blast – they were fortunate and escaped. The last three to come from the area alive were Horace Outram, Arthur Watson, and George Perrins. Volunteers immediately mounted a rescue attempt without any thought as to their own safety – they went into the area of the explosion and found the remains of Original Renshaw, the platelayer. Attempts to go any further were stopped by virtually impassable roof falls and the men came out of the pit. Another attempt was made but to no avail. At a hasty management meeting it was unanimously decided that because of the condition of Original Renshaw's body and the distance he was found from the actual site of the explosion, coupled with the fact that the fire was still burning, there would be no possible chance that anyone would have survived after this point. The decision was made to call off the rescue attempt. Stoppings were put in place and the area was sealed off, leaving the bodies of the remaining twenty-six men inside. This effectively sealed off 50 per cent of the mine workings.

The coroner for the West Riding of Yorkshire, Mr Frank Allen, conducted an inquest on the body of Original Renshaw and a jury returned a verdict of accidental death as a result of an explosion. Sir Thomas Mottram, CBE, the chief inspector of mines, set up an enquiry into the cause of the disaster, which was opened on Tuesday 18 September at Sheffield town hall. The enquiry went on for seven days and the evidence showed without doubt that the disaster was caused by an explosion of firedamp ignited by spontaneous combustion. Stoker, the overman, was killed in the explosion, so it is not known whether he took steps to pull out the men because of the presence of gas, which was previously know to be present. Sir Thomas remarked on the bravery of the rescue teams and the officials of the mine before bringing the enquiry to a close. The names of those that perished in the disaster are as follows – the youngest was only fifteen years of age and the eldest only forty-eight – John Stoker, aged thirty, overman; George Perrins, aged thirty-seven, deputy; Harry Norwood, aged thirty, deputy; Ernest Clixby, aged twenty-six, analyst; Richard Ernest Dunn, aged twenty-eight, collier; John Henry Garraty, aged thirty-eight, corporal; William Emberton, aged twenty-seven, collier; George Hickling, aged forty-seven, ripper; John William Green, aged thirty-eight, byeworker; Silvanus Turner, aged twenty-seven, collier; George Brierley, aged thirty-four, collier; William Preece, aged twenty-four, collier; Aaron Daniels aged forty-six, collier; Bertie Bearshall, aged twenty-nine, collier; Leonard Meridith, aged twenty-two, collier; Albert Smithson, aged twenty-eight, collier; Joseph Best, aged nineteen, filler; Richard John Brooks, aged twenty-four, collier; Joseph Spibey, aged twenty-nine, collier; Raymond Clinton Bourne, aged eighteen, haulage hand; Harold Bourne, aged thirty-five, haulage hand; Benjamin Jones, aged twenty-six, collier; Alfred Leslie Fellows, aged fifteen, haulage hand; Original Renshaw, aged forty-eight, platelayer; Edward Michell, aged twenty-three, byeworker.

The Barnsley seam provided all of the pit's output for the next sixty years. After the 1926 coal strike, the Denaby & Cadeby Colliery Company took over the ownership of the colliery until it became part of the Amalgamated Denaby Collieries Ltd in 1936, when it was producing 1 million tons of coal per year. This was achieved purely by the use of compressed air as a power source for the coal getting machinery and transportation of coal and materials, although diesel and battery powered locomotives

were introduced at a later stage. For fourteen years, after nationalisation of the mines in 1947, the colliery underwent significant modernisation and the Barnsley seam was further exploited to increase the colliery's output by a further 250,000 tons from estimated reserves of 36 million tons. Both shafts were deepened by another 50 yards, which allowed the Barnsley seam to be accessed horizontally from the new pit bottom, and skip winding was installed over the No. 2 shaft in 1961. Maltby Main was the only colliery to use its own fleet of buses to bring its employees from outlying areas to work at the colliery and to return at the end of a working day.

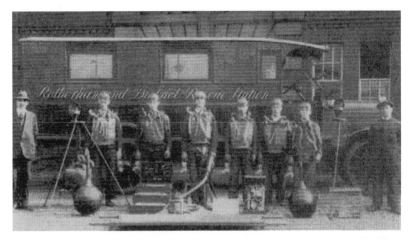

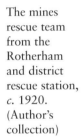

The mines rescue team from the Rotherham and district rescue station, *c.* 1920. (Author's collection)

Methane pump under load test at Fence Central Workshops. (NCB)

It was soon realised that the colliery had new horizons and could be developed into a super pit, with a life expectancy that would run well into the twenty-first century. Both No. 1 and No. 2 shafts' steam winding engines were replaced with electrically powered winders, a new coal preparation plant was erected and a new mine ventilation fan was installed in a scheme which cost in excess of £3.25 million. As at Manton Colliery, Maltby Mains Barnsley seam was very gaseous and produced large quantities of methane. In 1961 the newly built Worksop No. 1 area fence central workshops at Woodhouse Mill opened a new department for the repair and maintenance of compressed air-operated Meco Moore coal cutting machines and Huwood Slicer power loading machines along with methane pumps, which were used to rid the Maltby Colliery workings of the methane gas. Maltby Main was the last colliery in the Worksop area to have electricity at the coal face, where it was introduced in 1966, because of the methane gas nuisance; electricity was first used underground to power a pump at Trafalgar Colliery in the Forest of Dean.

The very first pit to become all electric was the Britannia Colliery in Monmouthshire. In the late 1950s, methane was piped from Maltby to Manvers coking plant, where it was used to fire the coke ovens. 1968 saw further exploitation of the Swallowood seam as by this time the Barnsley seam was exhausted. The scheme cost £1.25 million and took three years to complete.

Maltby celebrated a 1 million ton output on 23 March 1973 and the colliery went from one strength to another and in 1975, in conjunction with British Rail, a scheme was devised whereby coal destined for the BSC coking plant at Scunthorpe could be speeded up by introducing a rapid loading scheme into 'Merry Go Round' trains on a specified circuit between Maltby and Scunthorpe. By the 1980s the scheme proved to be so successful that most of the high producing collieries adopted the same system for delivering their coal to the power stations, which were taking a high proportion of the output at the time. British Rail used a particular type of diesel-powered locomotives to haul the coal trains and some of the engines were named after different collieries and power stations that they served, showing British Rail's commitment to the coal mining industry.

A further £1.25 million exercise was carried out in an exploratory boring programme which was to identify further coal reserves of at least 100 million metric tons. 'King coal was in its heyday.' This was bonanza time and a further programme costing a massive £172 million, which was the NCB's largest ever investment in an existing working colliery, upped the pit's output to 2 million metric tons per year. It was the only colliery in South Yorkshire to achieve such a fantastic output. The work commenced in 1981 by sinking a third shaft to a depth of 1,000 metres with a diameter of 8 metres, allowing it to handle all of the colliery's output from the one shaft. The operation took seven years to complete and extraction of coal had now commenced from the Parkgate and Thorncliffe seams, opening the door to a further 50 million tons of reserves. Even though all this had been achieved, after the 1984 coal strike the onslaught had begun with the decimation of the mining industry in its entirety by a combination of a government with a bloodied nose and cheap foreign coal imports and even though British Rail ploughed all this money into transportation of coal to

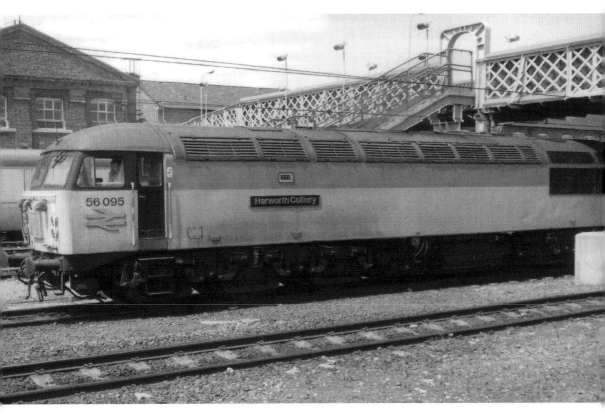

British Rail's merry-go-round engine. (Ken Wain)

the power stations, the CEGB decided to use road transport due to a small amount of disruption during the strike when the rail workers backed the miners. British Coal Corporation decided in its wisdom to mothball the colliery in 1992. This was at a time when the colliery's coal achieved the coveted British standards approval BS 5750 for quality and was entered in the Lloyd's register of quality assurance, an internationally recognised seal of approval. Maltby was the first colliery in the world to receive this plaudit. In the face of adversity, a complete u-turn in policy by the powers that be (possibly a sweetener for RJB) ensured the colliery's future by a further injection of £40 million in developing its massive reserves. Maltby Main was purchased by the R. J. Budge Mining Company only two years later, in 1994, when the remaining working collieries were returned to the private sector.

This and next page: Maltby Colliery, 2012. (Ken Wain)

33
Harworth Colliery

Harworth Colliery. (Ken Wain)

Maltby Colliery was eventually taken over by UK Coal, who ran it for several years, but due to heavily subsidised imported coal it issued an ultimatum to the workforce that unless they could come up with a viable rescue plan for the colliery it would greatly reduce the manpower with a view to early closure in favour of the remaining reserves being brought out form nearby Harworth Colliery (Nottinghamshire). It was a sore point for the (South Yorkshire) miners at Maltby Main, seeing as they went on strike to try and secure the future of the mining industry while the Nottinghamshire miners broke ranks and continued to work during the dispute. RJB suspended work at the colliery in 1997, blaming poor contract agreements. Only 200 or so maintenance

workers were retained, but the mine eventually started work again to develop the Parkgate and Thorncliffe/Silkstone seams to give the pit further life expectancy, although it was estimated that the Parkgate would be worked out by 2014. Hargreaves transport services bought the pit from UK Coal for £21.5 million, in a move that was hoped would save the jobs of hundreds of mineworkers for the foreseeable future. In October 2012 Hargreaves announced that the colliery's new T125 unit was experiencing severe geological conditions and that oil and water contamination along with gas seepage was posing a serious threat to the colliery's future viability. 540 men working at the colliery were waiting for the results of scientific investigations which would determine their future at the colliery. This was not the only viable face at Maltby, but further investment was required. Let's not forget that twenty-five years ago, 100 million metric tons of reserves were found. At 2 million tonnes per year, that's fifty years of coaling, with twenty-five years left. 1981 found another 50 million tons and British Coal sunk another 40 million into the pit only two years later. Maltby was the only British mine left producing coking coal, of which it sold almost 250,000 tons per year to the glass industries. There are still millions of tons in the area between Maltby and Harworth. Maltby was mothballed in December 2012 and Harworth was under review in March 2013 with a view to reopening the colliery. Underground roadways are currently being maintained and visits are being made to European collieries with similar geological conditions with a view to bringing Harworth back into production. Maltby's closure was announced on April Fool's Day 2013.

34
Rotherham Main Colliery

Old company advertisement for John Brown's steel works, Sheffield.

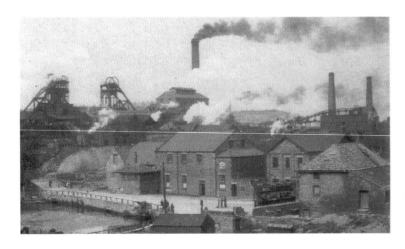

Rotherham Main
Colliery c. 1920.
(Old postcard)

The John Brown Iron & Steel Company of Sheffield, which was founded in 1856 and one of the largest employers in the city, with about 4,500 men on the books, had already taken over Aldwarke Main Colliery in 1873 and went on to sink two shafts at Canklow, about 2 miles from Rotherham town centre, in 1890. This was to be Rotherham Main Colliery. The company's steel works were already producing new headgear assemblies for collieries on a nationwide basis, to replace the old wooden structures, which were now condemned for safety reasons – mainly stress and fire risk.

Tragedy struck on Tuesday 7 July 1891 when eight men fell from a platform of four timber beams, held by four chains fastened at the top of the shaft. The men were on the platform lining the shaft with bricks about 80 feet from the surface when one of the beams broke in two and the men fell 20 yards down the shaft into 10 feet of water. Four men tragically lost their lives and four were badly injured.

The Edward Medal for bravery.

Queen Victoria awarded the Edward medal to Ambrose Clarke and Robert Drabble for their gallantry during this tragedy. The medal was designed by W. Reynolds-Stephens and the sovereign's profile was on the obverse while the reverse depicted a miner rescuing a stricken miner. The top of the medal was inscribed with the words 'For Courage'. The medal had a ribbon attached, which was dark blue with yellow edging down either side, and each medal was engraved with the recipient's name. A group of philanthropists headed by the leading mine owner, A. Hewlett, set up a fund for the purchase of these medals.

Both shafts were sunk into the Parkgate seam at 608 yards, passing through the High Hazels, Barnsley and Swallowood seams at varying depths. Coal production commenced in 1894. The colliery company built houses for the miners and a school for their children. Rotherham Main was unique in that its No. 1 shaft was used solely for winding coal from the Parkgate seam, but the No. 2 shaft was served by two winding engines, one to wind coal from the Barnsley seam and the other drawing from the High Hazels. By 1910 there were 1,007 employees at the pit, 960 of these working underground; in 1927, this had shot up to 2,028, which included 460 surface workers due to the manpower requirements in the coke ovens and by-products plant. From this time and into the 1930s the colliery did relatively well and at the beginning of the Second World War it was producing in the region of 3,000 tons per week – about 1,000 tons of this was used by the colliery itself, in the coke ovens and by-products plant, the remainder being sold to external markets. However, this was to be short-lived because as early as 1942 a report published by the mines departments technical advisor stated that due to the remaining reserves being very low and roof conditions beginning to deteriorate, it should be urgently considered that what was left should be brought out at Aldwarke or Silverwood collieries, which were both nearby. As a consequence, the manpower had diminished to 399 by 1949, producing a mixture of coking coal, gas coal, household and steam coals.

The Parkgate seam did start suffering from bad roof conditions and workable reserves diminished very quickly, causing the mine to be closed in 1954. As a point of interest, the Rotherham Corporation had a tramway system built to serve the colliery, which transported miners from Rotherham town centre directly into the pit yard. After the coronation of Elizabeth II in 1953, the NCB scrutinised the colliery's future and decided on an investment programme of £3 million to ensure the pit's longer term prospects. The scheme took almost ten years to complete and consisted of major works both on the surface and underground, which included a new coal preparation plant, installation of skip winding and new powerful electric winders, completion of the colliery's electrification, and new diesel and electrically operated locos for underground transportation of coal and materials.

The Cottam coal-fired power station near Retford (shown overleaf) was commissioned in 1969 by the then Central Electricity Generating Board. The power station has a generating capacity of 1,970 megawatts. When the electricity supply industry was denationalised in 1990, it came into the ownership of Powergen. The plant was sold in October 2000 to London Power, a subsidiary of EDF Energy, for £398 million.

Cottam power station. (Ken Wain)

35
Silverwood Colliery

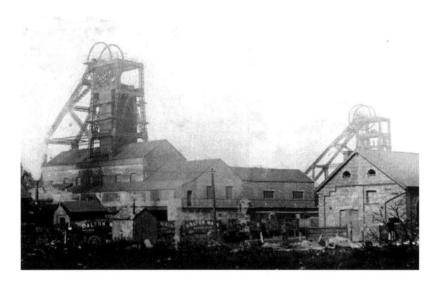

Silverwood
Colliery.
(Old
postcard)

Silverwood Colliery, originally Dalton Main, was on Hollings Lane at Thrybergh near Rotherham; sinking was begun in 1900 by the Dalton Main Collieries Ltd. In December of 1903, two 21-foot diameter shafts were put down and reached the Barnsley seam at a depth of 740 yards and coal winding commenced via the No. 1 shaft in October 1905. Water problems were encountered during the shaft sinking and the shafts were double lined with brick to a depth of approximately 60 yards to prevent ingress of water and single lined brick or stone in some places to the bottom of the shaft. A further shaft was sunk into the underground watercourse, purely for pumping out the excess water and providing the colliery with its own water supply. The old Roundwood Colliery, which was approximately 3 miles from Silverwood, belonged to the same colliery company and roadways were driven into Silverwood to allow coal from both collieries to be wound from Silverwood, while Silverwood benefited from better ventilation, assisted by the Roundwood fan installation. Mr James Else was installed as the manager in 1907 and a year later he had a manpower contingency of 2,532 working underground and 576 on the surface.

By 1909 the colliery was working well, the colliers earning £25s a week, and was in the process of building coke ovens, a by-product plant and a brickworks. The coke

ovens and the by-product plant were both up and running by 1912, producing top-quality coke for the steel making industries and a whole host of by-products, including tar, benzol, and ammonia products. The colliery's output for 1912 was an amazing 27,000 tons with 3,467 men working underground and 828 on the surface. King George V and Queen Mary came to Doncaster station on Monday 8 July in 1912, on their way to stay with the Fitzwilliams at Wentworth Woodhouse; they visited Silverwood Colliery on Tuesday and it was while they were there that they learned of the Cadeby Colliery explosions and went to Cadeby to give their support.

The Great War of 1914–1918 claimed the lives of 250 Silverwood men and sixty-two Roundwood men and even though mineworkers were exempted from conscription because of the importance of coal to the war effort, these brave men joined up out of a sense of duty towards their country. After the war, in 1919, over 700 men were set on at Silverwood to help get the colliery and the nation back on its feet. Just before Christmas of 1923, the Dalton Main Collieries Company Ltd erected a memorial in memory of the men who lost their lives in the 1914–18 war. The brickworks were now making in excess of 140,000 bricks per week and 1929 saw annual coal production top 1.3 million tons.

A story that seems to be shrouded in mystery is that sometime around July of 1933 it would appear that the cage guide ropes in both shafts seem to have broken. This meant that the men had to leave the mine via the Roundwood shaft, the repairs being completed sometime in September.

The Roundwood production finished in June 1931 and by 1949 Silverwood was producing quality household and steam coals, with 3,000 men under the management of Mr J. R. Williams, who was then laying plans for the exploitation of the Meltonfield seam, the manpower reduction as a result of increased mechanisation. By the early 1950s the Meltonfield seam had started producing poor-quality fuel and the Barnsley seam was becoming more expensive to retrieve due to the distance and the constant risk of spontaneous combustion. The NCB asked the colliery management to prove its long term viability, which resulted in the colliery opening up the Swallowood seam in a scheme set up in 1965. At 6 a.m., on 3 February 1966, the day shift men left the pit cage and made their way to the paddy mail train to be taken to their place of work; the train set off and at the same time another train set off behind them carrying materials – this was normal practice but the second train suddenly gathered speed and crashed into the back of the first train, killing ten men and seriously injuring twenty-nine others.

The Swallowood seam came into production in 1967, with a resultant increase in the colliery's production and profitability. In February of that year the chairman, Lord Alfred Robens, the industry's first butcher, visited Silverwood Colliery to see for himself during a whistle-stop tour of South Yorkshire's ten top-producing long-life pits. During his ten-year spell as chairman he closed 400 pits and halved the manpower to 300,000. But having said that, for those remaining in the industry he achieved 50 per cent extra output and wages were restructured to everyone's advantage. He was known to say that the NUM's militant left had a ridiculous enthusiasm for strikes and that their communist friends in the Iron Curtain countries were forced to work whatever the situation. He went as far as to say that 'strikes were illegal' and criticised

the government for assuming that they could always rely on cheap imports of oil. Further work was undertaken to the tune of a further £3 million and the Haig Moor seam was tapped via two drifts from the Barnsley seam.

Production from the Haigh Moor seam commenced in 1967, closely followed by the closure of the Meltonfield seam, which had never been really successful in 1968. Lord Robens said on a visit in 1969 that the men had turned one of the faces into one of the most profitable in the country because they were determined to keep it a winner. The Barnsley seam closed in 1972 due to exhaustion of reserves. By 1974 Silverwood was producing 1,100,000 tons per year with 1,300 men.

In 1975 a further injection of £2.5 million brought the full potential of the Swallowood seam into being, producing large quantities of top grade coking coal for BSC Scunthorpe and the local power stations. Further investment took place over the following years and the colliery went on to produce 1,500 tons of coal per day; by the 1980s the Swallowood four faces were producing 1 million tons per year between them. In 1982 the Haig Moor seam was brought into the equation, boosting production to even greater heights. Most of the fuel was supplied primarily to the Central Electricity Generating Board.

Towards the end of the 1980s, British Coal opted to invest even more money in up-to-the-minute technology for the Swallowood seam; it was very soon to reap the harvest on 5 January 1989 by raising the fastest 1 million tons in the history of the South Yorkshire coalfield. The colliery manager, Peter Cartwright, said that this was an outstanding achievement and the pit was now in the black by about £10 million, due to the output from this face. To achieve this, rapid loading systems were introduced and the Fence National Workshops at Woodhouse Mill played a great part in this by providing a rapid turnaround in the repair of loading machines for the colliery, thus providing the key for sustaining its production targets.

Fence Workshops' fitters stand by the EIMCO loading machine which they have just done a quick turnaround on for Silverwood Colliery. Brian Evangelista, Fence Workshops' manager bottom row (centre), and workshop superintendent, Denzil Price, far left, hand over 'the key', to help achieve the 1 million tonnes record for the South Yorkshire Coalfield, to the Silverwood Colliery representatives. (NCB)

The Silverwood team responsible for achieving the 1 million tonnes record pose for the camera in a jubilant mood. (NCB)

The colliery looked set to live well into the twenty-first century and although British Coal announced a £10 million scheme in 1992 to develop the Parkgate seam, which had reserves approaching 12 million tons, the idea never got off the ground and the pit was closed at Christmas in 1994. The NUM branch secretary said that there was a good fifteen years of life left in the pit, with at least 11 million tons left sealed beneath our feet. The manpower at this time had dramatically fallen to only 380 men. We are now importing millions of tons of foreign coal, which in many cases is produced by little more than slave labour in dangerous conditions. 166 perished in a Chinese mine explosion in November 2004, followed by hundreds more to the present date. The British government is paying out millions in benefits and redundancy payments to those who have been displaced by pit closures and cannot find suitable employment. British Coal spent millions on researching fossil fuel clean-burn technology at its own mines research establishment at Bretby. This was progressing well and would by now have been perfected, eliminating greenhouse gas emissions worldwide and earning the country millions from pounds from selling the technology all over the world and further millions in manufacturing the equipment for oversees buyers. Once the proverbial lid has been put on a pit it cannot be reopened, in this particular case losing well in excess of 12 million tons and effectively losing the jobs of nearly 400 men for approximately ten years, and unfortunately this has been repeated on a massive scale nationwide. Future planned bore holes could quite well have found further reserves.

A Northern Bus Company coach passing Silverwood Colliery on route to Maltby Colliery *c.* 1980. (Alan Philpotts)

36
Kilnhurst Colliery

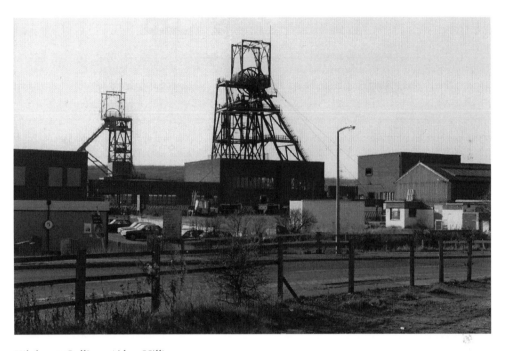

Kilnhurst Colliery. (Alan Hill)

J. & J. Charlesworth Ltd from Wakefield dropped two shafts to a depth of 275 yards into the Barnsley seam in 1858, the first coal production starting in 1860. Both shafts were used for raising coal, the No. 1 shaft being the downcast shaft. The colliery was about 3¼ miles from Rotherham and was fortunate in the fact that it was served by the Sheffield & South Yorkshire Navigation canal and the LMS and LNER railways, which were all nearby, giving the colliery the advantage of direct links to the east coast ports of Grimsby and Hull for shipping to overseas markets.

In 1870 a third shaft was sunk into the High Hazels seam at 225 yards for the evacuation of water from the seam, the shaft being used solely for this purpose with by the aid of a Cornish pumping engine, which was to be used for seventy-seven years until nationalisation in 1947. The No. 2 upcast shaft was deepened to 355 yards into the Haigh Moor seam in 1920 at the time of the opening of the Swallowood seam.

The colliery was coupled underground with Swinton Common Colliery. Stewarts & Lloyds Ltd purchased the colliery in 1923 and almost all the coke production was used to service their own iron and steel works at Corby, Bilston and Islip. The Parkgate seam was first exploited in 1927 and the No. 2 shaft further deepened in 1933 into the Silkstone seam at 653 yards. At around this time the company was embarking on a modernisation scheme for the whole company, which, as well as building new coke ovens and steel works, meant a greatly improved colliery surface layout including new screens and washery plant. The colliery was closed for eight months to allow the work to be done, along with extensive underground alterations.

In 1935 the High Hazels (Kents Thick seam) was further developed and produced high-quality house coal. The Tinsley Park Company took over the colliery in 1936 and sank a fourth shaft into the Silkstone seam at 642 yards and used the shaft for ventilation purposes in the Silkstone and Parkgate seams. By the early 1940s the pit was experiencing difficulties in maintaining its production targets due to difficult transportation problems from the Barnsley seam districts, because of distances of 2 miles or so from the pit bottom, and the Silkstone seam was also suffering from serious faulting. The colliery was taken over yet again by the United Steels Company in early 1945 and almost immediately taken into the realms of the Manvers Main collieries. In 1949 the colliery was producing coking, gas, household and steam coals with a manpower contingent of 903 men, under the management of Mr J. Shimmins. It was now part of the north-eastern division, Carlton No. 4 area of the NCB. The NCB started a £6.5 million scheme in 1950 called the Manvers Central Scheme, which would control four local collieries at one base (Manvers). Kilnhurst became one of these collieries – the scheme was developed over the next six years. Coal winding ceased at Kilnhurst during the reorganisation, coal being transported underground to Manvers to be wound to the surface.

Kilnhurst officially joined forces with Manvers on 1 January 1986, to become part of the new scheme to be known as Manvers Complex South. This was only short-lived and the British Coal Corporation ceased operations at the complex on 26 February 1988, ending a lifetime of 130 years at Kilnhurst Colliery.

Manvers Main Colliery

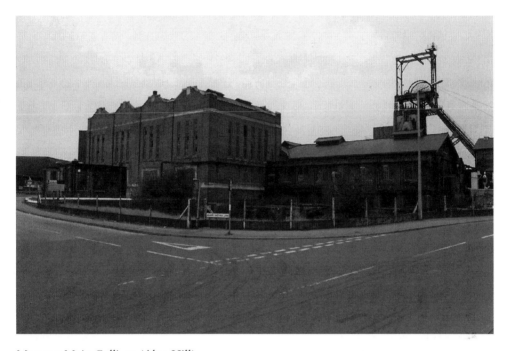

Manvers Main Colliery. (Alan Hill)

A consortium of seven local businessmen, having the freehold of land at Wath on Dearne, leased further land from Earl Fitzwilliam and Earl Manvers and commenced shaft sinking in 1867, near Wath on Dearne. Coal was reached in 1870, when the first production was extracted from an 8-foot-thick seam of good Barnsley coal at 284 yards. The No. 2 shaft was further extended down into the Haigh Moor seam in 1873 to a depth of 347 yards. No. 3 and No. 4 shafts were sunk in the early 1900s to 555 yards in the Parkgate seam. By 1880 the company had realised that other collieries in South Yorkshire were making large amounts of money from the sale of coke to the local iron and steel making companies and decided 'at the right time' to jump on the band wagon. The No. 1 pit was soon boasting a bank of beehive-style coke ovens, which were proven to be a great success and some six years later a similar installation was carried out at the No. 2 pit. The manufacture of coke and associated by-products

such as tar, benzole and toluol, etc. were soon to become the colliery's claim to fame and the colliery went on to rapidly expand its business over the next four to five decades, the Barnsley seam being the major provider.

Within thirty years of the first installation, the collieries had between them some 108 coke ovens, which were also making millions of cubic feet of gas, which was all sold to the local gas companies. Continuous working of the plant began to take its toll and the ovens were taken down to make way for a more modern advanced plant to be installed and by 1935 a total of forty-five new ovens were installed, which were to produce the same amount of output as the previous 108 ovens. The Barnsley seam was worked out by 1942 and the Haigh Moor seam was brought on line to compensate, the coal being wound from the No. 2 shaft.

On 4 March 1945, sparking from a faulty trailing cable was responsible for causing a firedamp explosion, causing the untimely deaths of five men. After nationalisation the NCB decided on a radical plan to combine four collieries by underground linking and wind all the output from Manvers, with the exception of Barnburgh, which would remain separate and wind its own coal. All the four collieries were producing the same four categories of fuel – coking coal, gas coal, household coal and steam coal – and had between them 7,643 men. The four collieries concerned were Manvers, Kilhurst, Wath and Barnburgh and the enterprise, which was a major development, was called the Manvers Central Scheme, commencing in 1949. The major part of the scheme was completed in 1955, at an estimated cost of £6.5 million. New pithead baths and canteen facilities were also built at Wath, Kilnhurst and Barnburgh and the combined production of the four pits was 2,314,855 tons per annum. By pooling the resources of the four pits and the introduction of skip winding, a new coal preparation plant and carbonisation plant, which was finished a year later in 1956 at a cost of a further £9 million, the complex was now using 3,000 tons of coal every day for coke production and the by-products plant was in full production, fulfilling the markets for its benzole, naphtha, tar, and sulphate of ammonia etc. The by-products plant and coke ovens continued as a very healthy and profitable business venture until their eventual closure in 1981.

The combined coal production was now in excess of 3.5 million tons per annum. Electric winders were installed in 1957 at the No. 2 and No. 3 shafts, which made for much faster coal winding. The No. 4 shaft was now used for winding men and materials. The complex enjoyed a relatively trouble-free productive life for the next twenty-three years, until for various reasons its profitability began to dwindle and losses of £54 million were recorded for the period 1983 to 1988, which took in the miners' strike of 1984–85. The Manvers Collieries Complex was finally closed down on 25 March 1988.

Manvers pit ambulance with its driver, Mr George Thorpe, who also drove lorries at the pit and went on to drive ambulances during the First World War. The photograph was taken *c*. 1900. (Alan Peace)

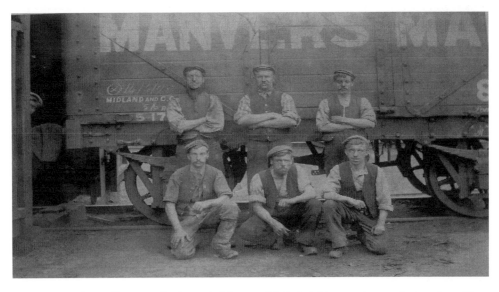

Mr James Bickerstaff (centre back row), Manvers Main bricklayer, who worked at the colliery for forty-three years until his retirement in 1932, shown here with his team of labourers *c*. 1898. (Alan Peace)

38

Recent Coal Industry Accidents in the Twenty-First Century

Recent accidents serve as a harsh reminder that the industry is still as dangerous as ever and that safety is not always at the forefront in colliery working practices.

At 6.30 a.m. on Thursday 15 September 2011, the Swansea valley in South Wales was again struck by tragedy when four men were trapped 300 feet underground by an inrush of water and debris in the Gleision drift mine at Cylibebyll near Rhos, where the colliery works above the banks of the River Tawe. Three others escaped from the mine – one man walked out of the drift and told the other two what had happened and then collapsed. He was taken by helicopter to the nearby Morriston Hospital in a critical condition. The other two immediately went back down the drift to help the rescuers due to their intimate knowledge of the mine, but they were all driven back by the debris and water. Mining engineers and the fire brigade brought in heavy duty pumps and started to pump out water down the steep banks from the entrance to the mine. Friends and relatives gathered in the local community centre, where they were looked after by villagers and charitable organisations. Toys were brought in for the children and the two local vicars, Peter Lewis and Martyn Parry, came to give their support and comfort to the families of the trapped miners. The four miners were named as Charles Breslin, aged sixty-two; David Powell, aged fifty; Garry Jenkins, aged thirty-nine; and Philip Hill, aged forty-five. The rescuers found no methane gas and a good level of oxygen, which gave them hope that the men may have been able to find shelter above the level of the water. The Welsh First Minister, the Right Honourable Carwyn Jones, and the Secretary for Wales, Cheryl Gillan, were accompanied by Peter Hain MP, the Shadow Welsh Secretary, to offer their support to the families. David Cameron, the Prime Minister, said that all possible help would be given for the rescue operation. Sadly, on the following morning, Police Superintendant Phil Davies announced that one of the miners had been found dead in the exit shaft overnight. Rescuers worked without a break to try and reach the trapped miners, but to no avail. The remaining three were found dead later that day.

Peter Hain, local MP for Neath, immediately set up an appeal for the families of the four miners and Cheryl Gillan called for a civil contingency meeting in the Cabinet Office. When the men had been brought from the pit, the police, along with the Health and Safety Executive's mines inspectors, launched an immediate enquiry into the causes of the disaster. Even though the mine was regularly checked by the mines inspectorate, it was clear from the photographs released to the media that the pit was still working in

conditions reminiscent of the early twentieth century and left a lot to be desired. It was ironic that the funeral of sixty-two-year-old Charles Breslin, the first of the four miners, which was attended by more that 200 mourners, was accompanied by the Tom Jones song Working Man, which has the words, 'I will never again go down into the ground'.

The Prince of Wales thanking the members of the rescue team after the Gleision Colliery disaster. (Press Association)

On 18 November 2011 Prince Charles went by helicopter to the Rhos community centre in the Swansea valley to meet with the members of the Gleision Colliery disaster rescue teams. The prince thanked everyone for their efforts) he is seen here speaking to John Herbert) and gave them his moral support before visiting the families of those who had lost loved ones at the time. At the time of his arrival, the prince was met by a crowd of more than 200 people who said that they appreciated his visit and that it was the first royal visit to a mining community since Aberfan. The prince is the royal patron of the Swansea Valley Miners Appeal fund for the bereaved families. This was set up by Peter Hain MP and has now topped £600,000, thanks in no small part to a substantial contribution by the prince.

The Gleision drift mine has always had serious water problems and two powerful pumps are in constant use to try and prevent any problems. Neath and Port Talbot council ordered the pit's owners to put further measures in place to rid the pit of

thousands of gallons of water, which was constantly threatening the pit's already weak infrastructure. It seems that the pit was always changing hands and the previous owners went into liquidation only two before with almost £500,000 worth of dept. The new owners' license was only extended after they agreed to install extensive drainage systems and heavy duty pumps etc. This seems to have been in vain, as water looks to have been the master yet again; let's hope the council protects these men from working in such archaic and dangerous conditions. The water will not go away and the cost to try and control it would be prohibitive. There are very few of these dangerous private organisations left and they are a blot on the landscape of a once proud nation of miners. The government should step in, pay compensation and close them for the good of mankind. Their contribution to the nation's wealth is miniscule and would not be missed. It would save lives for the future.

Malcolm Fyfield, the fifty-five-year-old colliery manager, was arrested on 18 October and questioned at Port Talbot police station on suspicion of gross negligence manslaughter and he was released the following day on police bail pending further enquiries. The Welsh mining industry has over the years pumped millions of pounds into the British economy, but it also had the worst disaster in British mining history when a gas explosion occurred in October 1913, killing 439 men at the Senghenydd Colliery. Almost 100 years later we are still seeing disasters throughout the world killing hundreds of men and maiming many others.

In November 2009 108 men died due to an explosion at the Xinxing mine near to Hegang in the Heilongjiang province in China; 392 were rescued in April 2010.

An explosion killed twenty-nine men at the Upper Big Branch mine in West Virginia USA in August 2010.

Thirty-three miners were trapped underground after a roof fall at the Copiapo mine in Chile; they were all rescued sixty-nine days later.

In November 2010 an explosion occurred at the Pike River Mine in New Zealand, which killed twenty-nine men and injured two others. This is not counting the accidents that are still happening on our own doorstep.

Ode Jed

He passed me each morning,
in his hob nail boots n' cap,
His dudley on his shoulder,
an' his snap tin at his lap.

He allus said good morning,
as he trundled down the lane,
His bright red 'Chief round his neck,
an I never knew his name

I havn't lived here very long,
so dunt know many folk,

So a thought ad mek enquiries,
an ask about this bloke.

I ask the village postman,
a miner long ago,
About this bloke wi, bright red chief,
Who allus said hello.

Nar that's ode Jed the postman said,
I knew him well afore.
But he died the day they shut the pit.
In 1984.

<div align="right">Brian Skillcorn</div>

Tragedy struck again when only twelve days later, on 27 September 2011, another death in the British coalmining industry occurred when married man and father of two Gerry Gibson, from Sherburn in Elmet, was working with a colleague, Phil Sheldon aged forty-six. They were trapped by debris when a roof fall occurred and Gerry died from asphyxia as a result of being buried. Phil was rescued and sustained only minor injuries. The accident happened at Yorkshire's deepest mine, 2,600-feet -deep Kellingley Colliery at Beal near Knottingley, North Yorkshire. Gerry had been a miner from the age of seventeen, when he joined the industry in 1979. A highly skilled, respected worker with thirty-two years' experience was how he was described by his colleagues and UK Coal management.

On Friday 30 September, Doncaster company UK Coal were making an appearance at Pontefract Magistrates Court over another death – that of miner Ian Cameron – accused of breaching the Health and Safety at Work Act section 2(1) by failing to ensure the health, safety and welfare of their employees. Mr Cameron was crushed to death when equipment fell on him in October 2009. Don Cook died in a rock fall in September 2008. The company was accused of failing to ensure that powered roof supports were maintained in an efficient state, in efficient working order and in good repair. It was also charged with exposing its employees to health and safety risks at the coal face and not ensuring the health and safety of its employees, including Mr Cameron.

Worcester company Joy Mining Equipment Ltd were also in court facing similar charges under section 6(1) (d): of failing to ensure that people, including UK Coal, were provided with all necessary information about health and safety risks with regards to the use of the powered roof supports. The case was adjourned until 24 October.

Andrew Mcintosh, UK Coal director of communications, said that the new company board was working to improve its safety record. He said that UK Coal deeply regretted any incidents that had occurred at any of its mines and that its sympathies were with the family, friends and colleagues of Ian Cameron. He said the company had invested in new equipment, overhauled working practices and put a stronger emphasis on

training. He went on to say that Gerry Gibson's tragic accident was a bitter reminder of how important this work is. Hundreds of Gerry's friends, family and colleagues bade him farewell at his funeral at Selby Abbey on 8 October.

Inspector of mines Mr John Wyatt told the North Yorkshire Coroner at an inquest at Selby Magistrates Court that it would appear from his initial investigations that the roof support system had failed; further investigations could take up to six months. Equipment had been sent away for analysis. The firm admitted safety breaches with regards to the deaths of Trevor Steeples, aged forty-six, at the Daw Mill Colliery near Coventry in 2006; Paul Hunt in August 2006 in another accident at Daw Mill; Anthony Garrigan in January 2007, also at Daw Mill; and Paul Milner who died at Welbeck Colliery near Mansfield, Nottinghamshire, in January 2007. UK Coal were found guilty of breaching health and safety regulations in the case of Anthony Garrigan. They pleaded poverty and asked the judge to be lenient as the company was in financial difficulty. UK Coal was fined £1.2 million for previous breaches and they admitted to all charges related to the latest accident and were charged later in the year after a full trial. Joy Mining Ltd of Worcester, who made the powered roof supports used at Kellingley Colliery, pleaded not guilty to all charges against the company and were tried later in the year.

UK Coal and Joy Mining Ltd were each found guilty of breaching health and safety regulations in the case of Ian Cameron and UK Coal was fined £200,000 for failing to ensure that powered roof supports were maintained in an efficient state, in efficient working order and in good repair and for exposing its employees to health and safety risks at the coal face and not ensuring the safety of its employees, including Mr Cameron. Joy Mining Ltd were fined £50,000 for knowing that a fault existed in its equipment and failing to inform UK Coal.

They chose not to mention that one-third of the nation's energy is provided by coal and that they are the largest producers of coal in the country with known reserves in excess of 50 million tons in their surface (outcrop) mines and more than 100 million tons in their deep mines. Their own energy-producing ventures manufacture electricity from waste mine gases and they are in current collaboration with Peel Energy to launch into the renewable energy markets in the form of wind farms. UK Coal also has a considerable portfolio of brownfield developments in the form of Harworth Estates, managing agricultural estates, business parks and thousands of homes generating large amounts of rental income. Its total property interests in 2010 were valued at £384 million.

Peel Environmental announced in September 2012 that it would be submitting a planning application to build a renewable energy plant at Kellingley Colliery that would generate energy from 280,000 tons of non-hazardous waste per year. Kellingley Colliery would receive a low-cost, stable, energy supply which would help cut its operating costs. The privately funded scheme developed in consultation with UK Coal could input up to 26 mw of power into the nearby electrical grid.

Kellingley Colliery Coal supplied direct to the local power stations.

Entrance to Kellingley Colliery. (Ken Wain)

Looking over the canal towards Kellingley Colliery. (Ken Wain)

Kellingley Colliery safety sign. (Ken Wain)

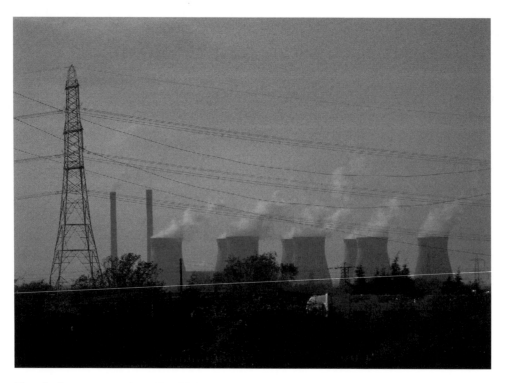

Knottingley power station. (Ken Wain)

Eggborough power station. (Ken Wain)

Above left: Pit bottom supplies. (NCB)

Above right: Trepanner coal cutting machine.

The Rundown of the Coal Industry

British Coal Corporation Chairman Sir Robert Haslam gave his review of the industry as he saw it at the end of the 1986–7 period of business. He said:

> During the past year the coal industry has faced the toughest competitive pressures in its history. It is there for particularly gratifying that we have been able to make such substantial advances in our performance. Productivity increased by 21 per cent and records were achieved by each of our deep mine areas and by the corporation as a whole.

In the last week of the year the overall output per man shift reached a new record of 3.76 tons, the fifteenth time in the year that a new weekly record had been set. Deep mine operating costs fell once again in real terms and for the year as a whole were some 23 per cent lower than in the period before the 1984 strike. Deep mine operating costs fell to £1.60 per gigajoule compared to the previous year, when it was £1.78 per gigajoule – a reduction in real terms of 13 per cent. The corporation as a whole made an operating profit of £369 million. He went on to say,

> The past two years have been extremely difficult for the industry, and have seen what I have characterised as "Dramatic Restructuring", involving a reduction of nearly 80,000 in our total workforce, and a reduction of fifty-nine in the number of collieries. Three of the thirteen corporations' national workshops were closed overall workshops costs decreased by £11 million.

The thin end of the wedge was knocked into place when the government-backed British Coal Enterprise Limited kicked in, creating 10,000 jobs in 1987 by committing £27 million to 1,184 projects with a total funding of £186 million. Bear in mind that not all mineworkers were budding businessmen and the 10,000 jobs created here still left 70,000 without work and this was an on-going process in line with the government's pit closure programme.

While all this was ongoing, the corporation's policy of disposing of its housing stock by 1988–9 was speeding up. Priority of sale was given to sitting tenants. Where they did not wish to purchase, or could not afford to purchase, the houses were offered for sale to local authorities and housing associations and failing this were offered for sale on the open market. During 1986–7 9,700 houses were sold, reducing the housing stock to 16,700

– further proof of the government's intention of eventual decimation of the industry, painting a very bright picture by publishing such encouraging facts and figures while openly preparing to put the whole workforce on the scrap heap, even to the tune of printing in the industry's newspaper *Coal News* an article regarding the development of new pits in Yorkshire.

Over a million tons was produced from Wistow Mine in 1986–7, a slight improvement over the previous year's output. The amount of coal used for electricity generation in 1990 was 84 million tons. Work proceeded on the construction of the new Asfordby mine in Leicestershire in accordance with the planned programme. Two shafts were sunk to a depth of 1,500 feet and coal production commenced in the early 1990s and built up to an annual output of more than 3 million tons by 1993–4. More than £300 million has now been spent on the project and coal is being turned from the pit's first coal face, 101s. The industry's manpower contingent in 1992 was 42,000 and was down to 15,000 in 1994 and the corporation's new chairman, Neil Clarke, said because of coal stocks held by the corporation and the power generators, sales had fallen from 40 million tons to 30 million tons per annum and he felt that the markets were rigged against coal in favour of the state-owned Nuclear Electric, which got a subsidy of £1 billion per year from electricity consumers and now has 25 per cent of the electricity generating market for England and Wales. According to the Coalfield Communities Campaign, the government has given permission to allow enough gas-fired power stations to displace another 1 million tons of coal per year; plus the changing of EU regulations pressed for by the British government now allowed gas to be used for electricity generation.

The 'dash for gas' had now begun and British deep-mined coal was priced out of the market, its sales to the generators now only being just less than 42 million tons and dropping. The writing was clearly on the wall! The corporation's remaining pits, including Asfordby were all sold to the private sector in 1994. The Retford-based RJB mining company purchased Asfordby, along with others and after only three years were to realise what British Coal knew all along: that the generators were now heavily reliant on gas and coal sales were dropping. His contracts with them were shortly to come to an end and he had only been able to secure a short-term contract with one of the companies. Things were looking glum and Richard Budge decided in 1997 that Asfordby mine would have to close because, as he put it, 'adverse geological conditions' made it impossible to make the mine safe. Budge's way of coercing the minister to force the generators to pay the price and keep the pit open. In a confidential memo from a senior civil servant to the industry minister, John Battle, he said, 'I wouldn't waste any tears over Asfordby if I were you. It was well known that it was a bit of dog; it was only built as a sop to the UDM who demanded it for supporting the government during the miners' strike.' This cost in excess of £300 million. Quite a price to pay for the Nottinghamshire miners to help in the destruction of their own industry, considering that Budge only paid £815 million for the lot. He went on to say that 'the government didn't owe Mr Budge a living and that he had already made back most of what he paid for British Coal. If you don't step in and make the generators pay up, what little is left of the coal industry might all but disappear. There is an argument that this would be no bad thing. Your predecessor, Tim Eggar certainly thought so. Coal is nasty environmentally unfriendly stuff. If you were wise you wouldn't intervene'.

British Coal Enterprise business setup poster. (NCB)

Much to the disappointment of RJB, the minister did not intervene and the colliery was closed. Demolition took place in 1998 and the site was cleared. Richard Budge bought his brother's opencast coal and plant division from the family business in February 1992 for £102.5 million and went on to buy most of the pits belonging to British Coal for £815 million when they were denationalised in 1994.

When the Labour government were elected, he told them that unless he got long-term contracts with power generators Powergen and National Power, ten pits would close. A life line was extended to RJB when in December 1998 a new £1 billion deal was struck with Powergen to supply 35 million tons of coal from then until March 2003. In the previous month RJB secured an £800 million deal with Eastern Group to supply 50 million tons of coal up to 2009. The company lost £10 million in the six months up to 8 September and a £75 million government aid package looks set to be approved by the European Commission. Richard Budge tried to sell off the pits to the American Renco Group.

On 14 July 2001 Budge stepped down as CEO of RJB and the company became known as UK Coal. He set up another company, Coal Power, in 2001 and bought Hatfield Main Colliery in April 2004 from the Hatfield Coal Company, helped with £7 million of state aid. Coal Power went into administration in 2003. His latest company, Powerfuel, is 48 per

cent owned by himself: the other 52 per cent is owned by Russia's second largest mining company, KRU.

In April 2000 he reopened Hatfield Colliery at a cost of £100 million, 50 per cent of which was financed by the VTB Bank. The colliery had approximately 27 million tons of coal reserves at this time and a 900 mw, IGCC power station known as the Hatfield IGCC Project was planned to be built next to the colliery. Powerfuel went into administration in December 2010 and the Dutch bank ING took control of all the assets, saving more than 400 jobs. British company 2Co Energy Ltd acquired Powerfuel Ltd out of administration

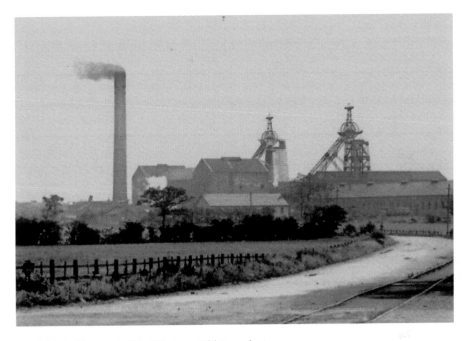

Hatfield Colliery c. 1920. (Chris at Old Barnsley)

in May 2011 and the Hatfield Carbon Capture and Storage project at Stainforth in South Yorkshire.

The £5 billion Carbon Capture and Storage scheme, partly funded by a £164 million grant from the EU, has attracted a 15 per cent investment from Samsung C&T and BOC among others. Talks are on going regarding future plans for the newly named Don Valley Power Project and, interestingly, Hatfield Colliery management has now been taken over by Hargreaves and August 2012 saw the company advertising for in excess of 200 extra men to work at the pit. If the above scheme takes off it could lead to 2,800 construction jobs for Samsung C&T and BOC. Its parent company, Linde, will manufacture the air separation units and provide the carbon capture technology, with upwards of 500 extra jobs at the pit to supply the coal to the power station. The clean burn technology would ensure that the power station would generate 900 mw of power for 1 million homes with little or no emissions. Between 2015 and 2016, 5,000 tons per year of captured carbon would be piped overland to the North Sea, where it

would be pumped below the sea bed and stored in the old oil fields out of harm's way for thousands of years.

The British government's department of energy and climate change has recently instigated a new competition between companies and suppliers for a share in a new £1 billion initiative to ensure that the UK is back on track to becoming a world leader in carbon capture and storage technology. The funding was decided upon in 2013 and production could begin by 2015 or 2016. This could quite well be the gateway for the British coal industry to once again show its capabilities in providing for the future economy of the nation. Clean electricity and thousands of jobs, with hundreds of millions of tons waiting to be explored and exploited. Interest is already being shown and as well as British energy companies, the USA, India and China are all waiting in the wings for future developments. Russia and Japan know the folly of nuclear power.

Black Rock

Black Rock; lies here below, The reason
why God only knows. Black Rock was
nature's best,
The Tories laid Black Rock to rest. Black
Rock made men united brothers, Clothed our
kids and our mothers. Black rock fed the sick
and old, Warmed the air when nights were
cold.
Black Rock was our power and our glory,
Remember 'The Victory Sign' if you vote
Tory.
Ash to ash and dust to dust, Black Rock to
our area was a must.

Peter Finnegan

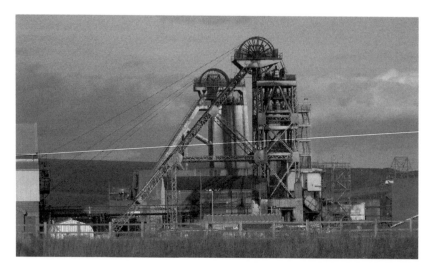

Hatfield Colliery in September 2012. (Ken Wain)

AMENDMENT TO PREVIOUS STORY

It seems that for all the years of hard work and investment cash, including that which was granted from the EU of £164 million and in full knowledge of the British Tory government, that has been expended on the proposed carbon capture scheme in the Don Valley, at Hatfield Colliery, the scheme appears to have fallen at the first hurdle after being denied government funding. It was widely anticipated because of previous government indications that the scheme would be short listed as one of four to be granted funding from eight possible contenders. Local MPs including Ed Milliband, the opposition leader, and company bosses are actively lobbying the government for urgent answers as to how this has been allowed to happen. So much for the government's supposed commitment to become a world leader in carbon capture when a scheme like this one, which is at such an advanced stage and the European leader in this technology, is allowed to fall by the wayside.

2CO Energy company bosses remain committed to the scheme and said they would continue, but missing out on the government money put the scheme under serious threat. The company's chief executive Lewis Gillies said,

> This is disappointing for Doncaster, where we would have built this plant and for our world class project team working to deliver it, the company will complete the current phase of the project and meet the knowledge share obligations of our existing EEPR funding from the EU but we cannot take this project further without funding from the UK government.'
> Doncaster Mayor Peter Davis said, 'I am in a state of shock and bewilderment that the project could not make the short list; the project was at an advanced stage compared with the short listed bids which are years behind in terms of their development. It makes you question the government's commitment to carbon capture and storage as they are turning the clock back.

It was announced on 30 October that the four shortlisted contenders were: DRAX's 304 mw North Yorkshire; Shell and SSE's 1,800 mw combined gas cycle plant in Peterhead; National Grid and Petrofac's 570 mw coal gasification project in Grangemouth; and Progressive Energy and GDF Suez's 330 mw coal and gasification project in Teesside. The government said it will make a final decision on the winners some time in the new year. The department of energy and climate change will put forward the DRAX coal project and the Progressive Energy Teesside project for the funding from an EU initiative that has earmarked two UK projects as contenders to win up to 337 million Euros for each project, but the EU commission will not decide whether to back a UK-based scheme until the end of the year.

The Peterhead scheme was put on the reserve list. 2CO Energy and the European Commission are trying to come to terms with the British government's decision, after the Don Valley scheme was selected twice for EU funding and was taking the crown as Europe's top-ranked project and the preferred winner of its tender. A government spokesman said that the decision was made on affordability, deliverability and value for the taxpayer, despite Don Valley having also won the previous £164 million EU funding. The EU's position in the scheme of things is to be admired and the British government's position

to be abhorred. Is this to serve as a reminder of thirty years ago when Margaret Thatcher's government sought to drive the coal mining industry into oblivion?

A stark reminder was dropped on us on 18 February 2013 when it was announced that further coal-fired power stations were to close by April due to EU regulations, which will reduce our energy production by a further 10 per cent, making us even more reliant on overseas producers because our own gas supplies are quickly depleting. Poland, America and China are already supplying us with coal for 40 per cent of our energy needs.

Living Hell

People on earth, a place to dwell,
A story I know, to you I must tell.
Not the type that's in your mind,
Listen friends and you will find.

Once upon our lands were green,
Air was fresh and very green.
Radiation now in the air,
Travelling toward our human lair.

Surely people can understand,
That radiation kills our land.
People will begin to fear,
Radiation is creeping near.

Governments of the United Nation,
Can't understand this radiation.
Produced from a nuclear cell,
Can make our life a living hell.

Nuclear waste begins to leak,
Father's Mothers begin to weep.
Barren lands that run for miles,
Mothers lose their only child.

Reactors now begin to blow,
No land left for you to go.
No escape from nuclear waste,
Stick to skin like burning paste.

Burns blisters, radiation sores,
Sea life dead from shore to shore.
Wildlife all forsaking,
Their food poison, there's no mistaking.

Water that was there to drink,
Looks more like pneumonic ink.
Poison clouds in our skies,
Fall out dust in our eyes.

Power from these foolish plants,
Kills our flowers, bees and ants.
Power which cannot be controlled,
How many times have they been told.

Birds fly high to escape the pain
Then get hit with yellow rain.
People dying slow but sure,
No time left to find a cure.

Governments say 'Oh what a loss,'
Do they know the human cost.
Who'll be left to care for others,
When one has lost their loving mothers.

For if this is man's own creation,
Then goodbye to our civilisation.
For if we can't stop this horror,
By Gods power, there shall be no tomorrow.

Peter Finnegan

Industry in and around, Sheffield and Barnsley areas benefited greatly by being in close proximity to the pits and suppliers of mining and associated equipment were soon not only supplying pits in the Sheffield and South Yorkshire areas but expanding to be nationwide colliery suppliers.

Below is a list of some of the suppliers to the industry, providing much needed jobs in the region as a whole.

Hardypick Ltd.
Sheffield 8.
Flameproof mining switch and control gear.

Wolf Safety Lamp Co.
Formerly Federation Lamp Co.
(William Maurice) Ltd
Saxon Road Works,
Sheffield.
William Maurice was the first president of the Association of Mining Electrical and Mechanical Engineers. The only person to hold the position for three years,

1909–1912. Manufacturers of electric lamps, flame safety lamps, air turbo lamps, alkaline electric lamps and acetylene mine lamps.

Ceag Ltd
Queens Road,
Barnsley.
Electric lamps, colliery lamp room equipment,
cap lamps, hand lamps and torches.

J. Youle & Co. Ltd
Millgate Works,
Rotherham.
Electric lamps, colliery lamp room equipment,
cap lamps, hand lamps and torches.

Robinson & Sons Ltd
Wheatbridge Mills,
Chesterfield.
First aid eqipment and surgical dressings etc

R. R. Longley.
Dearne and Dove Mills,
Worsborough Dale,
Barnsley.
Wooden and iron pit tubs, conveyors, metal structures, pit props and timber.

The Sheffield Wire
Rope Company Ltd.
Darnall,
Sheffield.
Steel wire ropes for all mining applications (output over 2 million yards per year).

Hayden Nilos Ltd.
Darnall Road,
Sheffield 9.
Air-driven percussive coal cutters, rock drills, conveyor belts and fastening, coal cutter picks, and coal cutter hose.

Thomas W. Ward Ltd
Sheffield.
Air receivers, boilers, steelwork, tanks, electric furnaces, hammer drills, rails, sidings, ferrous and non ferrous metals.

Plowright Brothers Ltd
Chesterfield
Ash handling plant, bearing metals, girders, steel bridges, elevator buckets, castings, cages, coal crushing machinery, bunkers, chimneys, coke ovens, conveyors, headgear, winding gear and coal washing machinery.

Mavor & Coulson
Olive Grove Road,
Sheffield.
Electric coal-cutting machinery. Conveyors and conveyor motors.

Baldwin & Francis
Eyre Street,
Sheffield.
Electrical switchgear and light fittings.

William Cook & Sons
Sheffield.
Steel castings, wheels, axles, tie bars.

Felco
Sheffield.
Hoists, pulleys, block and tackle, etc.

Tirfor
Halfway,
Sheffield.
Hoists, pulleys, block and tackle and hand operated ratcheted lifting tackle.

Dollery & Palmer.
Sheffield.
Pneumatic tools and general mining tools.

Qualter Hall & Co.
Barnsley.
Conveyors and coal screening equipment.

Stokes Paints
Sheffield.
Paints, varnishes and general decorating sundries.

The above list only takes into account the major equipment suppliers, but when you consider the supply of foodstuffs and general catering supplies, along with stationery and office equipment from local suppliers, along with all the other ancillary sundries

that are needed to run a colliery site, you can then begin to realise the dependency of thousands of people that relied on the industry for their livelihoods. Not only did the government's pit closure plans put tens of thousands of miners out of work but further thousands of workers in the above sectors were also put on the scrap heap, as happened after the government's decimation of the steel industry, which had exactly the same effect, wrecking the nation's economy.

This and next two pages: Some of the local suppliers to the coal industry who were affected by the pit closures programme. (Coal trades diary 1949)